IMAGES
of America

H.J. HEINZ
COMPANY

THE HOME OF THE 57

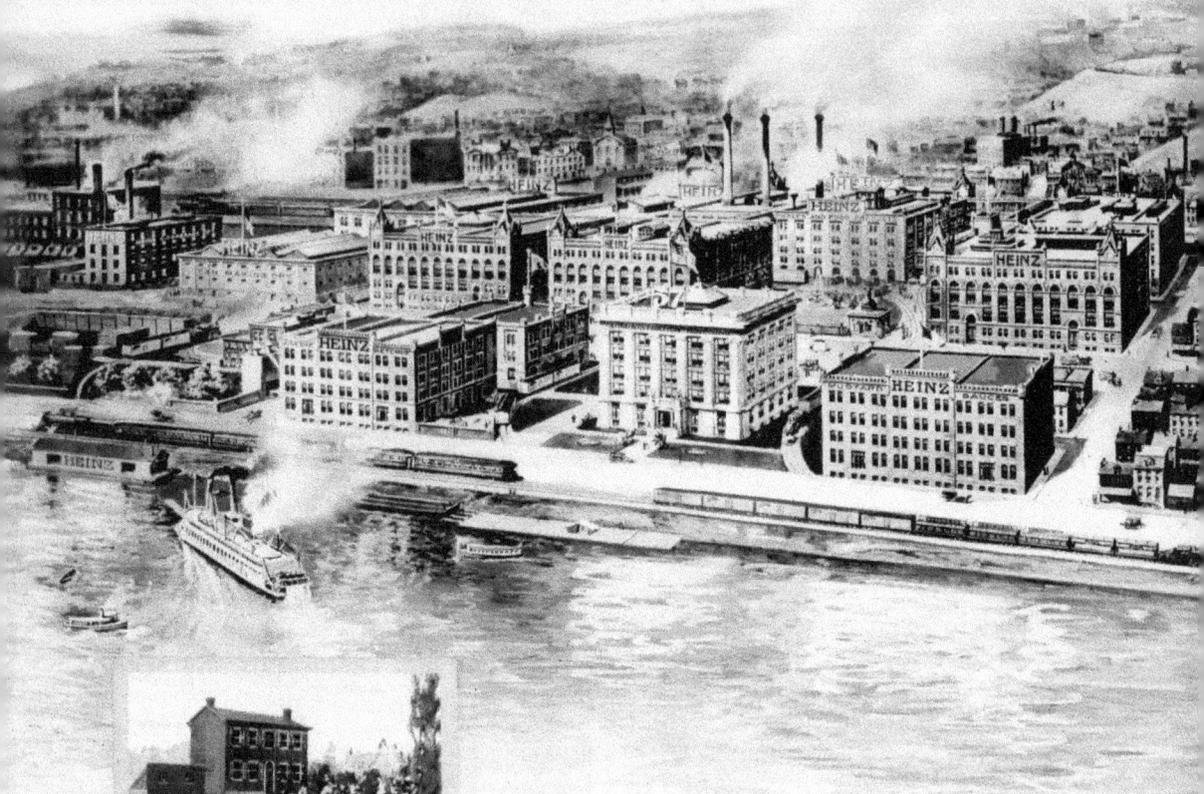

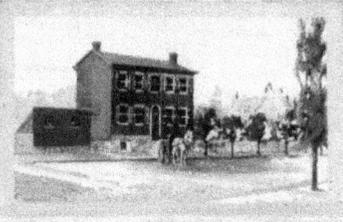

House where we began — 1869

H.J. HEINZ COMPANY
PITTSBURGH, PA.

Henry J. Heinz created his "worker's utopia" on the shores of the Allegheny River, just north of the city of Pittsburgh and the headwaters of the Ohio River.

On the cover: In 1901, H.J. Heinz Company's design shop turned out huge signs, the most effective advertising method at the time. (Courtesy of H.J. Heinz Company.)

IMAGES
of America

H.J. HEINZ
COMPANY

Debbie Foster and Jack Kennedy
for the H.J. Heinz Company

ARCADIA
PUBLISHING

Published by Arcadia Publishing
Charleston, South Carolina

Library of Congress Catalog Card Number: 2006926116

For all general information contact Arcadia Publishing at:
Telephone 843-853-2070
Fax 843-853-0044
E-mail sales@arcadiapublishing.com
For customer service and orders:
Toll-Free 1-888-313-2665

Visit us on the Internet at www.arcadiapublishing.com

To our colleagues at the H.J. Heinz Company, past and present, who have continued the traditions set forth by founder Henry J. Heinz. He encouraged us all with these words: "To do a common thing uncommonly well brings success."

CONTENTS

ACKNOWLEDGMENTS

This book came to life thanks to the collaborative work of many people, notably the team of folks in the Corporate Affairs Department at Heinz World Headquarters. We were encouraged from the beginning by Heinz chairman, president, and CEO William R. Johnson and senior vice president Ted Smyth.

The real contributions to this book, however, were made by past H.J. Heinz Company designers, illustrators, photographers, and writers, who consciously saved so much of our history through publications and early archives, including some of the very first industrial photographs in America. These currently are under the stewardship of the Historical Society of Western Pennsylvania, which has expertly cataloged and preserved each image. They graciously provided many of the photographs shared in this book.

We also drew from earlier company histories by Eleanor Dienstag and Robert Alberts, who conducted extensive and enlightening research.

And we are indebted deeply to the inspired work of Bill Exler, who for more than 25 years has shared with us with his photographic talents.

Works cited for this book include:

Dienstag, Eleanor Foa. *In Good Company: 125 Years at the Heinz Table*. New York: Warner Books Inc., 1994.
Alberts, Robert C. *The Good Provider: H.J. Heinz and His 57 Varieties*. Boston: Houghton Mifflin Company, 1973.
Alberts, Robert C. "The Good Provider." *American Heritage*. February 1972.

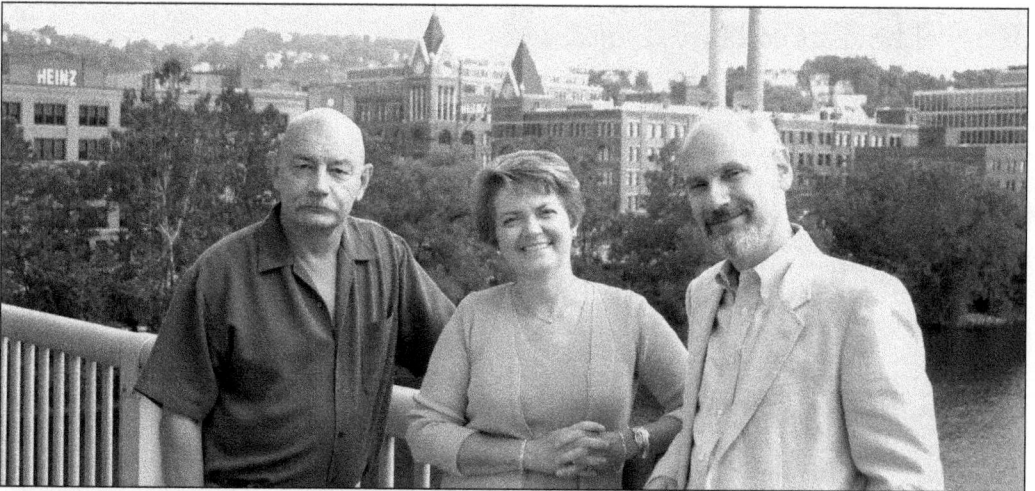

Photographic consultant Bill Exler (left) and authors Debbie Foster and Jack Kennedy each spent several decades working on behalf of Heinz. Today much of the company's original Pittsburgh factory complex is home to stylish loft housing. The other buildings are owned and operated by TreeHouse Foods, which has packed a range of soup and infant feeding products there since early 2006.

FOREWORD

The 1906 Pure Food and Drugs Act was one of the landmark pieces of legislation enacted during the Progressive Era in American politics. Progressives, led by Theodore Roosevelt, began to demonstrate through enforcement of this act, as well as the enactment of other pragmatic pieces of legislation during his tenure, that a federal government staffed with professional civil servants could work collaboratively and creatively to solve problems in many different sectors of American society. At the time the 1906 act was enacted by Congress and signed by the president, banking and railroad legislation were considered more important, but it was federal regulation in support of safe foods and effective medical products that survived the test of time. Likewise, the H.J. Heinz Company has also survived the test of time, and its keystone label remains one of the most recognized graphic designs in the world, little changed since two honorable men joined forces in support of a common goal.

The H.J. Heinz Company played a critical role in the enactment, interpretation, and enforcement of the 1906 statute. Founder Henry J. Heinz took a courageous stand on behalf of pure foods, which included reformulating his own ketchup. Heinz found himself first in agreement, and later in partnership, with another pure food pioneer, Dr. Harvey Washington Wiley, chief of the Bureau of Chemistry in the Department of Agriculture. Heinz understood that laws ensuring the purity of the packaged food would build consumer confidence in the nascent industry. It would be a particular advantage for a company like Heinz, whose products were already pure, by raising the costs for competitors who were adulterating their products with chemicals and cheap fillers. Heinz and Wiley both employed unconventional methods for delivering their messages. Heinz's advertising and promotion escapades were legendary, while Wiley's creation of a "Poison Squad" of young Department of Agriculture staff volunteers, whom he fed foods laced with common chemical preservatives of the day, proved similarly effective. Wiley fed the youthful chemists foods containing borax, benzoate of soda, and salicylic acid, all of which could be used in ketchup. Results of these studies convinced Wiley that preservatives, especially in large doses, were harmful to health. Wiley began to use his bully pulpit to become an effective advocate for federal food and drug legislation.

Heinz was convinced that the public did not support the use of preservatives and, indeed, associated them with low-quality foods. His fledgling company became the first major ketchup manufacturer to produce superior ketchup without the use of artificial preservatives, particularly benzoate of soda. Much to the company's surprise, its ketchup kept better than the ketchup that contained benzoate. The Heinz recipe, however, had to be altered to achieve a denser texture. It also contained more natural preservatives, including vinegar, which further enhanced flavor. Competitors accused Heinz of using some kind of "secret chemical ingredient." However, all the company did was create what eventually became known as "good manufacturing practices" for the production of tomato ketchup, starting with clean, red, ripe tomatoes and sterilized bottles in a sanitary manufacturing plant.

Following passage of the 1906 Pure Food and Drugs Act, the use of benzoate of soda in commercially prepared ketchup became so contentious that President Roosevelt himself became involved in the issue. The benzoate issue became a test of the intent and limits of this popular piece of federal legislation. Even after Heinz led the way and government scientists demonstrated that preservative-free ketchup was possible, there were manufacturers who resisted the change. The issue was ultimately decided in the marketplace. By 1915, one of the most popular ketchups at the beginning of the century had virtually ceased making and selling its ketchup preserved with benzoate. Heinz, in contrast, had increased his market share, expanded overseas, and his preservative-free ketchup became the most popular ketchup in America.

Wiley expressed his appreciation to Howard Heinz in 1924, citing his father's unwavering support during the early years of federal food and drug regulation. "I appreciate the loyalty with which your father and all the staff stood by me in the darkest hours of my fight for pure food," Wiley wrote. "I feel that I should have lost the fight if I had not had that assistance."

As we celebrate the centennial of this landmark legislation in 2006, there can be no doubt that it has produced what is today the safest food supply system in the world. Moving forward, there will be ample opportunities to continue the kind of private-public collaboration that has served both the food industry and consumers so well over the past 100 years.

Suzanne White Junod, Ph.D.
Historian, U.S. Food and Drug Administration

INTRODUCTION

It is my privilege to introduce you to this photographic history of the H.J. Heinz Company.

Within these pages, you will discover the industrious people, quality products, indelible personalities, and legendary marketing and promotion that have established Heinz as a preeminent global food company.

You will also appreciate the enduring cultural and economic bond that Heinz has forged with its native Pittsburgh, where prominent structures from the home of the renowned Pittsburgh Symphony Orchestra to the home of the 2005 Super Bowl champion Pittsburgh Steelers proudly bear the Heinz name.

Even as Andrew Carnegie's steel mills and George Westinghouse's electric distribution systems stoked America's march to industrial might, Henry J. Heinz helped pioneer the fledgling packaged food industry along the banks of the Allegheny River—first from the garden of his boyhood home in Sharpsburg and, later, a few miles downstream at the manufacturing complex he built that once was the largest of its kind.

Henry J. Heinz understood before most others that a quality food product, properly packaged and promoted, would find a ready place in the cupboards of a rapidly expanding nation. From that first product in 1869, horseradish, soon sprouted Heinz's famous "57 Varieties."

The promotional genius of Henry J. Heinz is a constant source of inspiration at Heinz. You will see examples of his groundbreaking merchandising and advertising in this photographic journey through time, including the ubiquitous Heinz pickle pin that was such a hit at its debut in Chicago at the World's Columbian Exposition of 1893, the magnificent Heinz Ocean Pier in Atlantic City, and the first lit advertising sign in New York City.

I am honored to follow in Henry J. Heinz's footsteps as only the fourth person to succeed him as Heinz chairman and the second non–Heinz family member to fill that role.

While maintaining the core values of quality in our products and equanimity with our employees, each Heinz leader has left a distinctive mark on this great company to position it for a new generation.

Howard Heinz, who assumed control upon Henry's death in 1919, successfully led the company through the Great Depression by expanding Heinz's product offerings to include soup and infant food. A chemist by training, he also introduced new methods of quality control.

Henry J. "Jack" Heinz II saw the company through World War II, even converting part of the Pittsburgh plant to make parts for war planes and K and C rations for the troops. Under Jack's leadership, Heinz continued the company's global expansion, pushing into Australia and China, as well as acquiring new brands like Ore-Ida potatoes and StarKist tuna in the United States and Plasmon baby food in Italy.

He was assisted in modernizing the company by R. Burt Gookin, an accountant who rose through the Heinz ranks to eventually become, in the 1960s, the first non-Heinz CEO. Following Burt, Anthony J. F. O'Reilly, my predecessor, continued the Heinz legacy of global growth, expanding Heinz's presence in Asia and Africa and bringing an enlightened perspective of the future possibilities of our great company.

Since 2000, when I became chairman, the House of Heinz has undergone a major renovation to adjust to the rapidly changing food industry landscape. A more focused Heinz competes today with leading brands in three categories: ketchup and sauces, meals and snacks, and infant foods. Through all the change, Heinz's basic commitment to bringing "Good Food, Every Day" remains the same.

The relationship between Heinz and Pittsburgh, meanwhile, has never been stronger. The most recent example of this is our just-opened Heinz Global Innovation and Quality Center

north of the city, a cutting-edge facility where new products that will drive Heinz's growth far into the new century are under development.

At Heinz, we are continuously nourished from the examples of the past as we build for a better future. I hope you enjoy this pictorial tour of the House of Heinz, one of America's iconic entrepreneurial success stories.

William R. Johnson
Chairman, President, and CEO, H.J. Heinz Company

One

THE FOUNDER'S DREAM

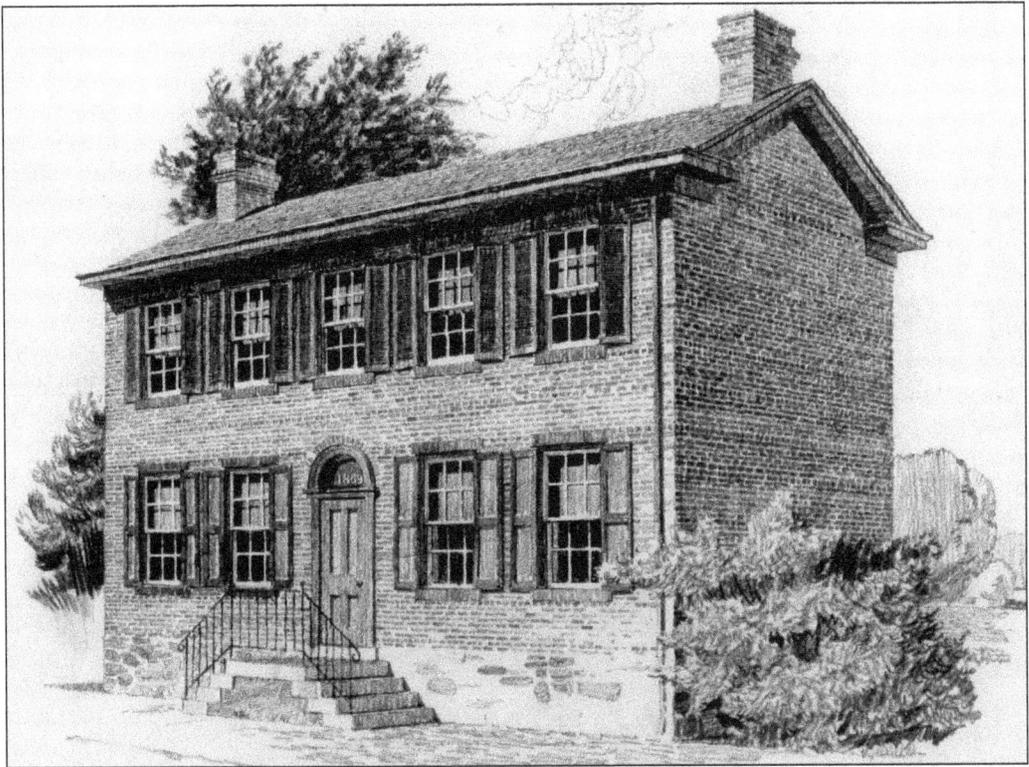

It is what some historians have called "the quintessential American success story." Indeed, it is a tale of how a mid-19th-century vegetable patch in Sharpsburg grew to become one of the world's premier food companies. A 12-year-old Henry John Heinz began peddling produce from his mother's garden, and by 1869, at age 25, he had started up a fledgling bottling business. Much of the activity centered on his family homestead, which Heinz later dubbed "the House Where We Began." At the time, it was nestled in four acres of rich farmland. In 1904, he enshrined it in a sprawling factory complex near the headwaters of the Ohio River in Pittsburgh.

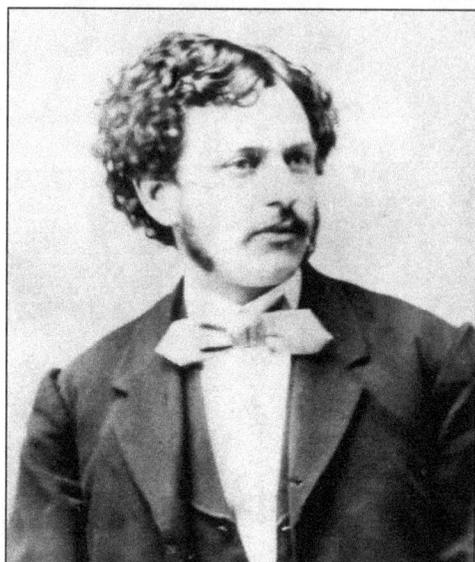

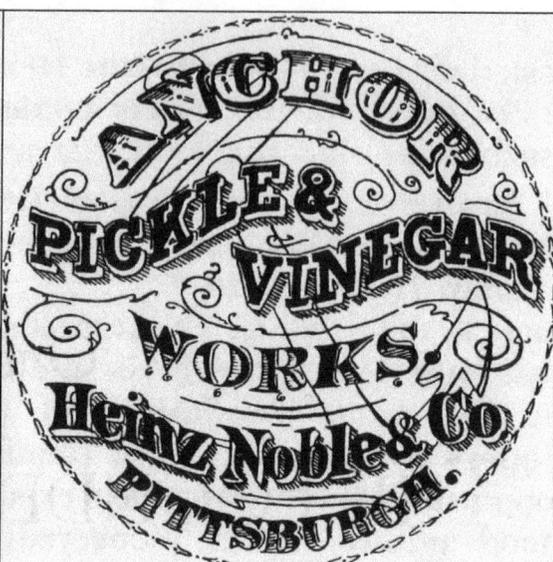

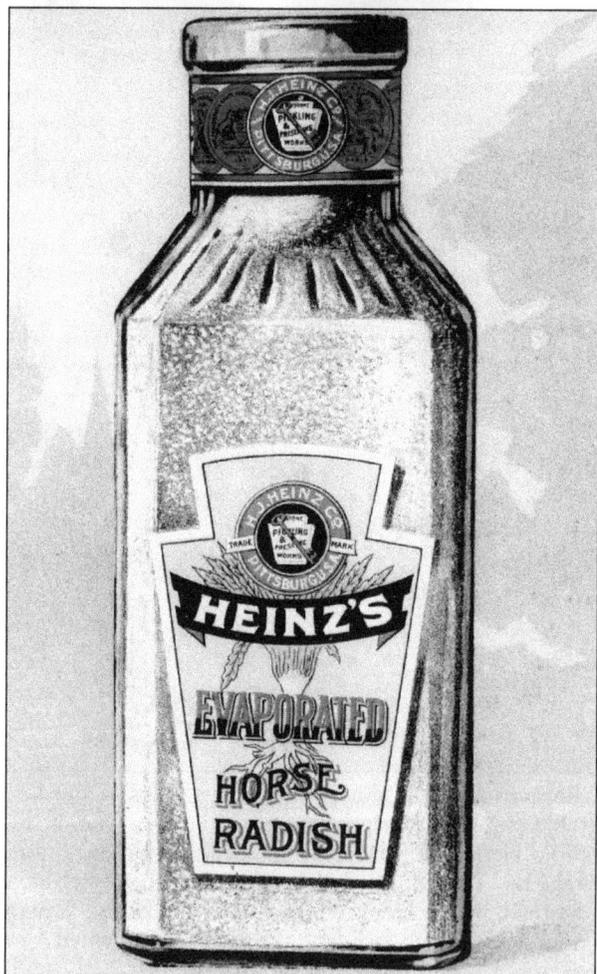

At age 24, Henry J. Heinz already had developed a sharp business acumen, and with his friend and neighbor L. Clarence Noble, he launched Heinz Noble & Company. Its first product was grated horseradish and, contrary to its competitors' offerings, Heinz and Noble's was bottled in clear glass to showcase its purity. It was a novel idea at a time when packaged foods were notorious for such low-cost adulterants as turnip filler and wood fiber. A keystone, the symbol of Pennsylvania, served as the company's first trademark.

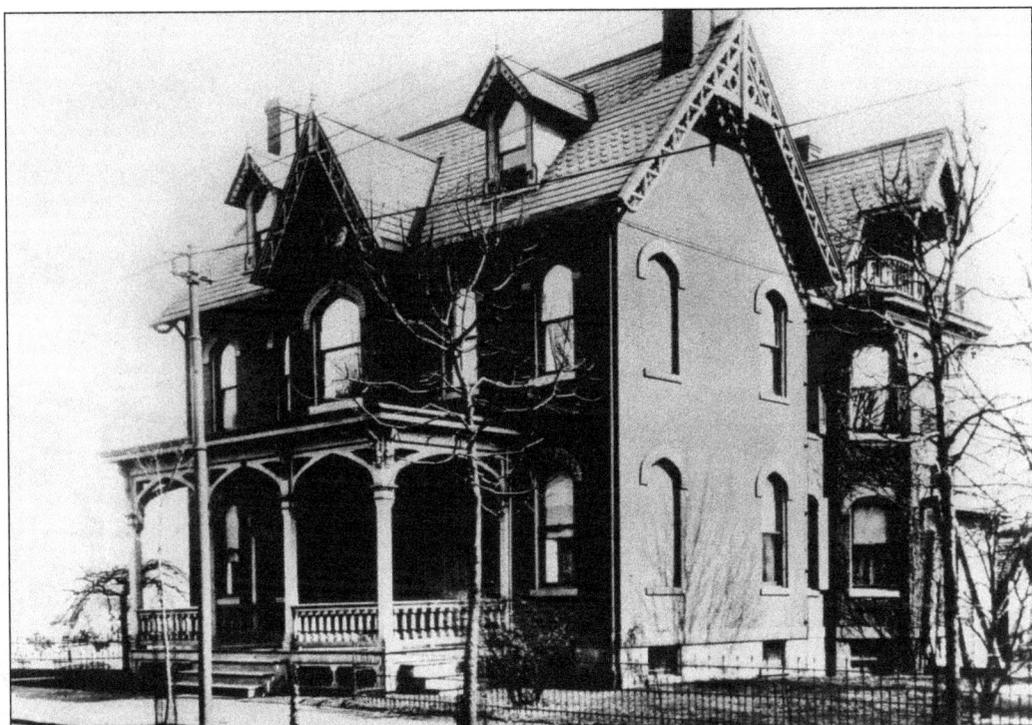

Henry J. Heinz was 21 years old when his father, owner of a successful brickyard, returned from a sojourn to his native Germany. Henry surprised him with a two-story brick home that he designed himself and financed by collecting debts his father had deemed "uncollectible."

Henry J. Heinz and his eldest son, Howard, appear in an early company photograph, which is inscribed on the bottom with this caption: "The Senior and Junior Members of the Firm on Their Way to the Office in 1885."

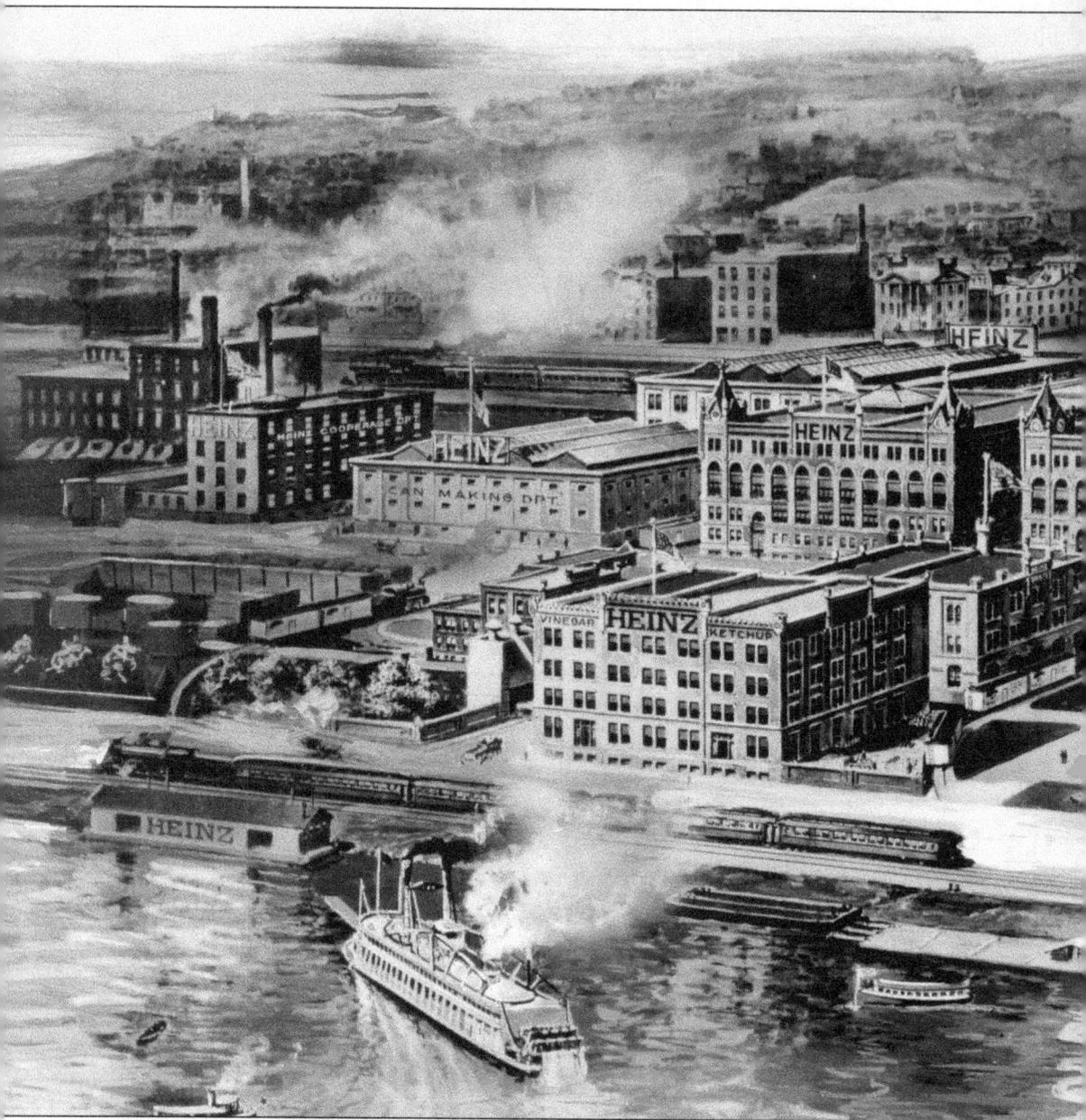

"The Home of the 57 Varieties" was built between 1890 and 1898 on the northern banks of the Allegheny River near downtown Pittsburgh. The 17-acre complex provided easy access to rail

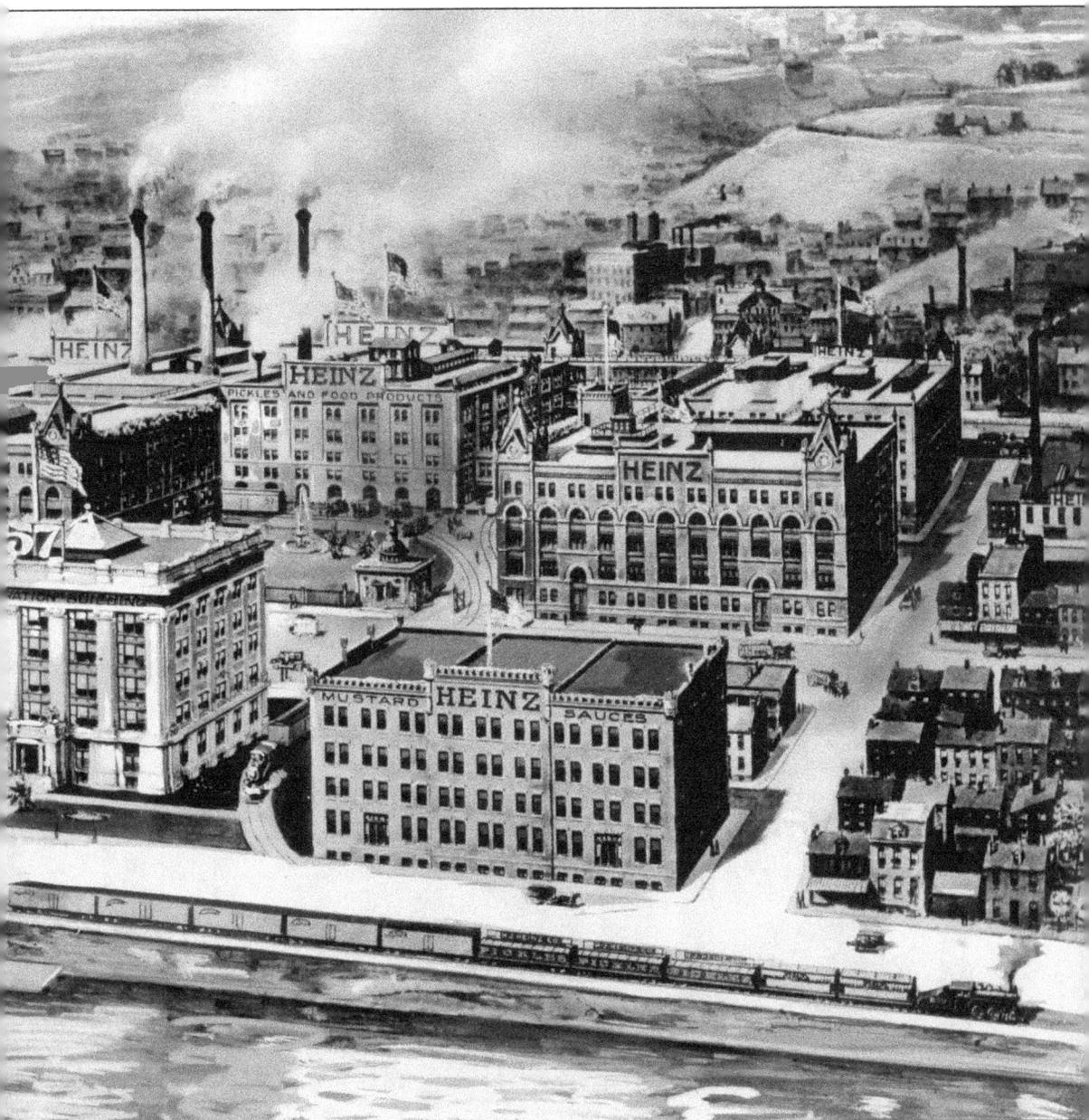

and river transport and was considered a "worker's utopia." Factory and office buildings arose from a central courtyard along Progress Street.

Employees who handled food received professional manicures at least once a week. The emphasis was on cleanliness and sanitation, rather than vanity.

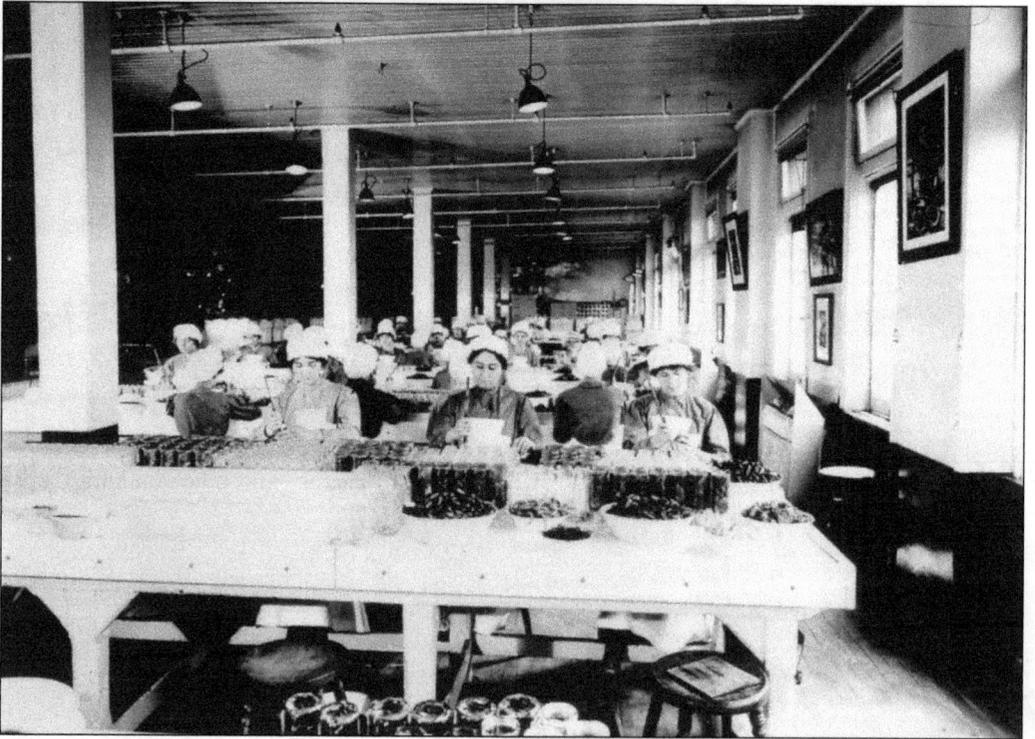

Every pickle-packing line maintained the order and fastidiousness of Henry J. Heinz's vision.

The Time Office, set at the entrance to the complex, was modeled after early plans for the Thomas Jefferson Building of the Library of Congress. Both were completed in 1897. The 25-foot-by-25-foot building was constructed of terra-cotta Pompeiian brick and topped by a golden eagle whose beak held a cluster of electric lights. Circular stained-glass windows displayed inspirational mottos, including "Labor sweetens life; Idleness makes it a burden." For 30 years, employees passed through the building twice daily to record their "compensable hours of labor." On their breaks, women employees were offered the luxury of wagonette rides around the grounds in their best finery.

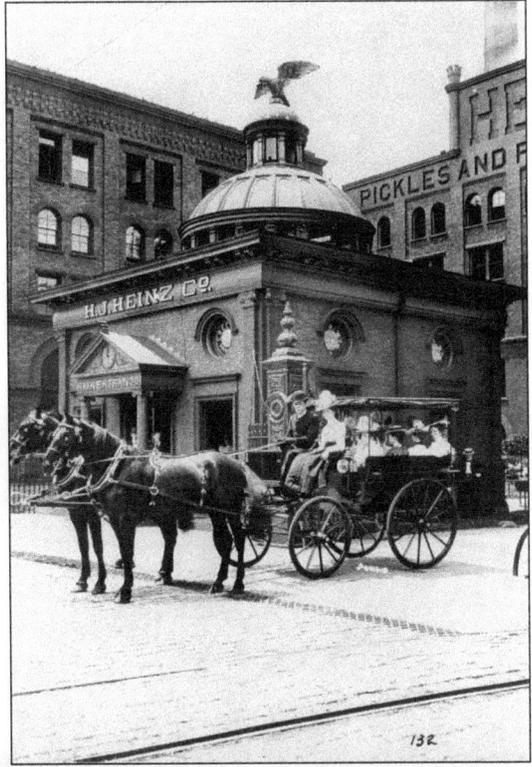

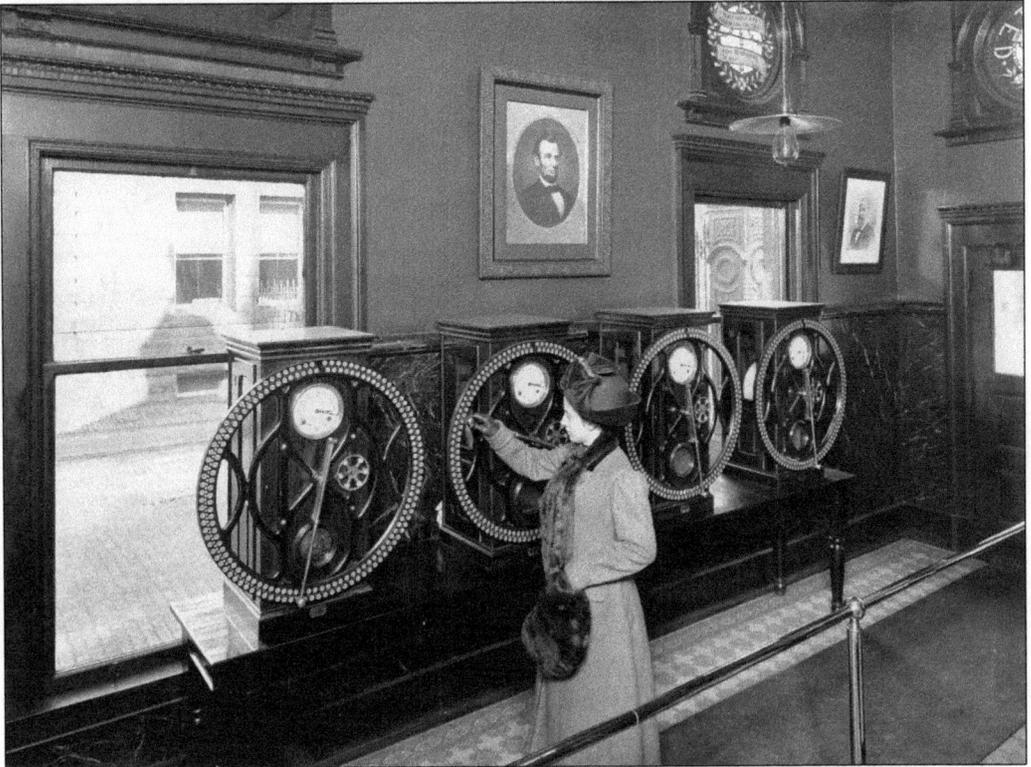

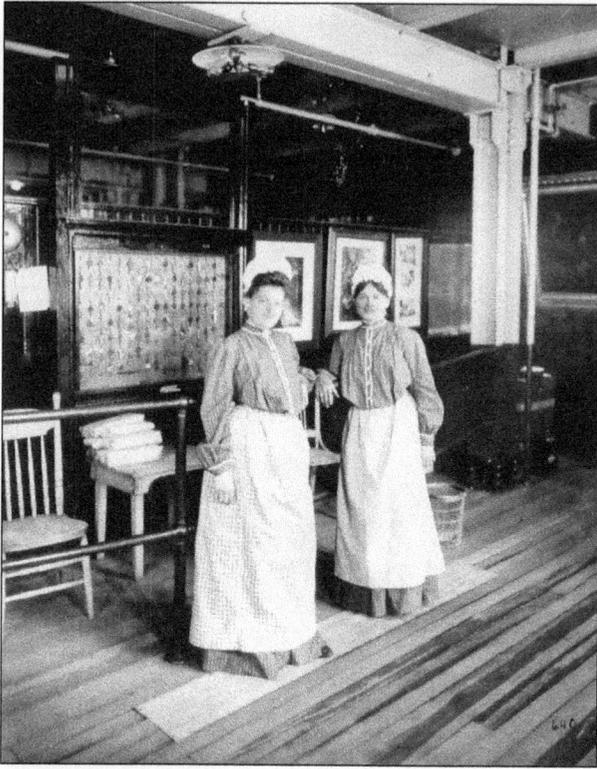

Considered the "Prince of Paternalism," an endearing term at the time, Henry J. Heinz provided factory workers with many amenities, including sparkling locker rooms, which included running water, a comfort not found in the homes of many employees. Each day, workers were given freshly laundered uniforms.

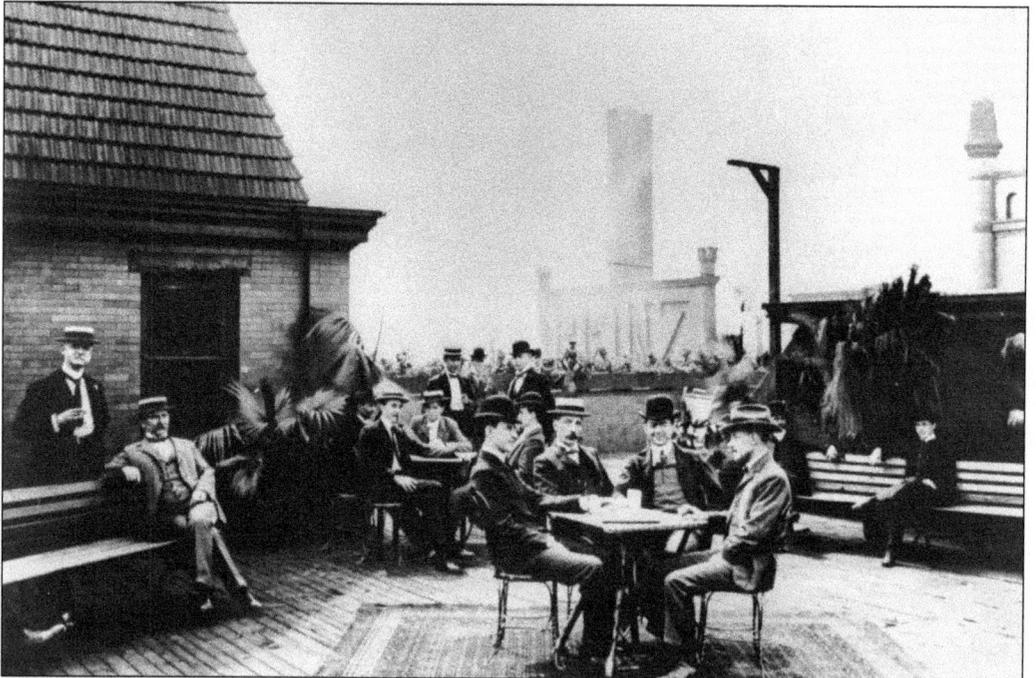

Roof gardens—separate ones for men and women—provided leisure-time enjoyment, albeit in the not-so-clear Pittsburgh air of the time. Other employee services included organ recitals, dental care, lunchrooms, and social clubs.

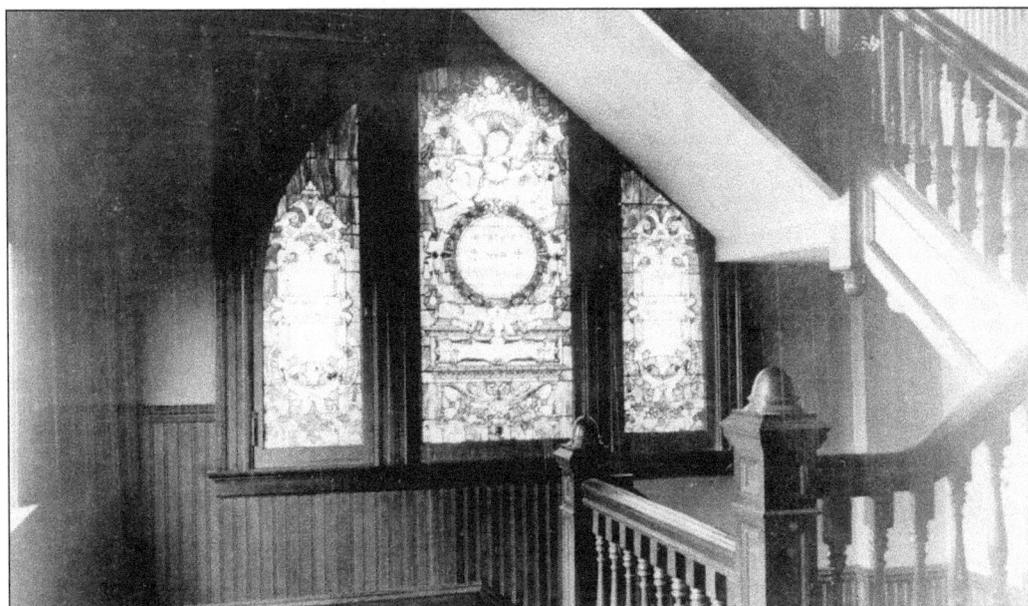

Stained-glass windows throughout the complex provided inspirational messages and were part of the vast art collection that Henry J. Heinz displayed for the enjoyment of his workers. Artist Horace Rudy, in 1906, completed a commission to design and install art glass windows—complete with Heinz's favorite maxims—throughout the factory complex. The mottos ranged from the humorous ("Luck may help a man over a ditch if he jumps well") to the founder's favorite ("To do a common thing uncommonly well brings success").

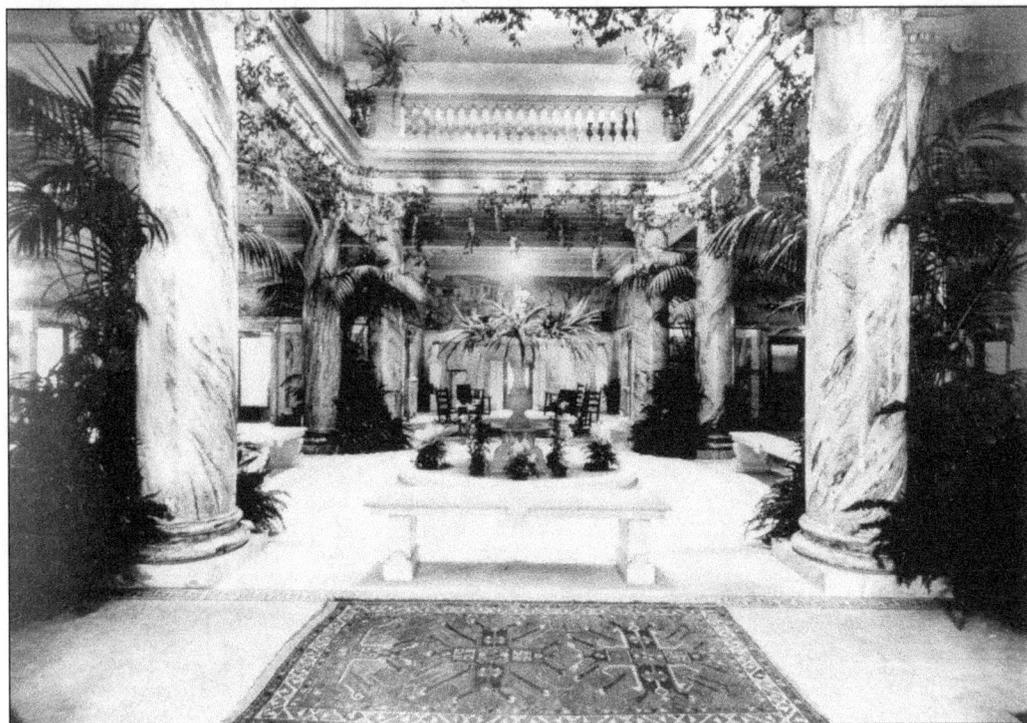

The rotunda of the Administration Building was lavishly decorated to welcome visitors.

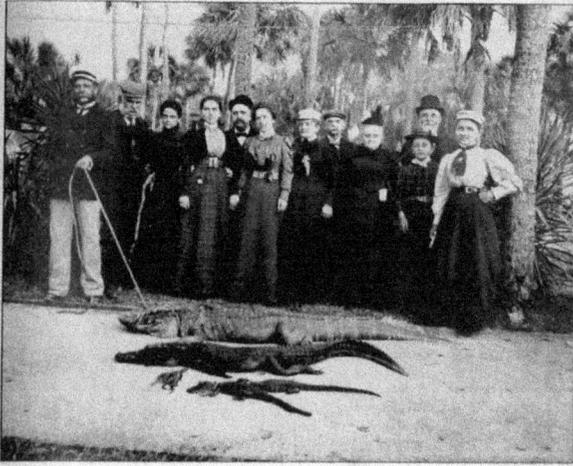

Pickles—initially published in 1897—is considered among the very first employee newsletters. This edition details a Heinz family trip to Florida's Indian River to "hunt 'gator."

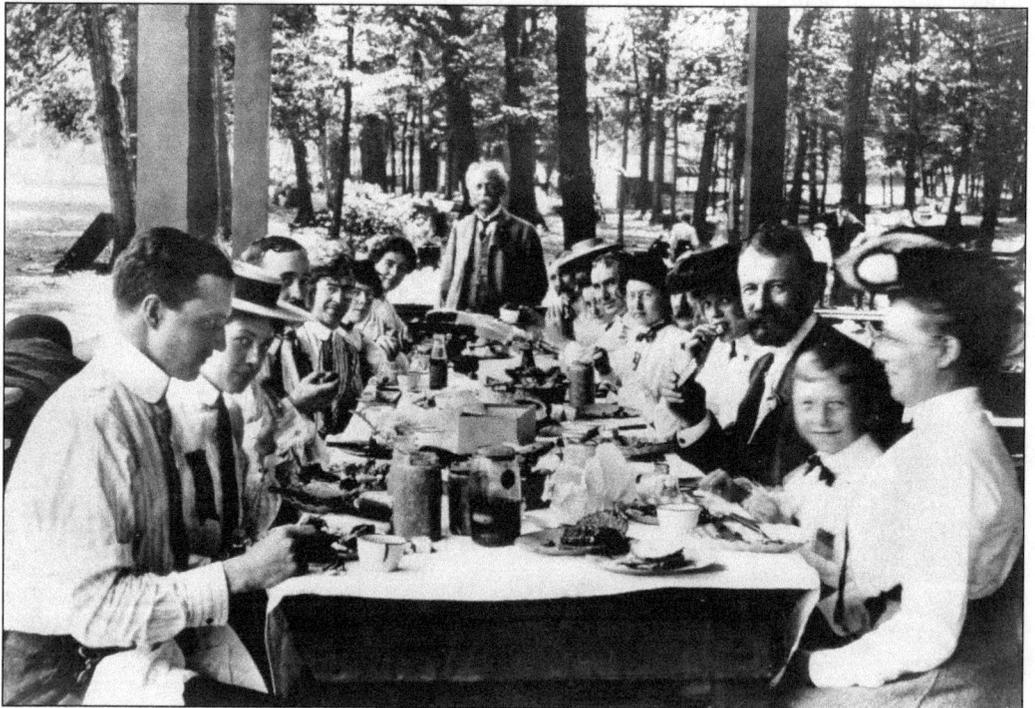

Family picnics were the highlight of every year for Heinz employees. Henry J. Heinz presided over the annual gatherings.

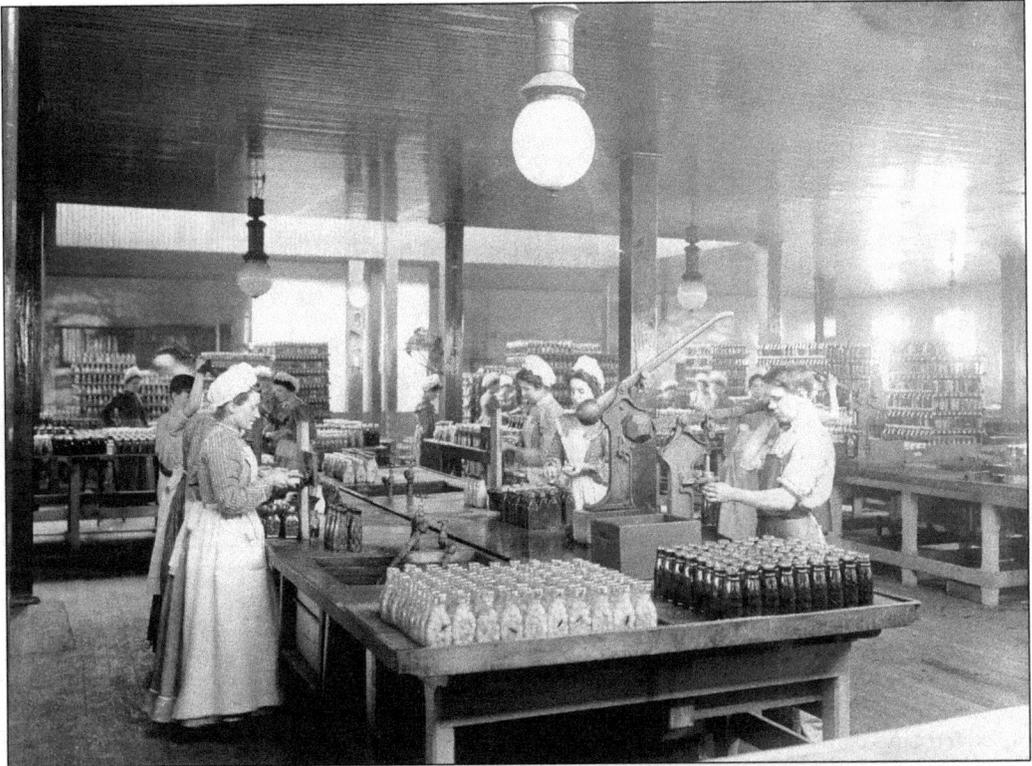

In 1901, company employees used assembly-line discipline for corking and wrapping pickle jars. The heavy work of operating the corking machine was left to male employees. Tours of the pristine plant were popular and widely advertised in Pittsburgh streetcars starting in 1899.

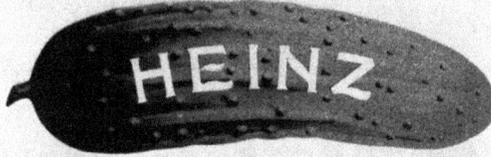

ESTABLISHED 1869

HEINZ

57 VARIETIES

WE PICKLE TO PLEASE!
Nine minutes ride to see cleanest and best equipped Food product plant.
Take yellow cars 5th & Wood or 6th & Liberty.
HOURS FOR VISITORS 9 A.M. TO 4 P.M.

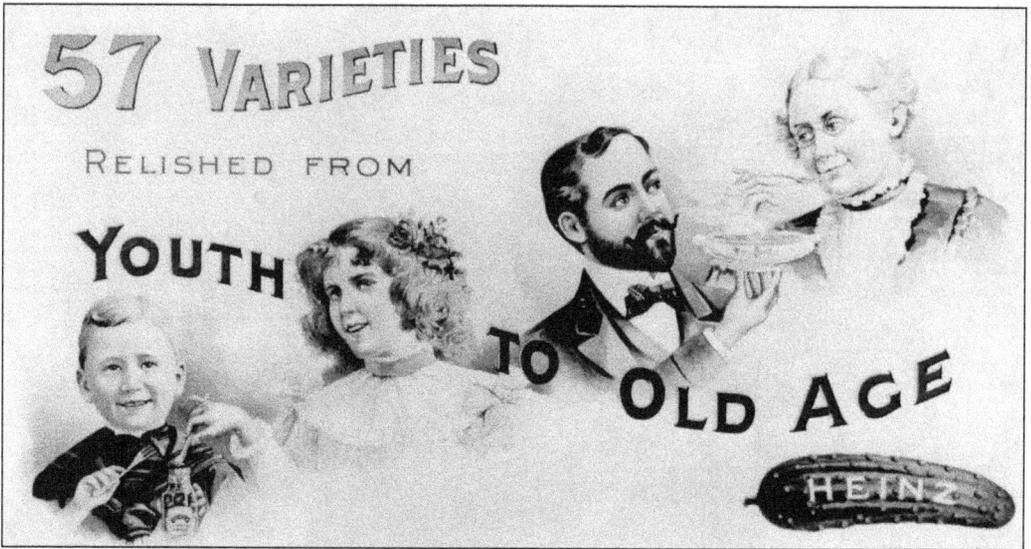

One of the earliest "57 Varieties" advertisements (around 1897) was created for display inside a horse-drawn streetcar. Henry J. Heinz devised the famous 57 Varieties slogan while riding in an elevated train in New York. There he spied a car card advertising "21 Styles" of shoes. The idea of using a number to promote his food varieties intrigued him, and he soon struck upon the number 57 as being memorable—despite the fact that he offered far more than 60 products at the time. According to his diary, Heinz "jumped off the train . . . began the work of laying out my advertising plans . . . and within a week the sign of the green pickle with the '57 Varieties' was appearing in newspapers, on billboards and on signboards and anywhere else I could find a place to stick it."

Despite the new 57 Varieties slogan, the company continued to market the taste, nutrition, and value of its foods.

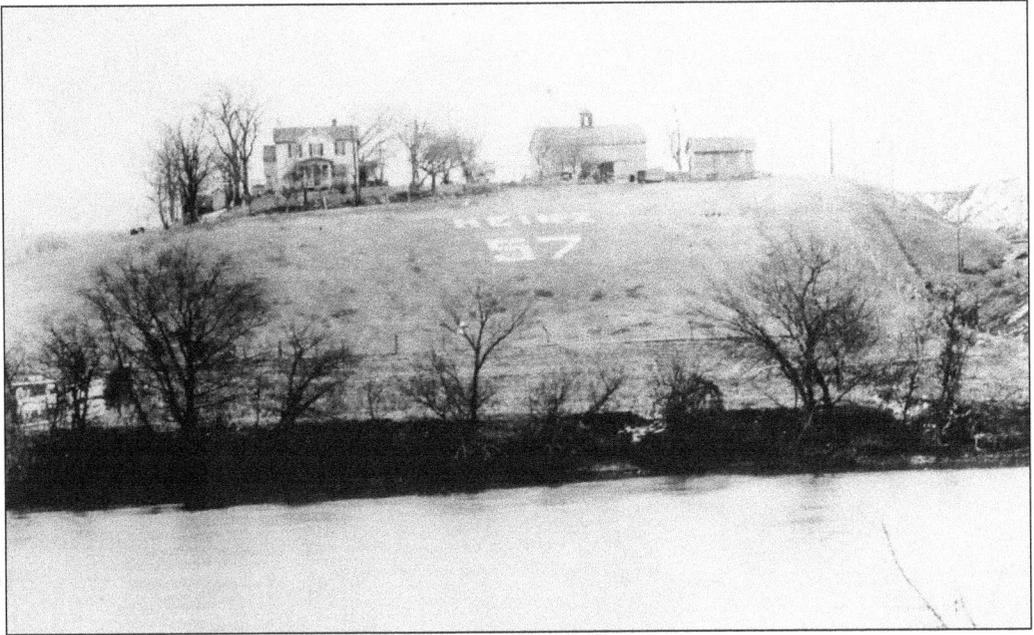

Like other admen of his day, Henry J. Heinz engaged in the physical transformation of America's countryside. He marked hillsides with the massive concrete words "Heinz 57," often outraging local citizens. Without fail, he expressed regret, turned the hillside over to the community, and turned the controversy into a public relations coup.

"Charming" appropriately describes many of Heinz's other advertisements, which drew upon popular images of children.

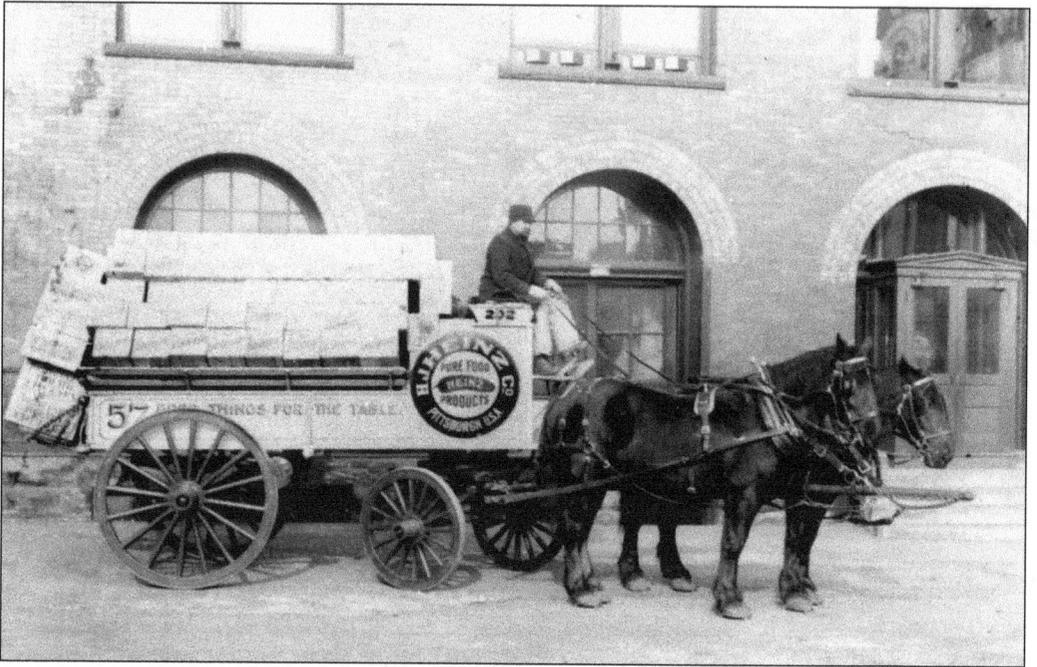

In 1903, Heinz delivery wagons were drawn by pairs of prize-winning draft horses. The founder favored Percherons, a breed developed for medieval knights and strong enough to adapt to the heavy labor of pulling full wagons up the cobblestone streets of hilly Pittsburgh.

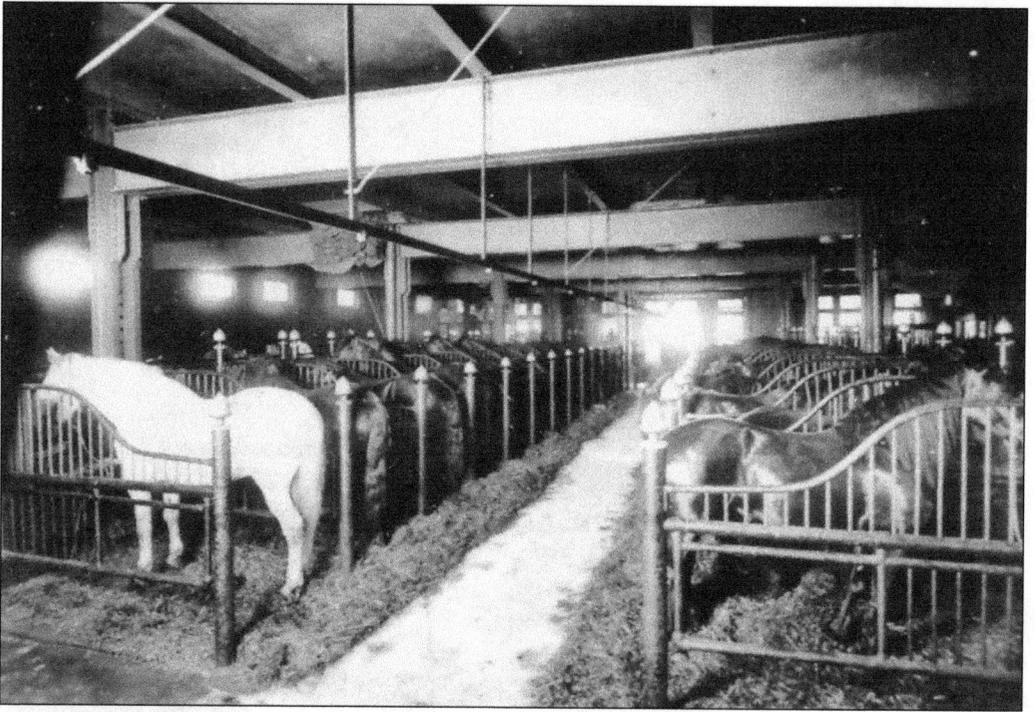

The company maintained a four-story stable. Considered an "equine palace," it featured steam heat, electrically operated brushes, and the finest feed and care available.

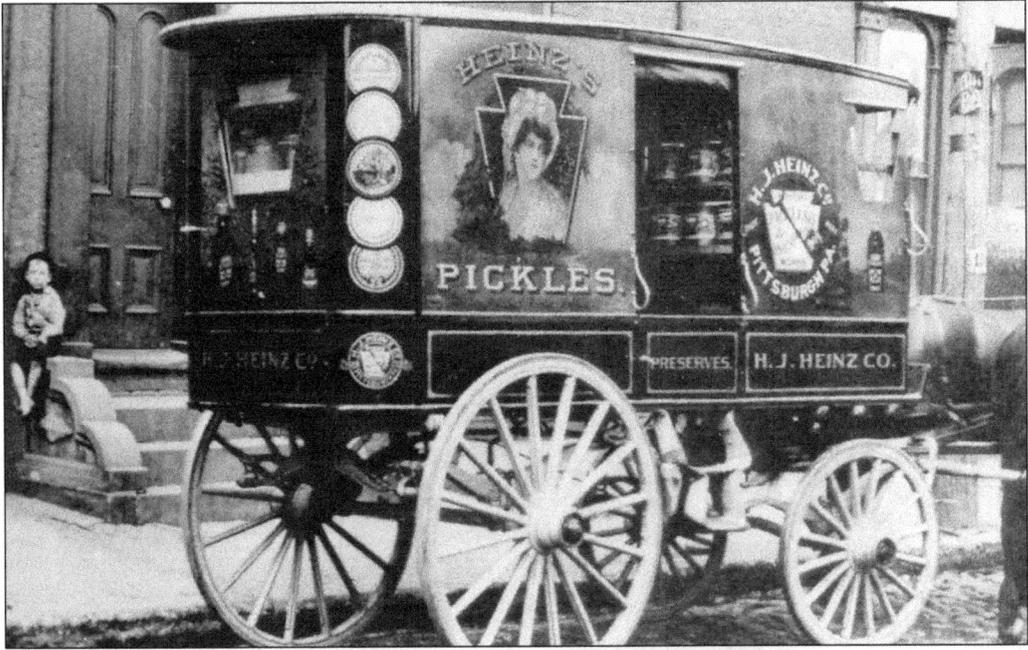

Elegant delivery was a hallmark of the H.J. Heinz Company. Early wagons were heavily decorated. This one carries illustrations of the keyhole-and-key trademark (reminiscent of the keystone brand), a striking young woman, product packages, pickles, five medallion awards, and distinctive keystone windows.

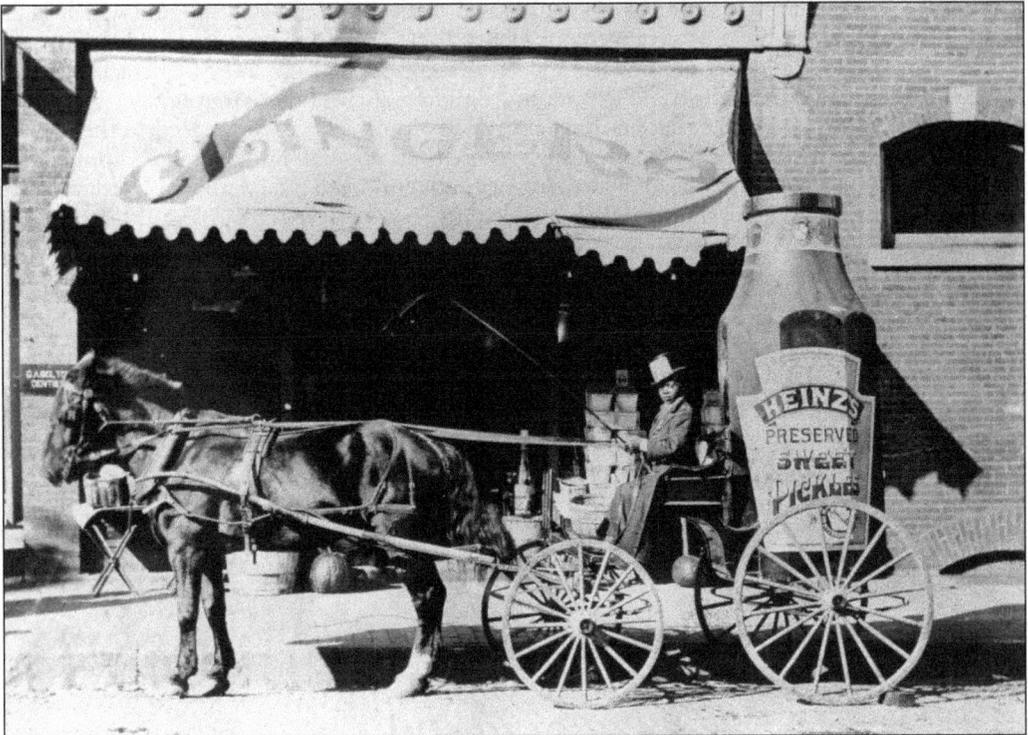

Wagons of every size and shape were used as rolling billboards.

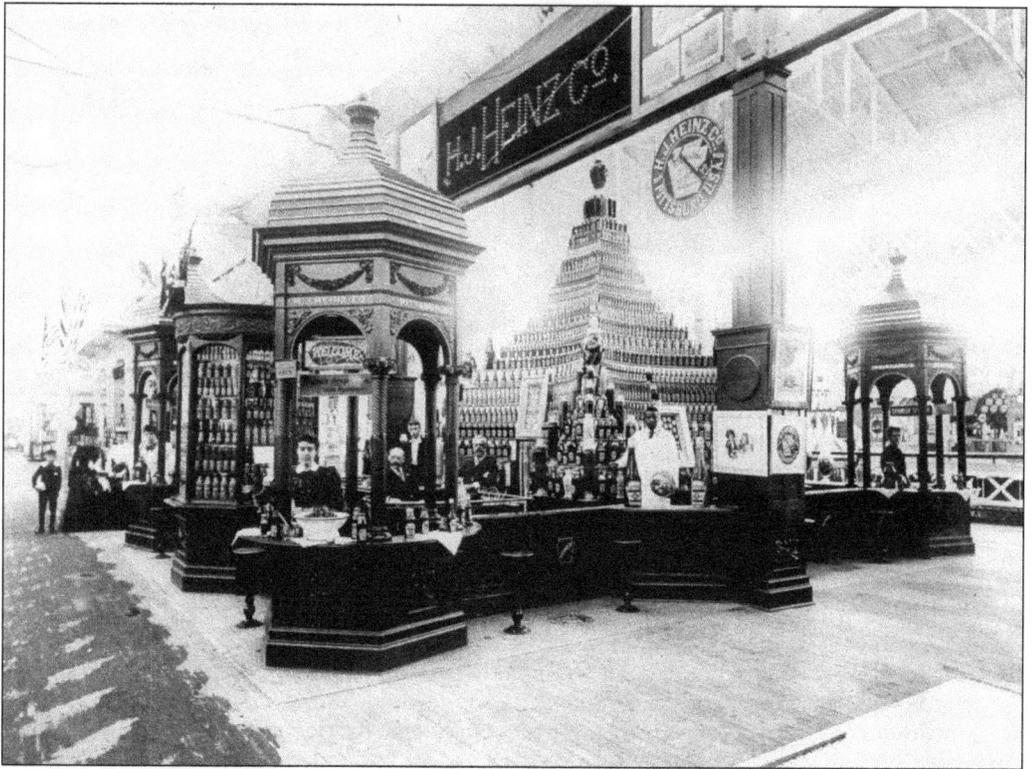

The Heinz pickle charm (which was originally used to decorate a watch fob and which later became a pin) was designed by an ingenious Henry J. Heinz on the spot at the 1893 Chicago World's Fair. He created what became the industry's most popular giveaway to attract fairgoers to his out-of-the-way display in the Agricultural Building. Across the fairgrounds, young boys distributed small claim checks that promised a free souvenir to those who redeemed the checks at the second-story H.J. Heinz Company display. More than one-half million people stormed the building, and, as a result, fair officials added security and reinforced the floorboards. Today Heinz continues to distribute more than a million pickle pins a year.

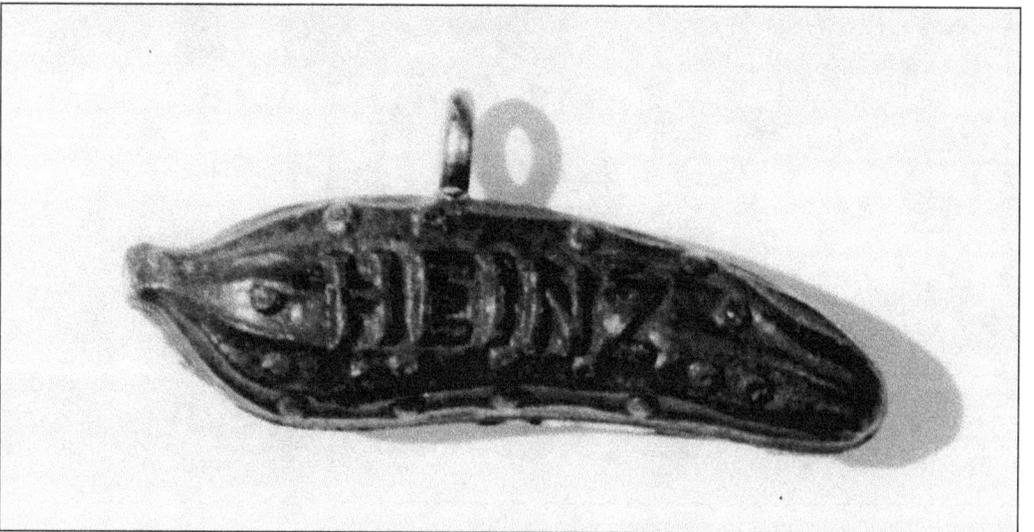

PICKLES

Vol. V. PITTSBURGH, U. S. A., MARCH, 1902. No. 11.

AROUND THE WORLD WITH HEINZ PICKLE CHARMS.

BY HARRY STEELE MORRISON.

WHEN I left New York in July to start upon a trip around the world, I determined to carry as little luggage as possible. But there was one thing which I felt I couldn't afford to leave behind, and that was a box of Heinz pickle charms. I remembered my last summer's experience at the Paris Exposition—how the Frenchmen flocked around to beg "*un petit cornichon*", and how they often saved me half a franc as "*pourboir.*" Who could tell of what advantage these little mascots might be in a trip around the world? So I packed the box of pickle charms among my necessary belongings and then sailed away across the Atlantic Ocean toward the Rock of Gibraltar.

One sunny morning we came in sight of the coast of Spain, and a few hours later we were anchored opposite the great Rock of Gibraltar. It was my first visit to a Southern European port, and I couldn't at first understand why so many small boats came crowding round us as we lay in the roadstead. These "bomboats" hover round arriving steamers to sell tobacco, cigarettes and various articles. I was much interested in them, and it was a strange coincidence that in one of the nearest boats the first thing I saw was a box marked in the familiar green letters: "Heinz India Relish." It was almost like a glimpse of home and I longed to ask the man where he came by that box. He had some pickles to sell; but he disappeared before I could find out what kind they were.

While our vessel lay at Gibraltar an excursion was arranged to the neighboring city of Tangier, in Morocco, and it was an excursion that none of us are likely soon to forget.

THEY ALL CLAIMED PAYMENT.

The city is but twenty miles from the Rock, but from the difference in people and their ways of living, one

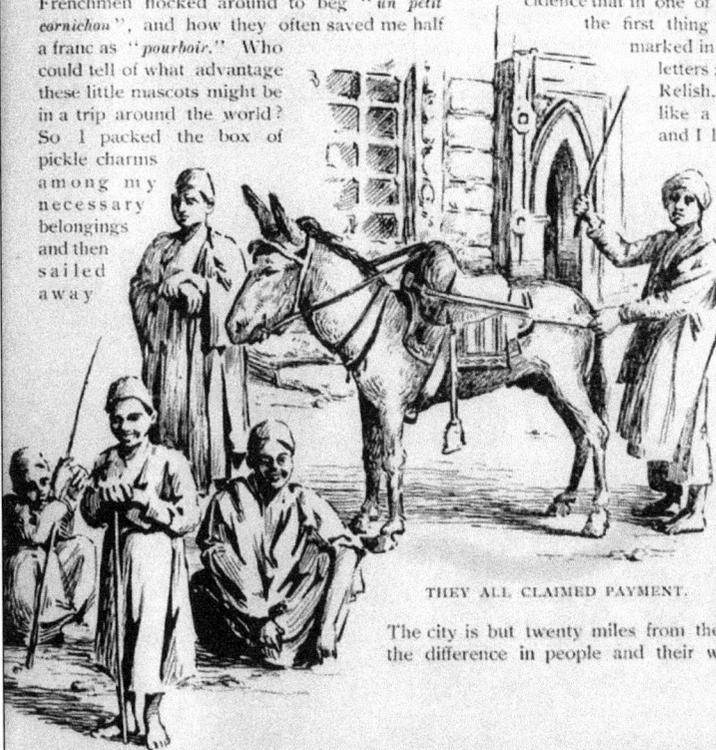

By 1902, the company became so well known for the pickle charms that salesmen carried them in their sample bags. In this edition of *Pickles*, salesman Harry Steele Morrison offers a detailed account of his trip around the world and the pleasure that he had in distributing the tiny "mascot," which Parisians called "*un petit cornichon.*"

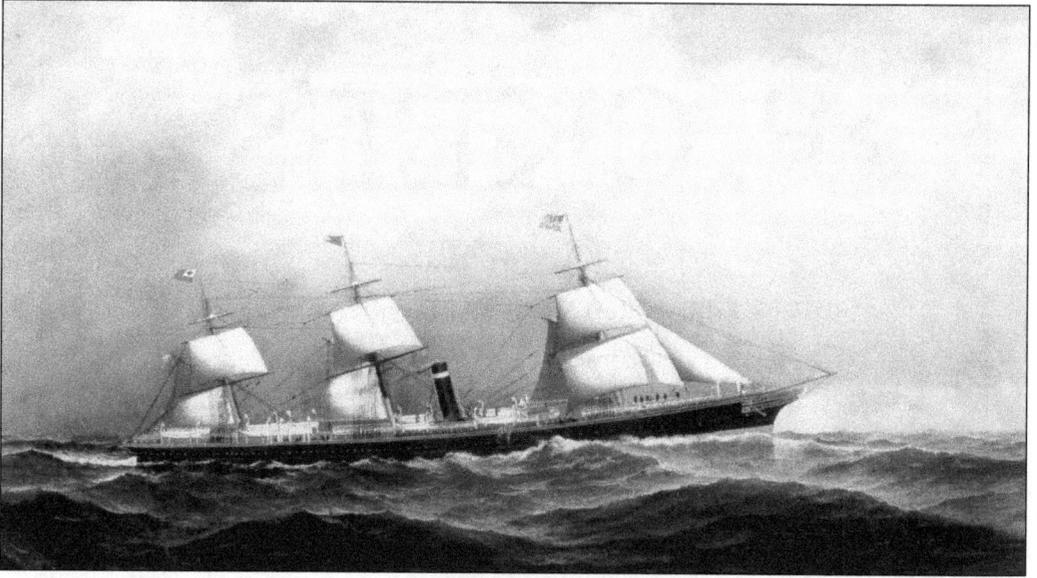

Henry J. Heinz took his first overseas trip to Europe in 1886 aboard the *Berliner*. There he discovered a new and ready market for the 57 Varieties. Although he had no appointment, he toted a gladstone bag filled with his best products to Fortnum and Mason, purveyors to the queen of England. Once the head of purchasing tasted the products, he agreed to buy them all. Within a few years, Heinz had established offices and factories abroad, and his burgeoning global enterprise was under way.

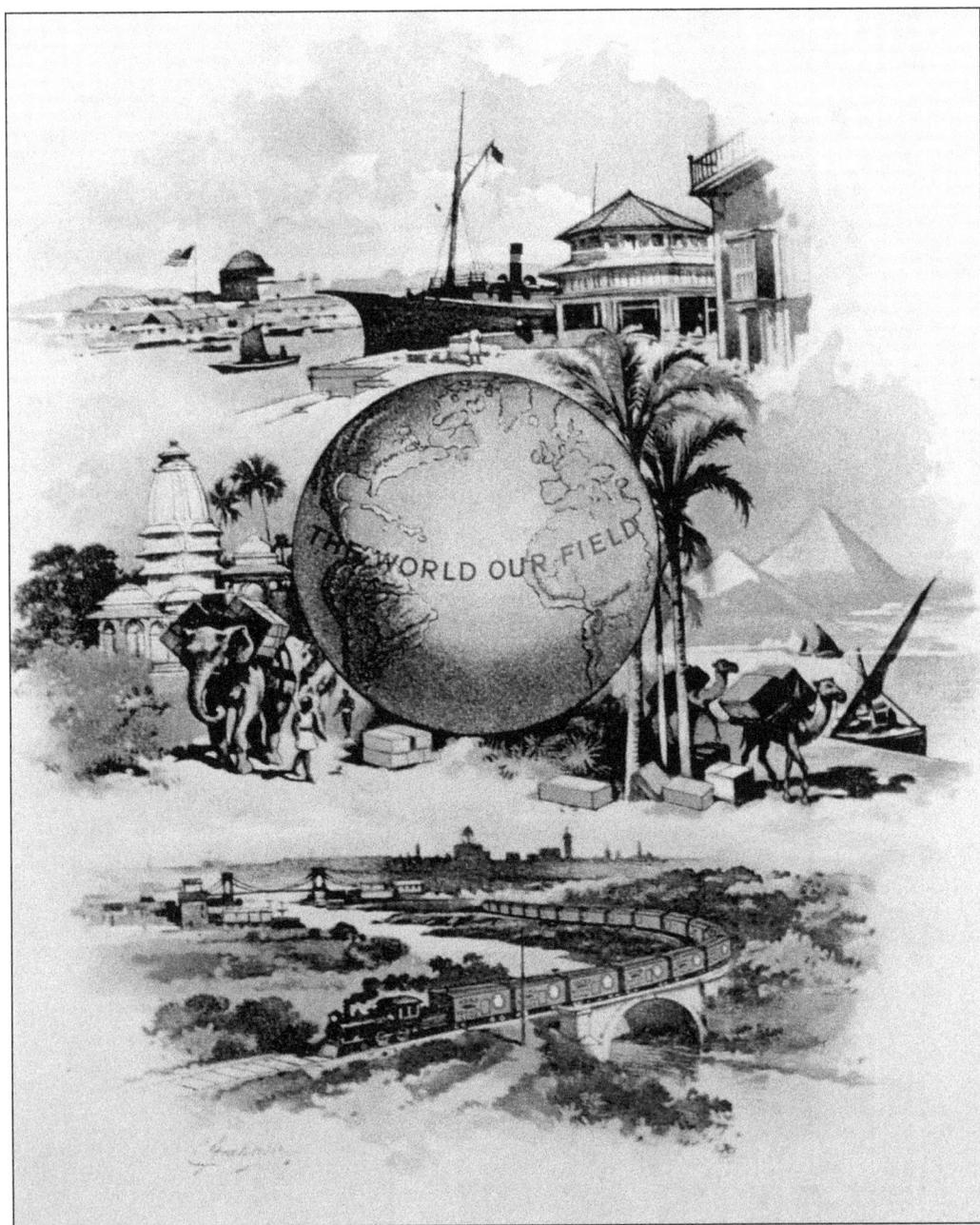

Just 20 years after founding his small horseradish business, Henry J. Heinz commissioned this painting to celebrate the company's 20th anniversary and its burgeoning operations. He titled the work *The World Our Field*.

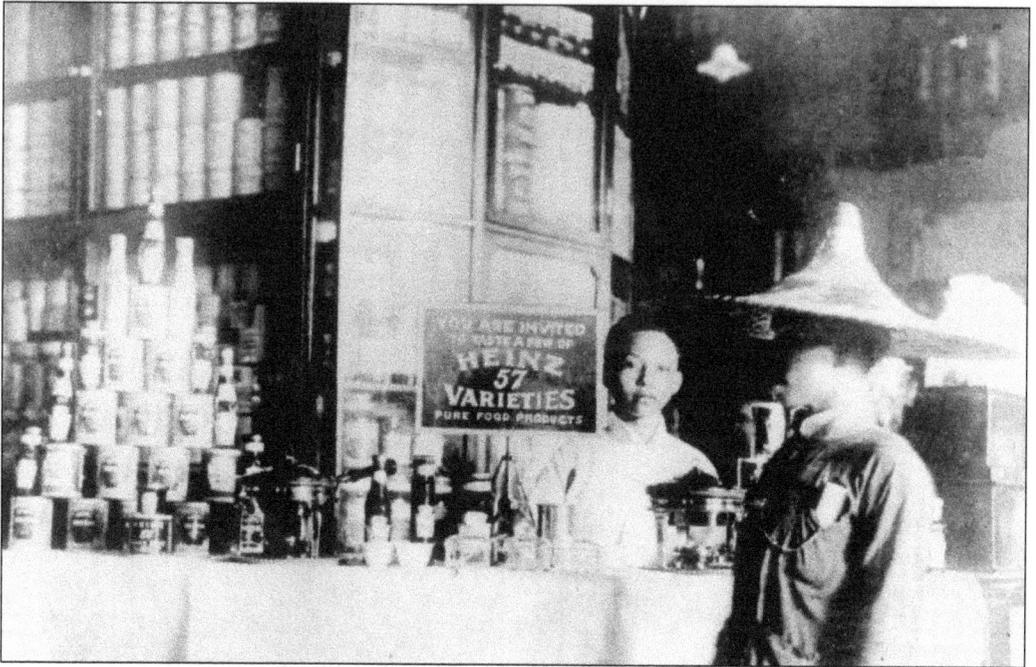

Henry J. Heinz visited China in May 1913 on a 6,000-mile global tour for the World Sunday School Association. He was greeted with displays of many of his finest varieties, proof of his reputation as one of the first global marketers.

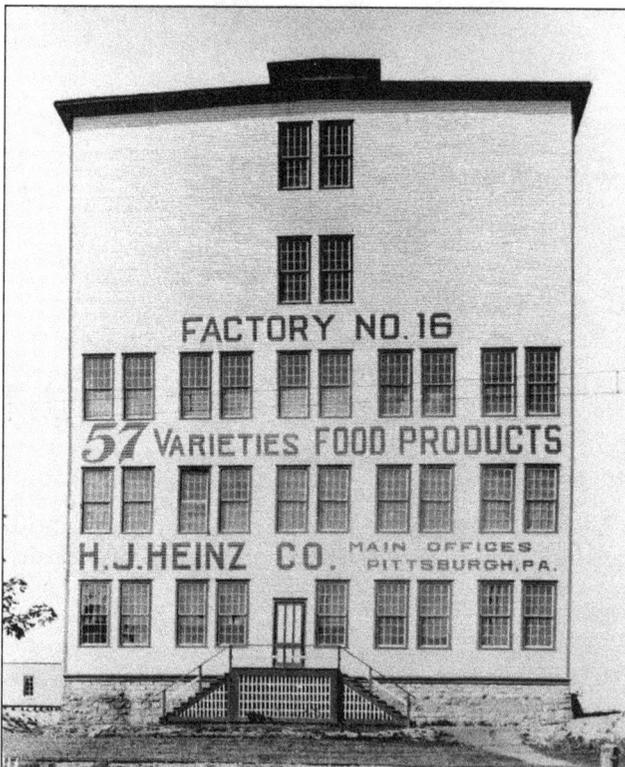

In Canada, Heinz opened one of his initial foreign branch factories in the rich tomato-growing region north of the Great Lakes in Leamington, Ontario.

The London branch office and warehouse building was centrally located and included a convention room. The frontage afforded excellent advertising space.

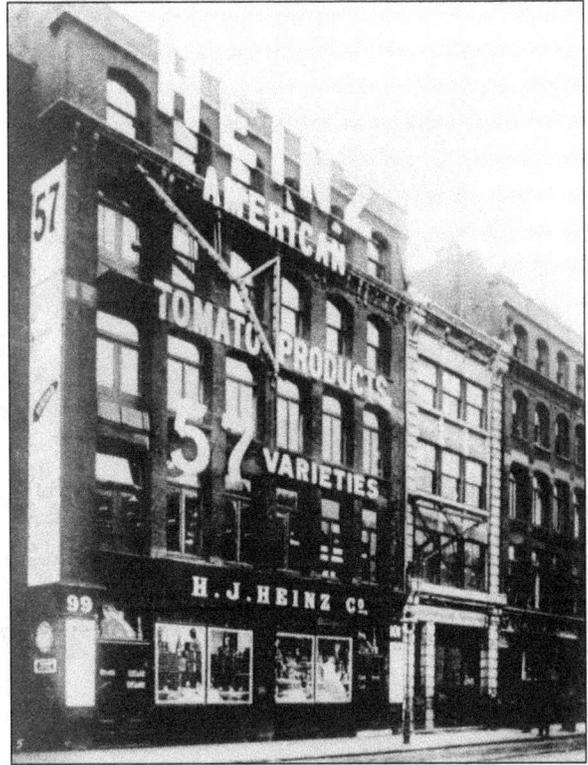

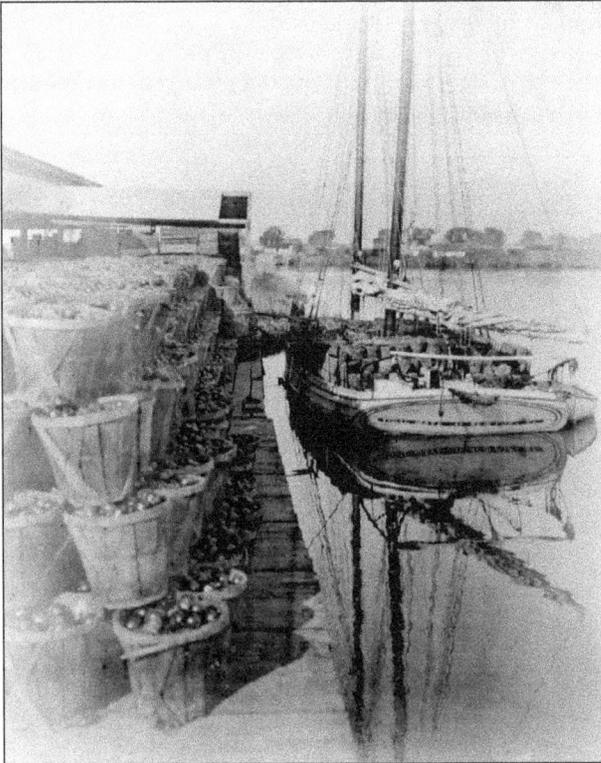

By 1901, Henry J. Heinz's management team had secured a network of factories, receiving stations, and warehouses across the United States. All means and manner of transportation were used, including small sailboats like this one bound for the Salem, New Jersey, tomato plant.

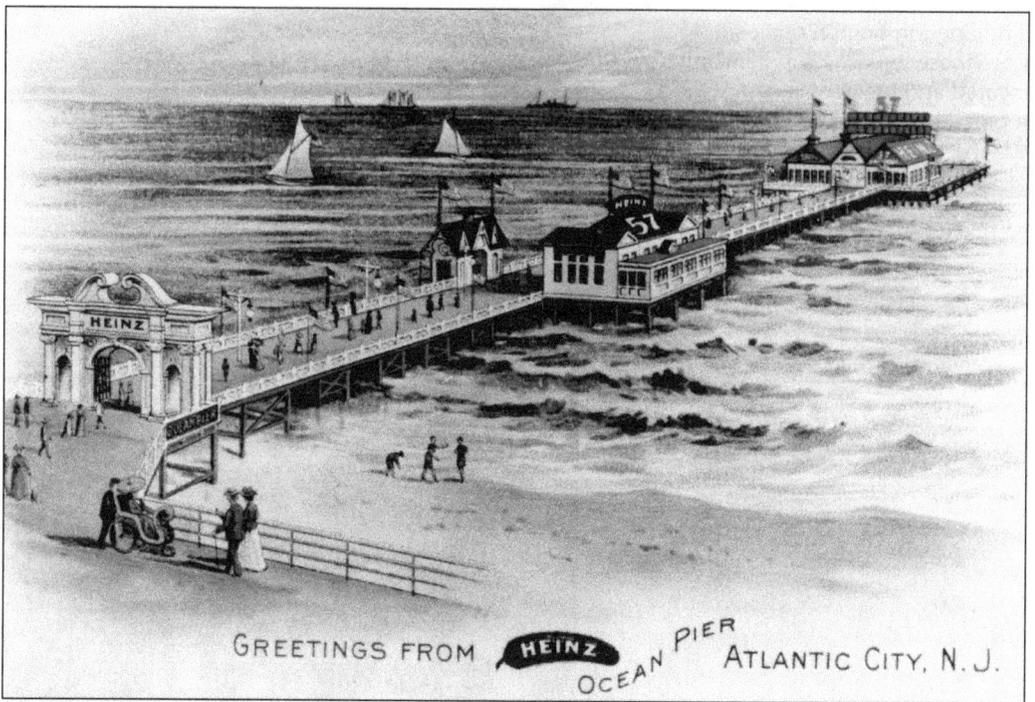

GREETINGS FROM HEINZ OCEAN PIER ATLANTIC CITY, N.J.

An inveterate promoter, Henry J. Heinz seized every opportunity and every location to advertise. Perhaps his most extravagant promotion was the Heinz Ocean Pier in bustling Atlantic City. Purchased in 1898, the pier also became known as the "Crystal Palace by the Sea." Rocking chairs and product samples provided comfort to weary tourists, as did a spectacular array of paintings and sculptures. Other attractions included daily organ recitals, pickle pins, stuffed pelicans, lectures, motion pictures, and the chance to order Heinz product baskets for shipment home. Plus, all visitors were given postcards to send from the pier to friends and family.

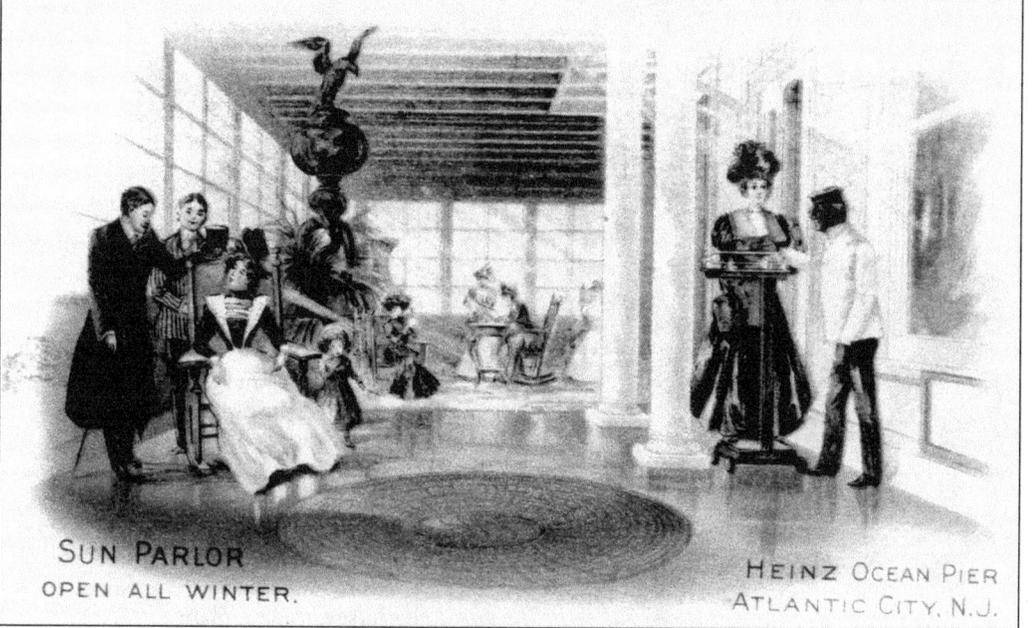

SUN PARLOR
OPEN ALL WINTER.

HEINZ OCEAN PIER
ATLANTIC CITY, N.J.

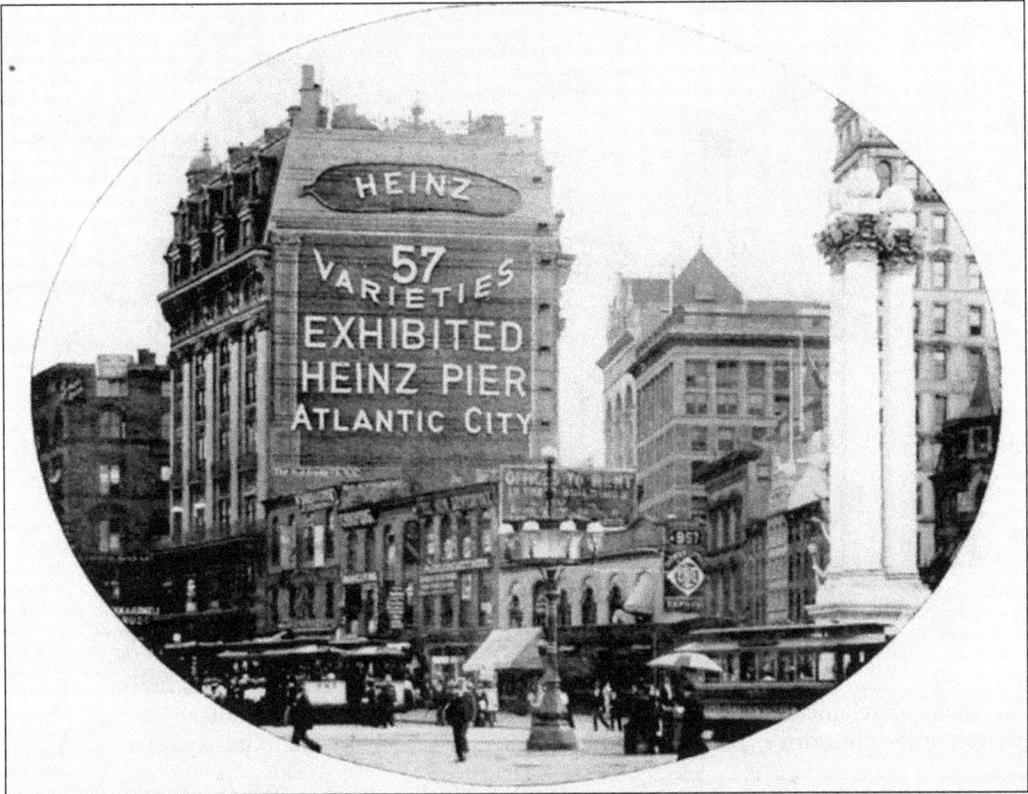

New York City's first electric sign, built in 1900, flashed an advertisement for Heinz Pier in 1,200 incandescent lights. Situated at the corner of 23rd Street and Fifth Avenue, then Manhattan's bustling shopping district, the structure was eventually replaced by the Flatiron Building.

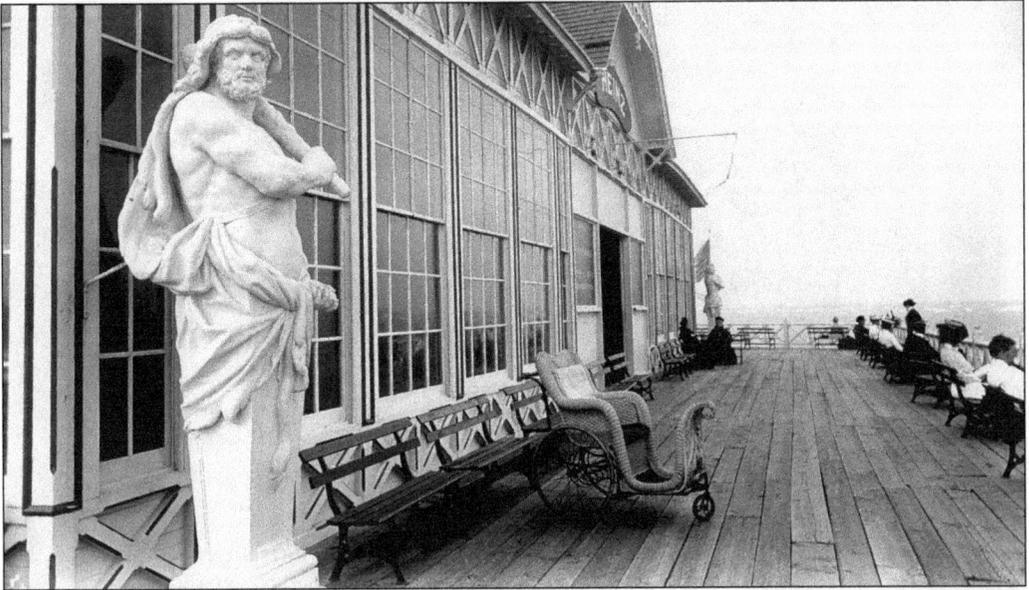

By 1904, the pier was one of the resort's most popular destinations for sharply dressed tourists who enjoyed the sophisticated atmosphere.

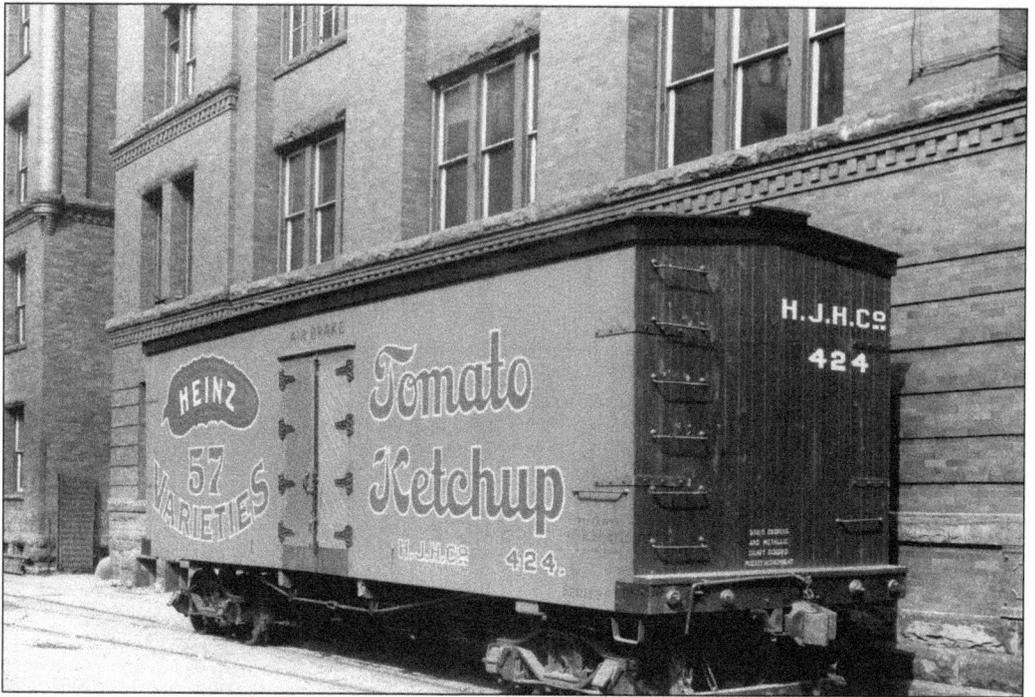

As America's reliance upon the railroads grew, so did Heinz's. By 1907, railcars carried a large portion of the company's goods across the continent and contributed to its explosive growth.

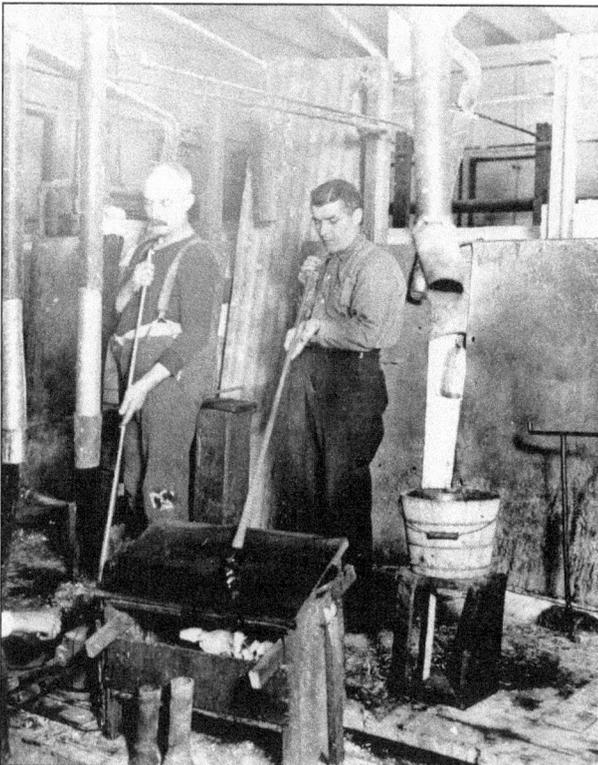

Heinz's Pittsburgh complex continued to expand and in 1911 incorporated the firm's own glassblowing operation.

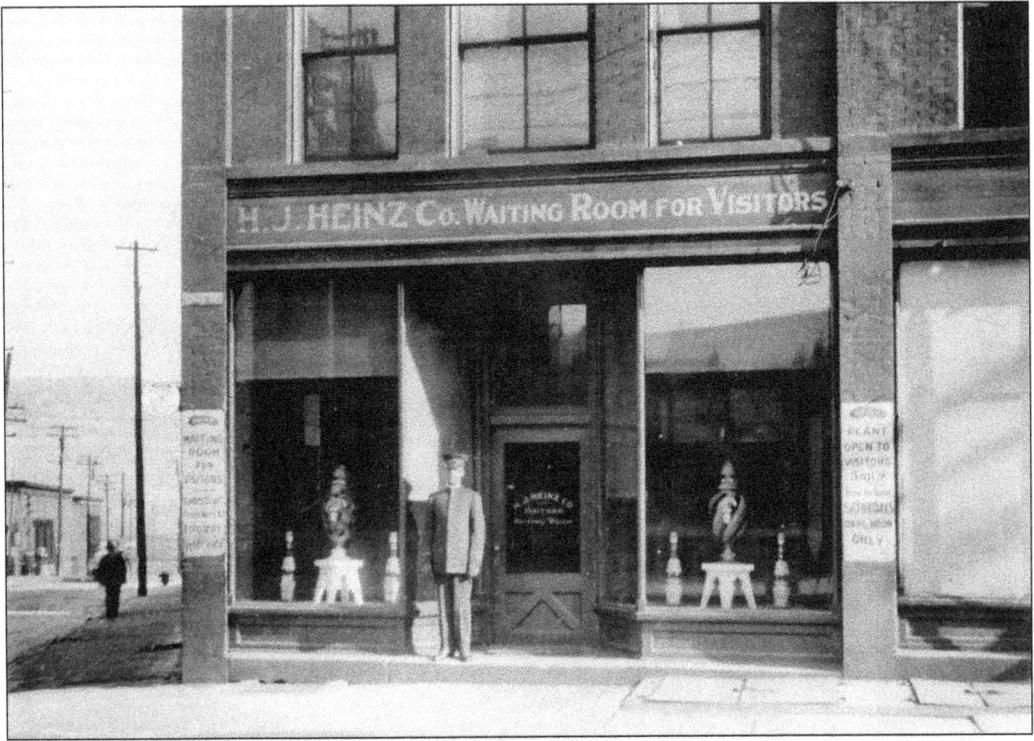

Visitors to the Pittsburgh operations were welcomed at the waiting room on nearby East Ohio Street. Tour guides offered consumers behind-the-scenes peeks at modern food production.

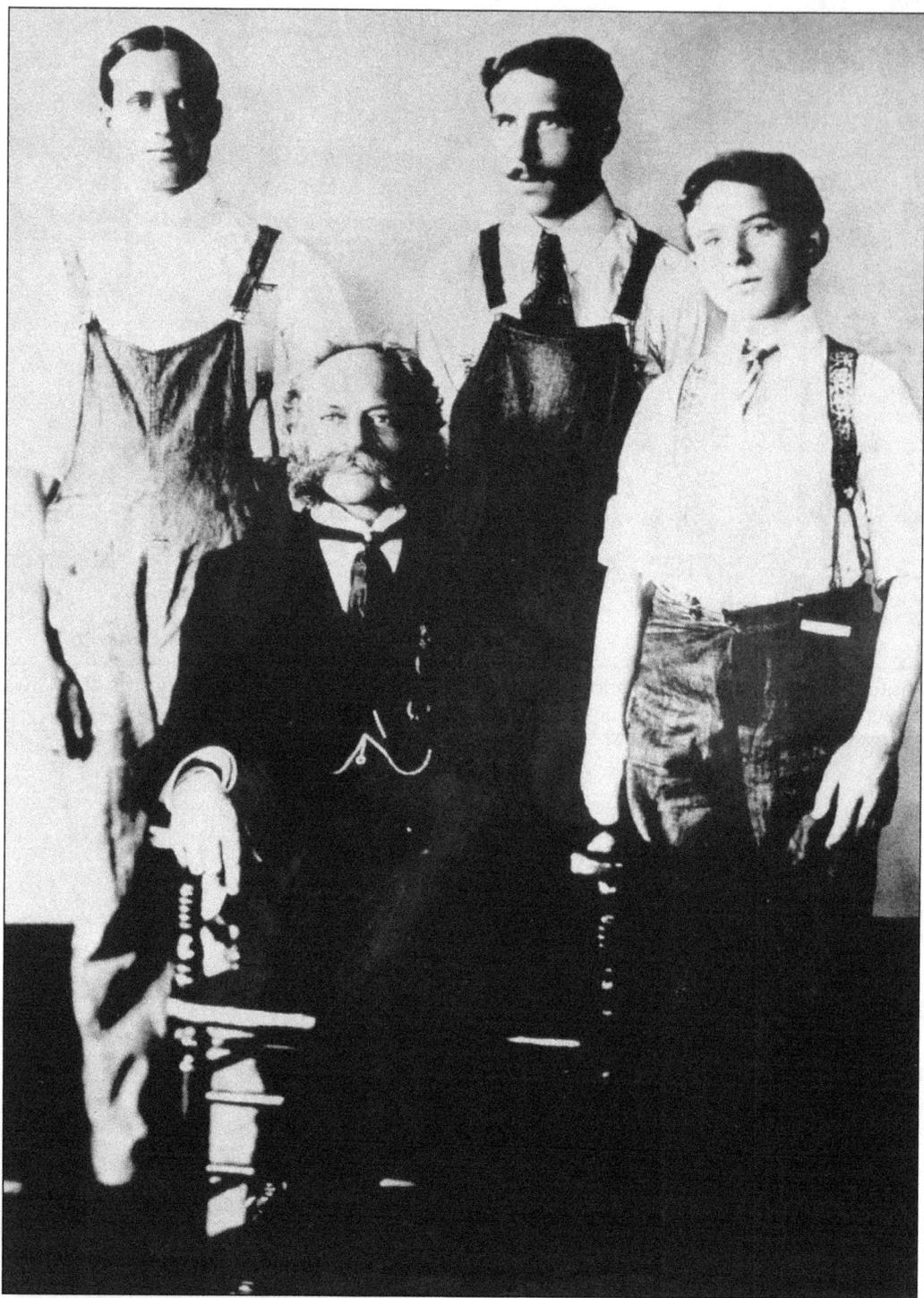

On the reverse of this 1904 family portrait, a proud Henry J. Heinz wrote, "Experience and Gaining Experience" to describe his relationship with sons Clarence (left), Howard (center), and Clifford.

Two

THE COMMITMENT
TO QUALITY

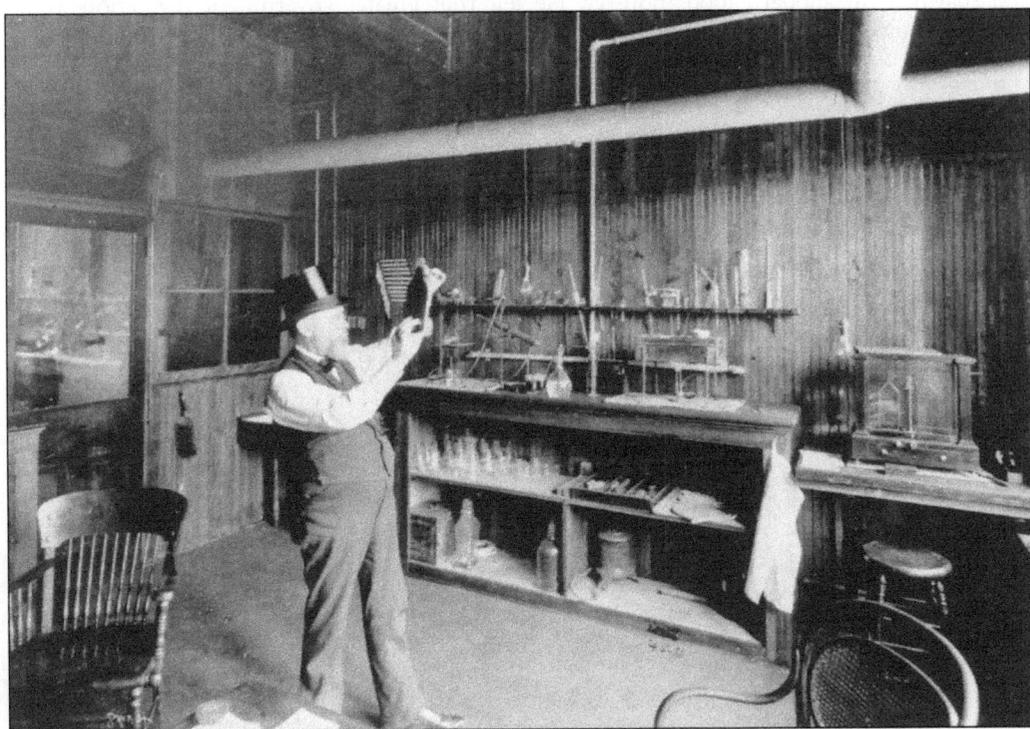

In 1901, Heinz was among the few U.S. food companies to employ professional chemists. In fact, Heinz is given credit for coining the term "quality control department." The first chemists were given to drama, as is this gentleman thought to be Shady Graves, a technician responsible for the correct salting of pickle tanks.

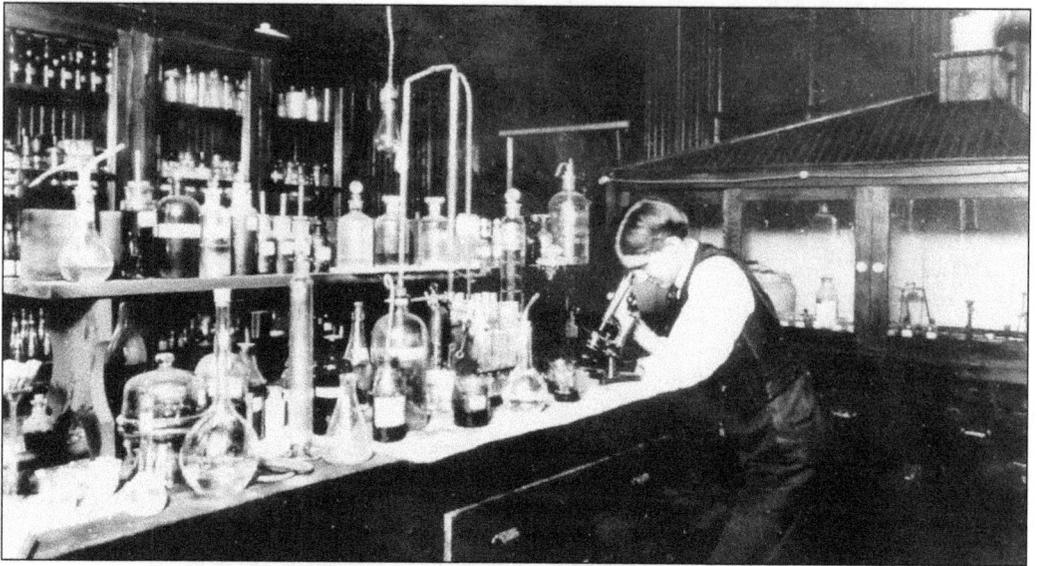

Five years before the passage of the 1906 Pure Food and Drugs Act, Heinz laboratories buzzed with activity. This scientific approach is credited to Henry J. Heinz's son Howard, a Yale-educated chemist, who was a strong proponent of quality standards and procedures. Henry was the sole food processor who backed passage of the act, which created the Food and Drug Administration and spawned the modern food industry. He felt that greater government regulation would create consumer trust and sales would boom. (See the introduction and foreword for further information on this landmark approach.)

Dr. Harvey Washington Wiley, chief of the Bureau of Chemistry at the Department of Agriculture, expressed his gratitude to Henry J. Heinz for his backing of pure foods legislation by writing, "I feel that I should have lost the fight if I had not had that assistance." (Courtesy of Food and Drug Administration.)

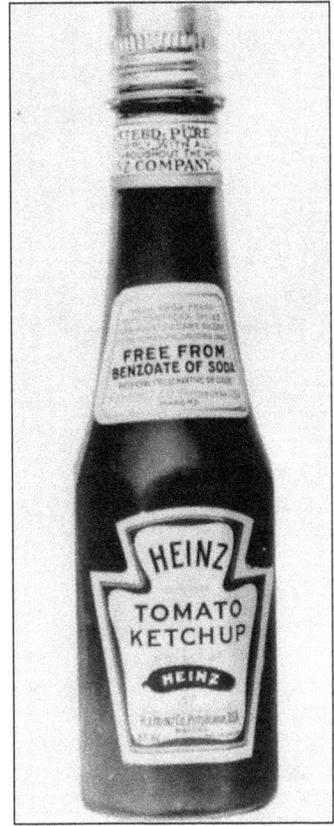

Following passage of the 1906 act, Heinz touted its ketchup as "free from benzoate of soda," an ingredient common to most other brands and considered harmful by the Food and Drug Administration. The neck band of the bottle also proclaimed, "guaranteed pure," and it assured buyers that the product complied "with all laws throughout the world." Magazine advertising at the time highlighted the fact that Heinz Ketchup was "unadulterated."

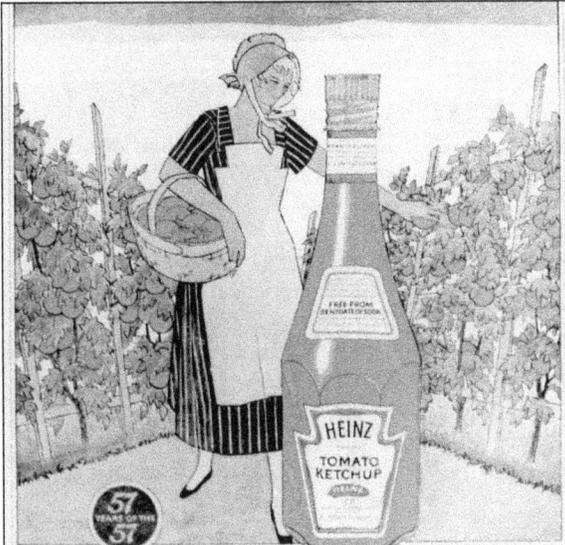

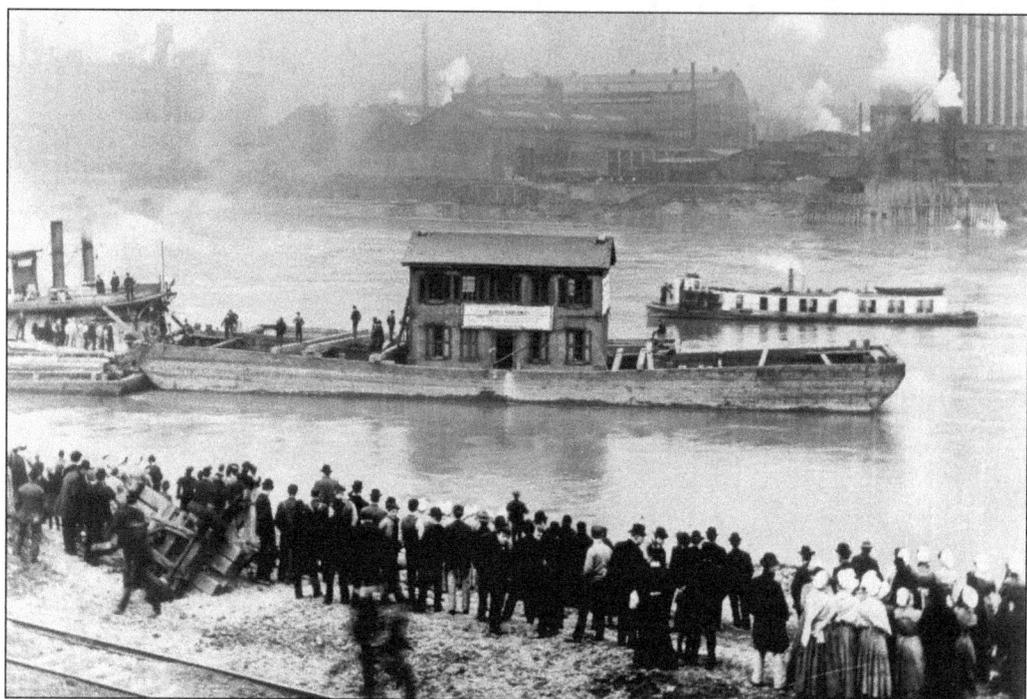

Employees lined the north shore of the Allegheny River in 1904 when Henry J. Heinz undertook the massive project of floating the original House Where We Began down the river to enshrine it at the center of his manufacturing complex, where it became a popular stop of factory tours.

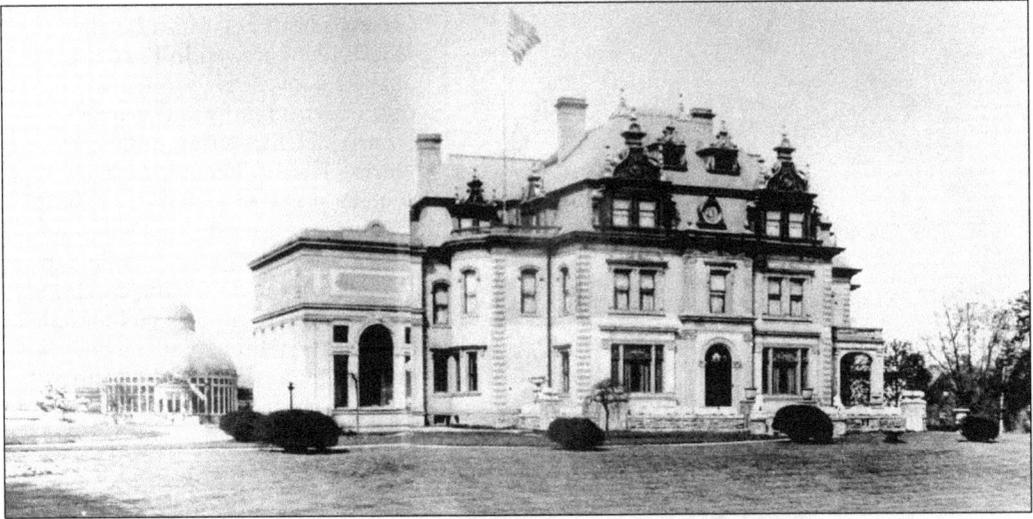

By 1919, Henry J. Heinz had expanded Greenlawn, the family home in Pittsburgh's tony Point Breeze section, to encompass a museum and nine greenhouses. He bought the home for $35,000 in 1892. It contained 30 rooms, with each of the seven "sleeping rooms" connected to a bathroom.

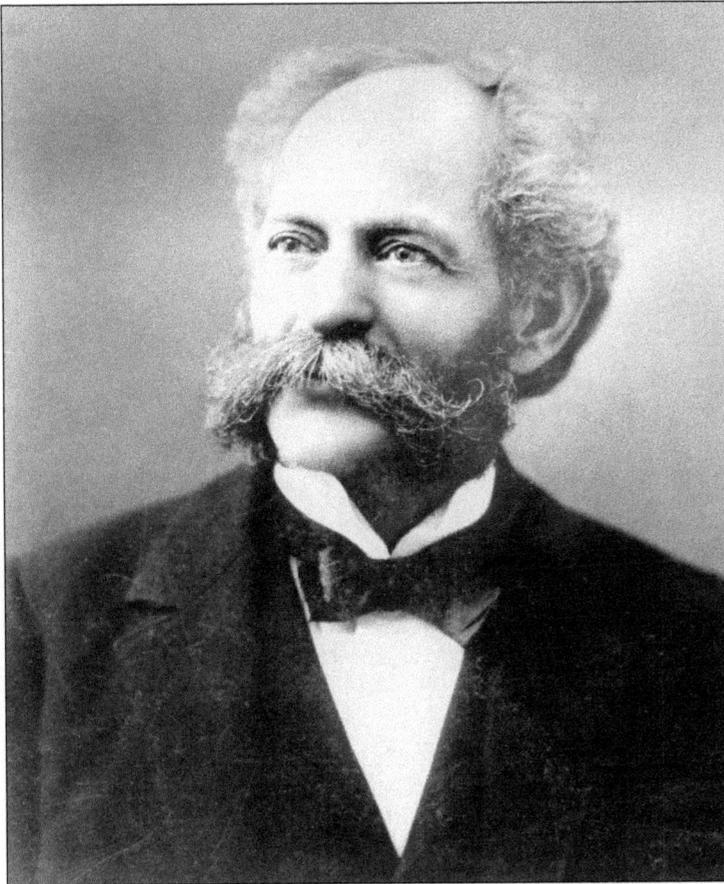

Founder Henry J. Heinz died in 1919 at age 75. As historian Eleanor Foa Dienstag wrote, "he was energetic and optimistic to the end . . . a hard act for his sons to follow." Howard followed in his father's footsteps and ably led the firm through the tough economic years leading up to World War II.

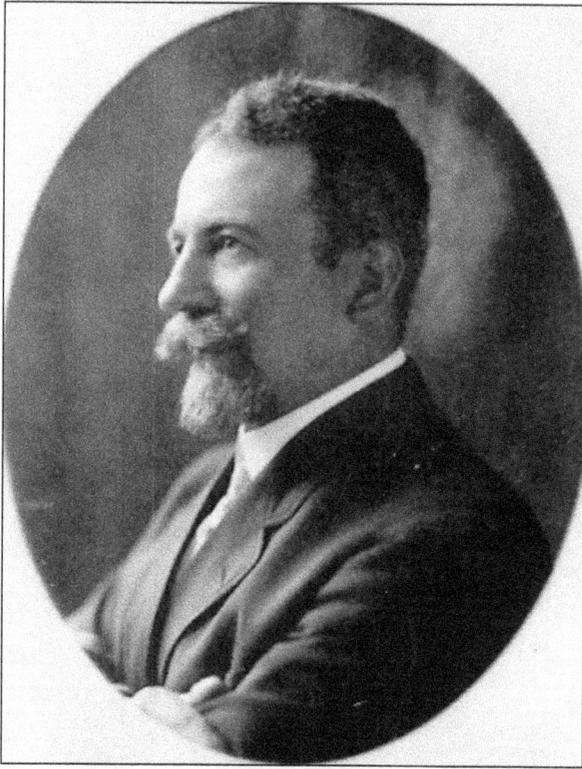

German-born Sebastian Mueller (1860–1938) arrived in Pittsburgh at the age of 24. He was a cousin of the Heinz family and married Henry J. Heinz's sister, Elizabeth. During Henry's extended travels, Mueller presided over the operations and became a leading authority in the U.S. food industry. Mueller strove to create optimal working conditions at all factories. Howard Heinz lauded him as "the man who had made the greatest impression on the Heinz business, with the exception of the Founder."

After his wife and three children passed away, Sebastian Mueller continued to look after the welfare of the company's working women. Upon his death, he left his country home, Eden Hall Farm, in trust as a retreat for them. Today a separate Eden Hall Foundation also provides financial support to nonprofit organizations in the region.

Sarah Heinz House—dedicated as a memorial to Henry's wife—continues to be a nationally recognized youth center. Located adjacent to the factory complex, it has served nearly 100,000 members since its dedication in 1915.

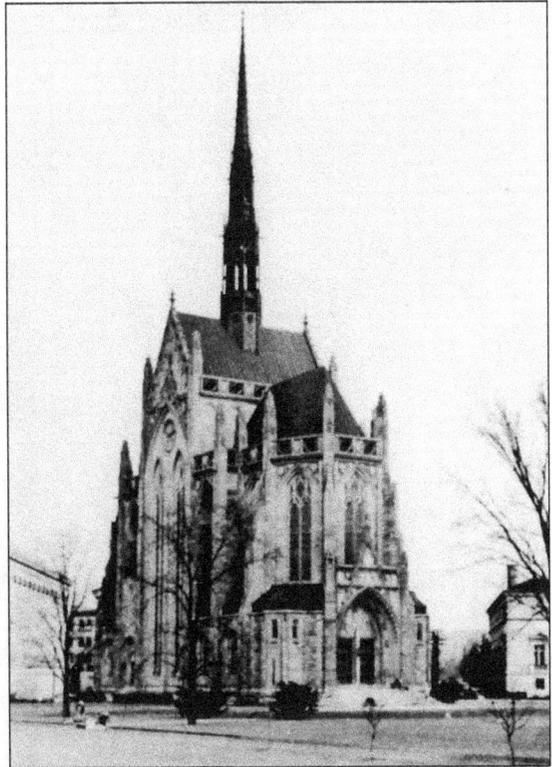

Although Henry J. Heinz originally left a bequest to the University of Pittsburgh for a chapel to honor his mother, his children—Howard, Clifford, Clarence, and Irene—enlarged the proposal and commissioned the French-Gothic Heinz Memorial Chapel, dedicated in 1938. The chapel receives more than 100,000 visitors yearly.

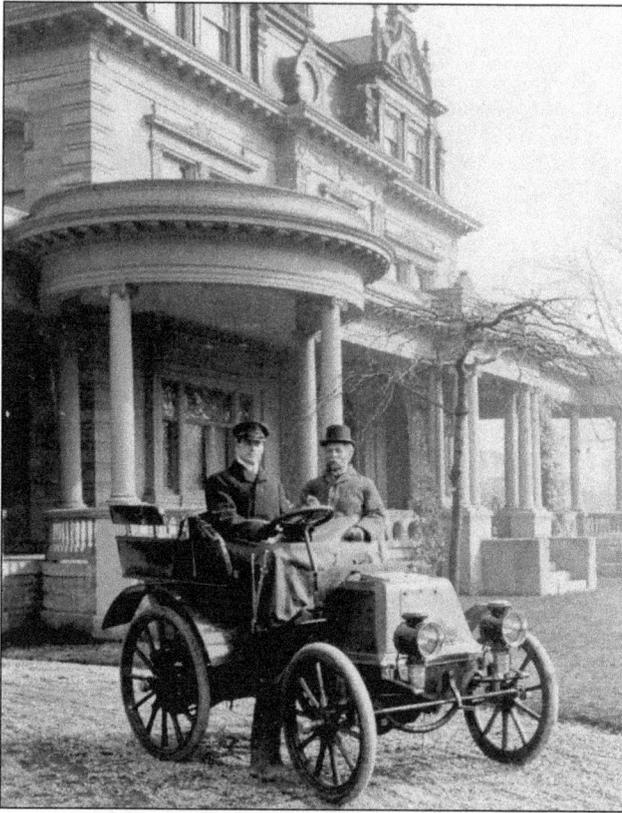

Howard Heinz owned one of the first automobiles. Brought to Pittsburgh from Paris in 1900, it was a Panhard-Levassor. Father and son, Howard and Henry, took a test drive at the family home, Greenlawn. The car featured a double-chain drive and manufactured its own acetylene for the headlamps.

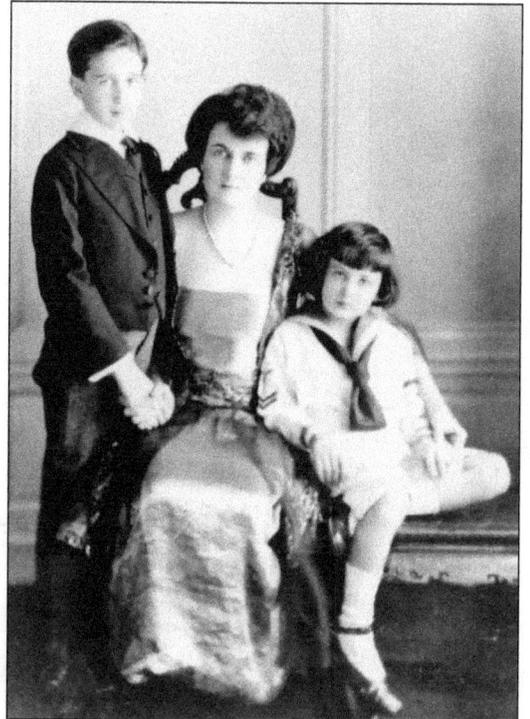

Elizabeth (Betty) Heinz (née Granger Rust), the wife of Howard, poses with sons Jack (left) and Rust around 1920. On the day of her marriage in Michigan to Howard, the bridegroom ordered production stopped at the Pittsburgh factory so that all employees could attend a reception and dinner.

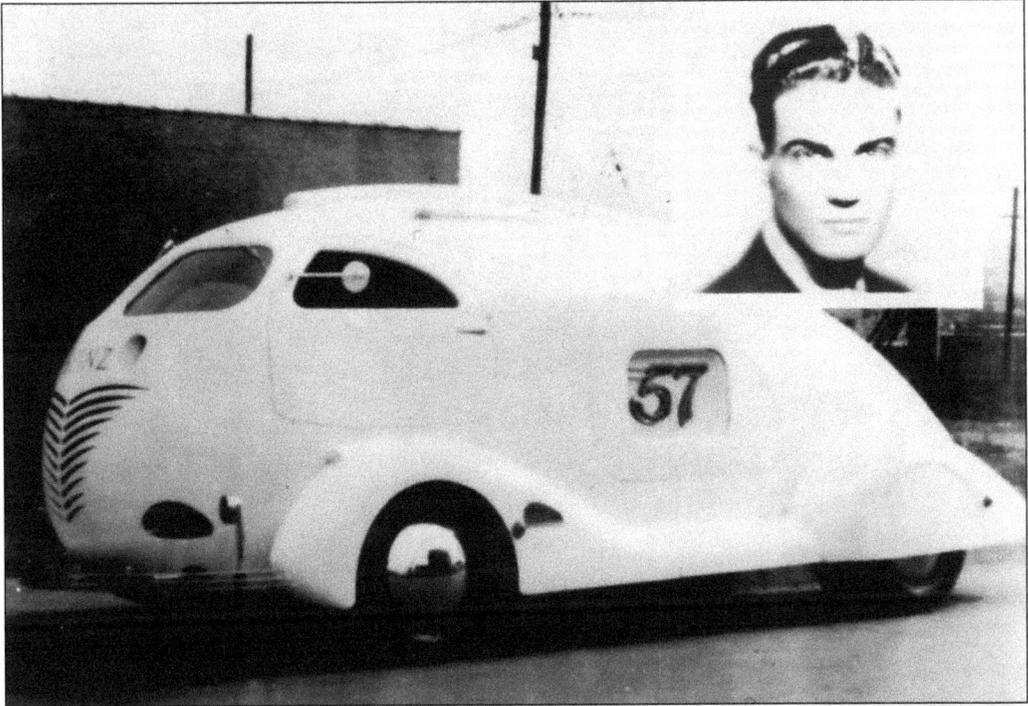

Young Jack Heinz went on to head the family firm. Rust, an artist, moved to California, where he became a noted car designer. He created the Comet (above), a streamlined Heinz company delivery car, and the Phantom Corsair (below), a 1938 coupe with imaginative touches, such as altimeters and an "all-wave" radio. It seated four in the front and two in the back. Rust died the following year in an automobile accident in Pittsburgh. (Courtesy of Road & Track magazine.)

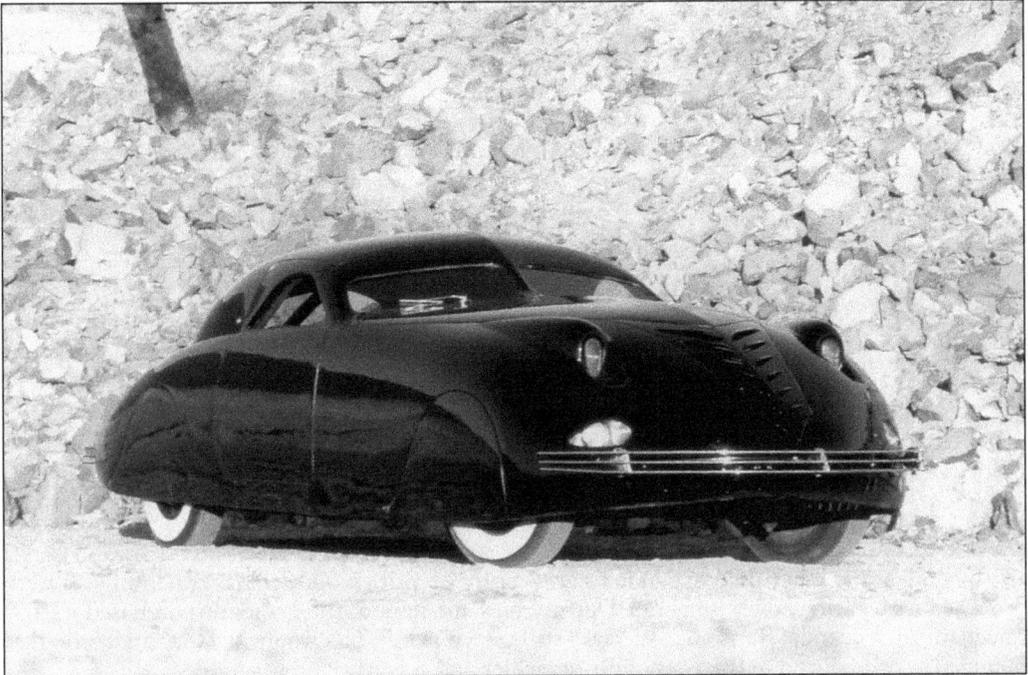

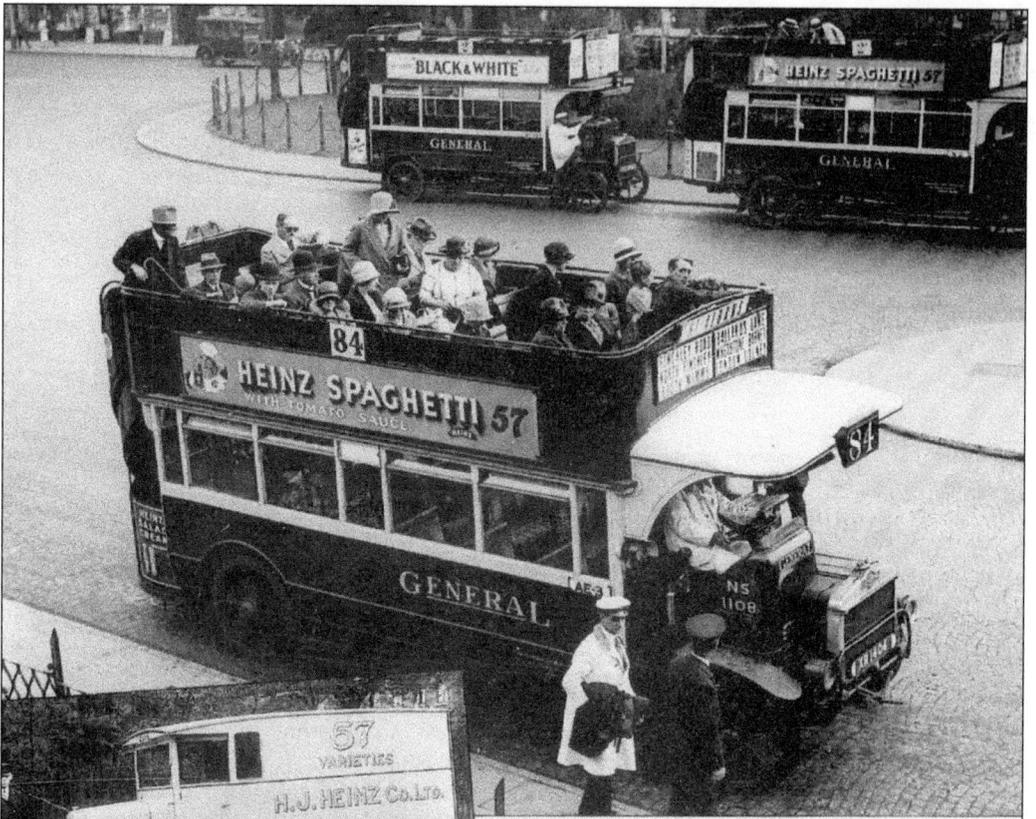

By the mid-1920s, Heinz had expanded significantly its British operations. London buses were bedecked with Heinz advertisements. During the same period, the company purchased its first "mechanical truck," a Ransome "electric stillage vehicle." The young factory in Harlesden hummed as it produced massive amounts of pickles and other brined vegetables.

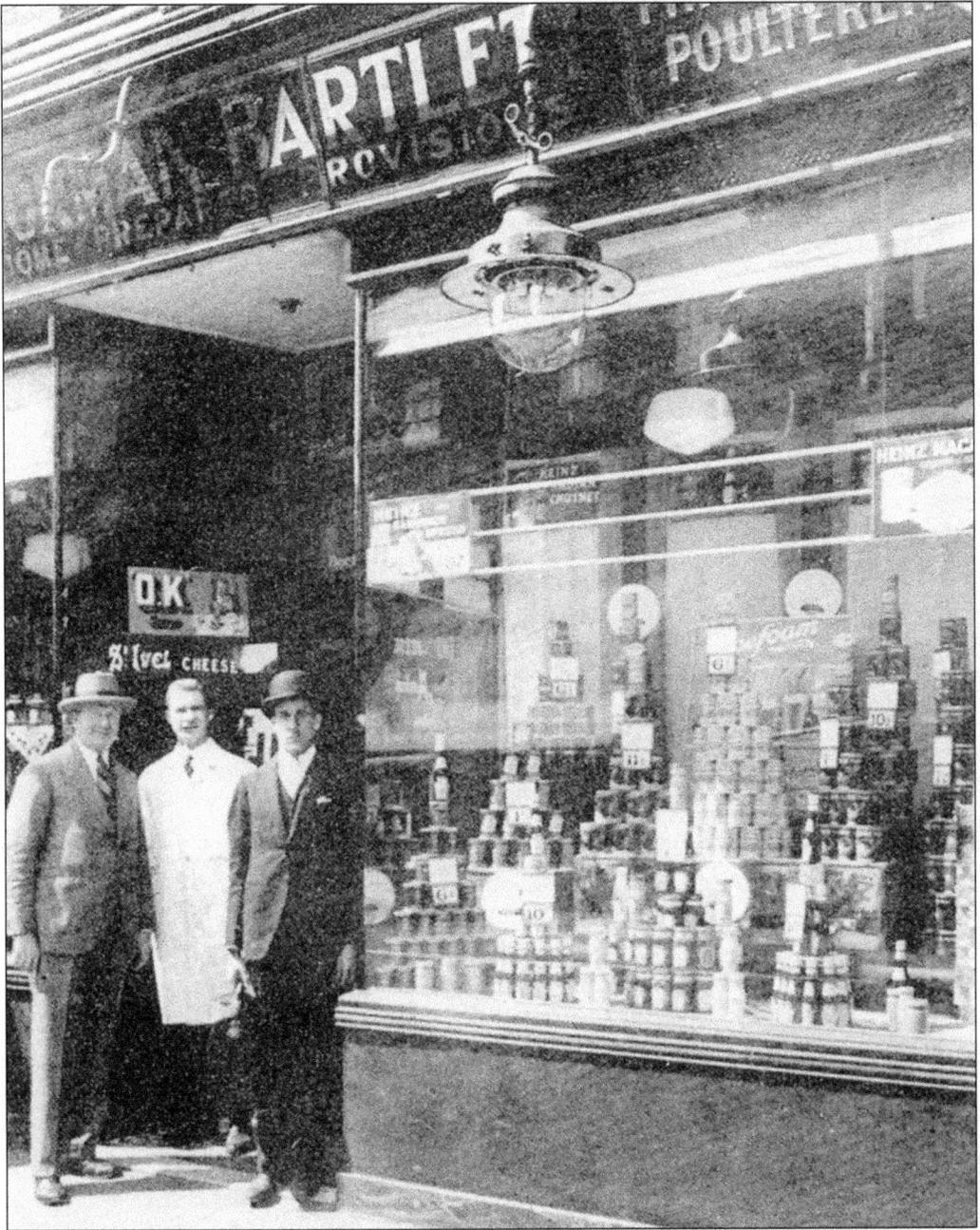

Future chairman Henry J. "Jack" Heinz II spent three years in England at the company's Harlesden factory after graduating from Yale and taking postgraduate courses at Trinity College, Cambridge. Here young "Mr. Henry," as he called himself to hide his famous name, stands in the doorway of a typical 1930s British grocery store.

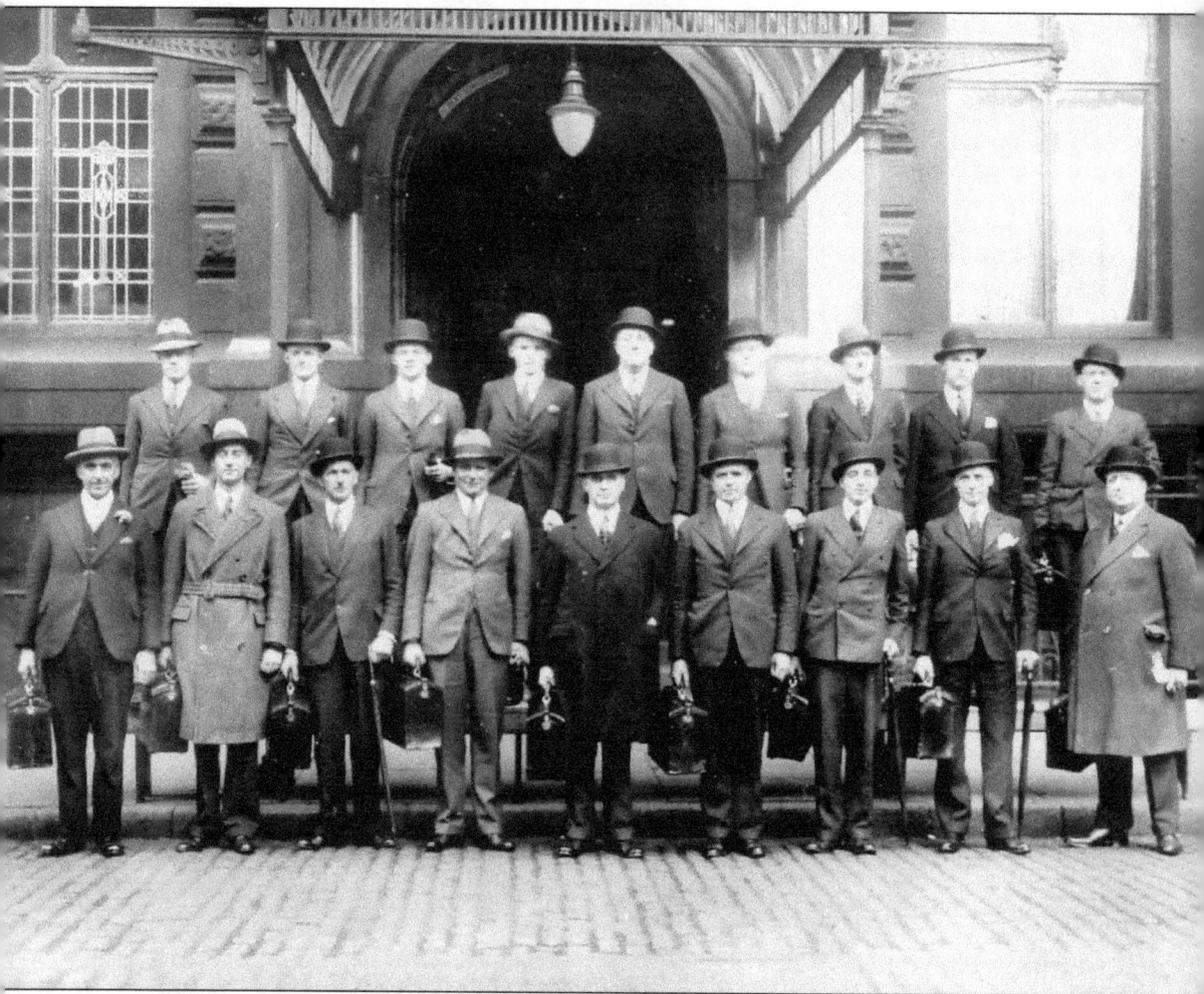

The incomparable British sales force, nicknamed the "Red Army," was distinguished in appearance, as evidenced in its 1930s trip to the annual sales conference. Every salesman was at least 5 feet 10 inches, constantly carried his black sample bag and furled umbrella, and topped off his sartorial look with a black bowler.

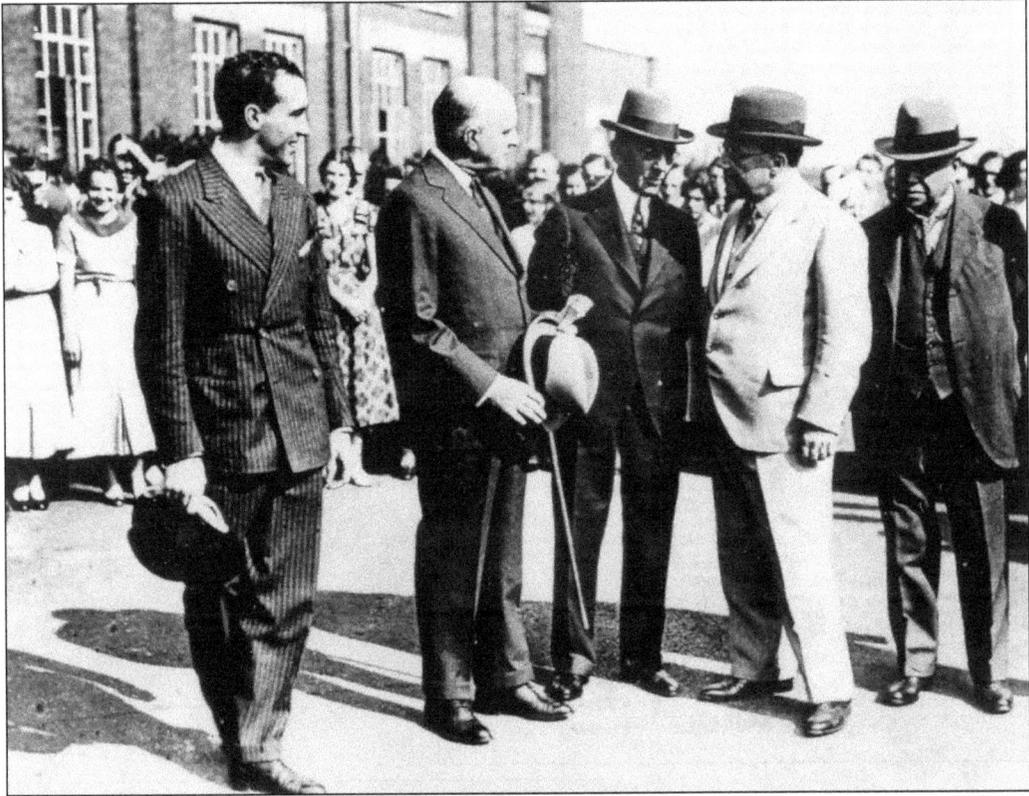

In 1931, young Jack Heinz (left) met with Charles E. Hellen (center) and other senior Heinz executives at the Harlesden factory. Hellen joined the U.S. company as a salesman in Washington, D.C., in 1889 and was sent to the fledgling U.K. businesses in 1905. He transformed the unit into a hugely profitable affiliate and presided over it until his death in 1944.

The famous Heinz U.K. "Joy of Living" advertising campaign began in 1927. It emphasized great-tasting, low-cost nutrition and high quality, including no preservatives and no artificial coloring. At that time, the beans were shipped from America. The following year, when baked beans rolled off British production lines with lower prices, sales took off.

Howard Heinz fought the slumping U.S. economy with an inventive product line, canned baby food. First introduced in 1931, Heinz boasted 14 varieties by 1941.

This advertisement ran in the January 16, 1932, issue of *The Saturday Evening Post.* During the Depression, Howard Heinz was a contrarian who increased his advertising budgets, figuring that advertising was a powerful tool for those companies that could afford it. (Note his signature at the end of the advertisement.)

During the 1930s, farmworkers handpicked and hand packed tomatoes. (Courtesy Historical Society of Western Pennsylvania.)

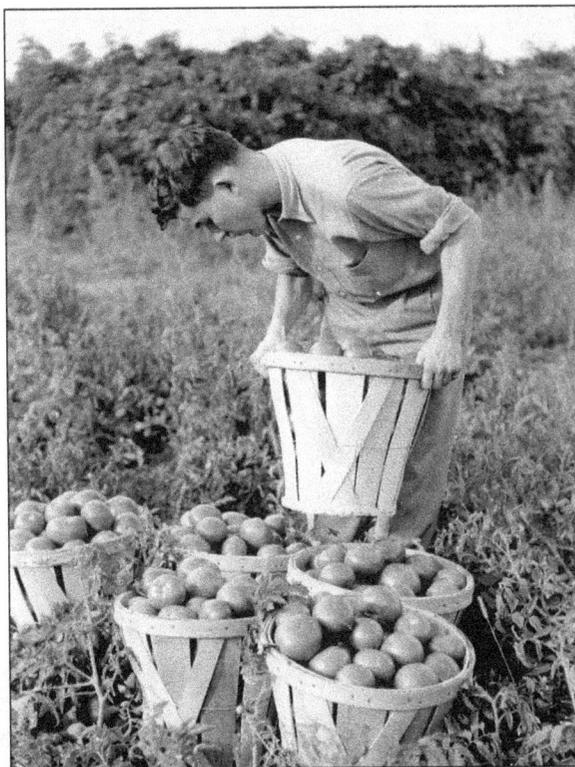

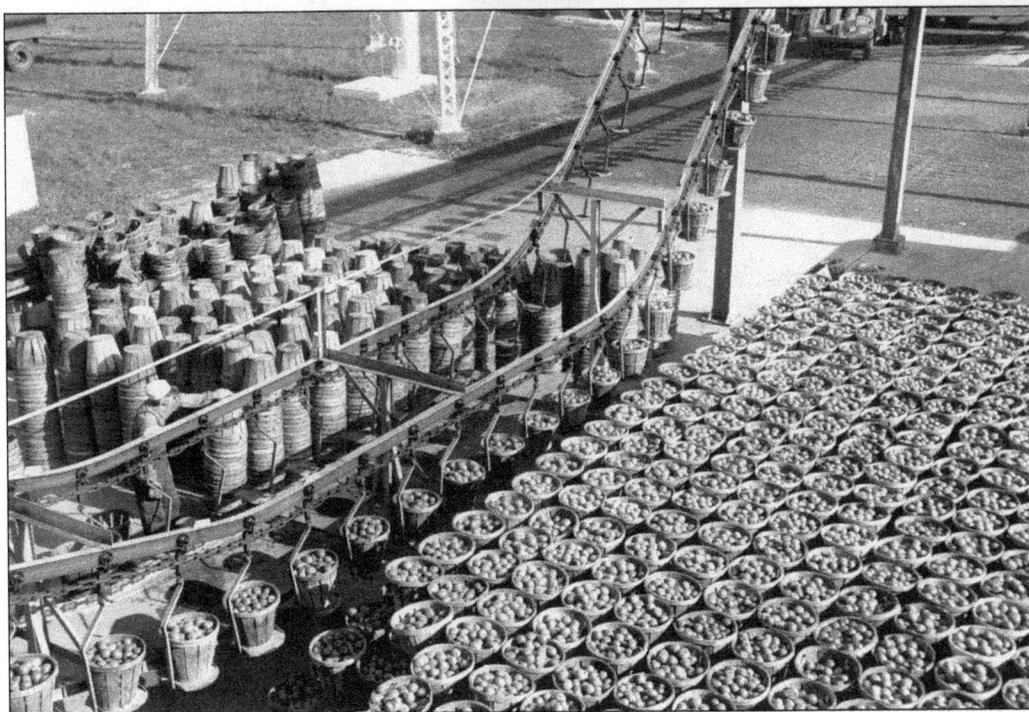

The Leamington, Ontario, factory was a hub of activity as mechanized handling began to increase productivity.

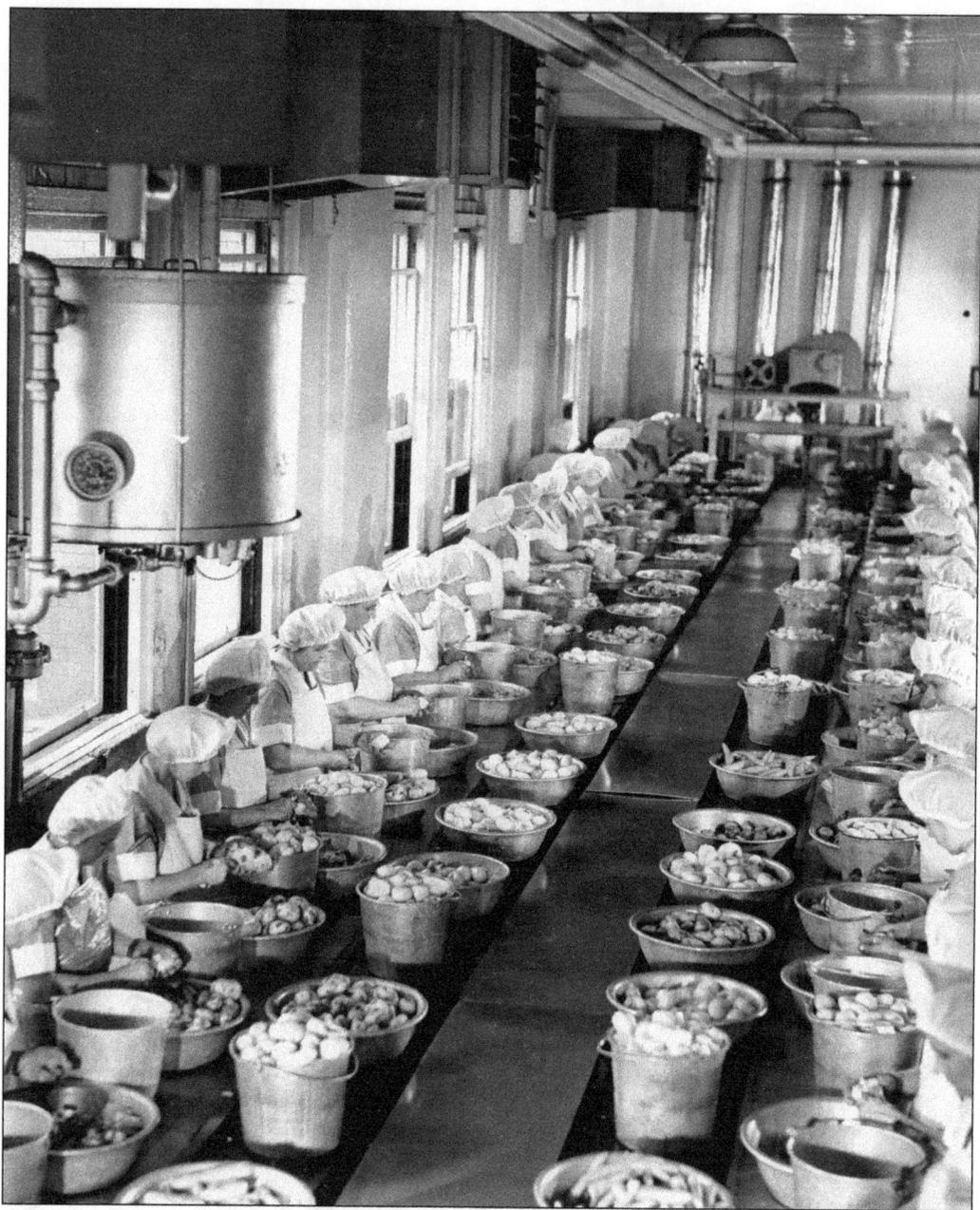

Hand peeling of vegetables required fast and meticulous work by scores of smartly uniformed women at the Pittsburgh factory in 1936.

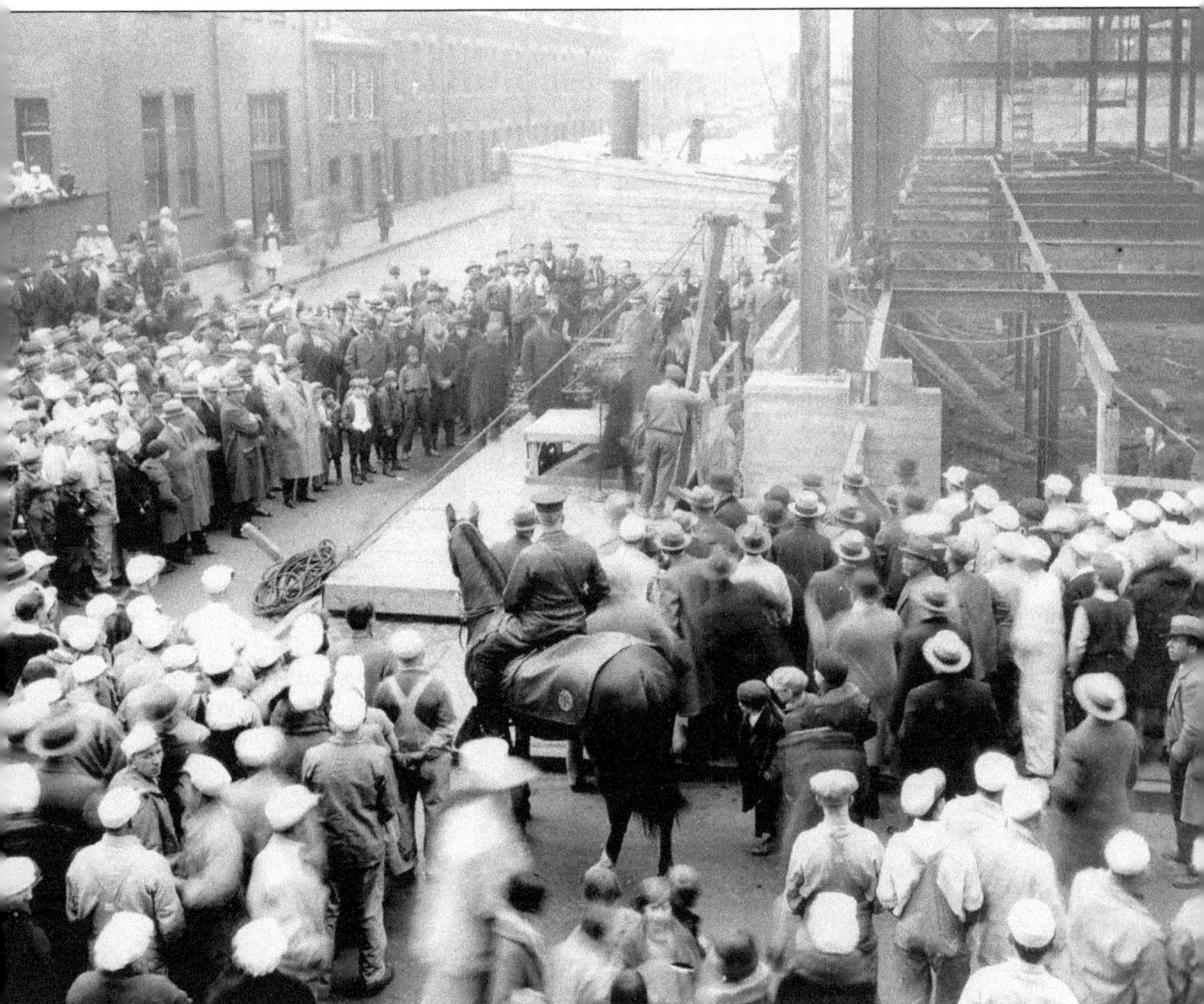

On January 8, 1930, Howard Heinz and Sebastian Mueller sealed a time capsule in the cornerstone in the Service Building, a new structure for housing employee activities at the intersection of Heinz and Progress Streets near the center of the factory complex. The building was considered by some to be a "grand gesture of paternalism." The sealed box contained a history of the firm, photographs, and other items. When opened on the company's 125th anniversary, it was discovered that floodwaters from the nearby Allegheny River over the years had disintegrated the contents.

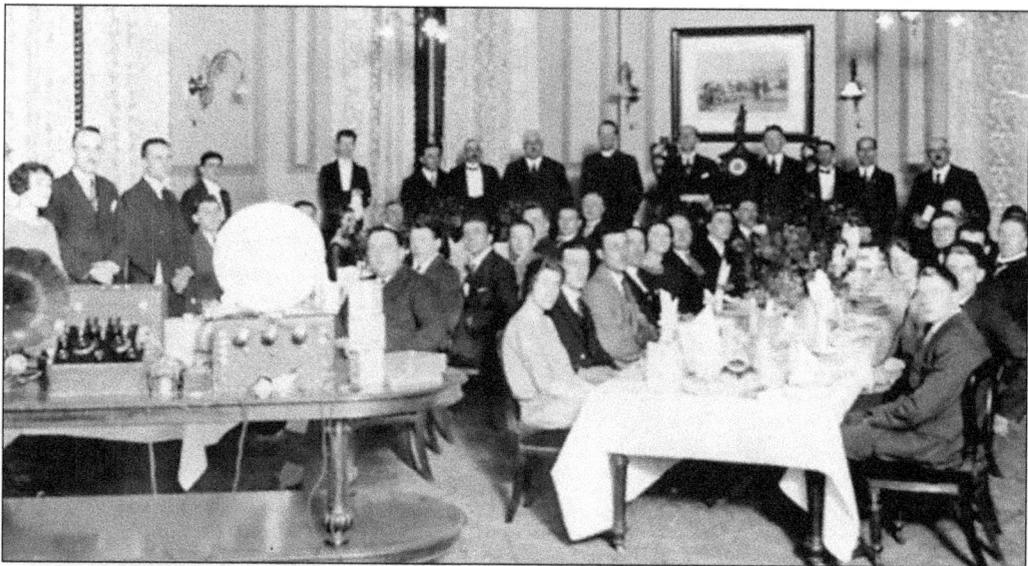

In 1926, the 57th anniversary of the company, a live radio broadcast (cutting-edge technology then) simultaneously linked employees from the United States, Canada, and Great Britain. Together they celebrated with banquets, as this group is doing in the Bristol branch in Great Britain. All employees listened to Howard Heinz, an inspirational orator. Two years earlier, for Founder's Day, a shortwave radio broadcast had linked 10,000 employees at 62 different banquets around the world. It was among the first of its kind and included greetings from Pres. Calvin Coolidge.

On the 70th anniversary of the company's founding, Howard Heinz, on December 28, 1939, hosted a meeting for employees in the company's auditorium. He spoke of the importance of free enterprise, rugged individualism, and free trade.

Howard and Betty Heinz, like so many Americans at the time, enjoyed strolling the Atlantic City boardwalk.

"Her Guests Couldn't Believe It," declares this 1935 advertisement from Heinz U.K. It featured a formal white-tie dinner to verify the upmarket quality of Heinz canned soups.

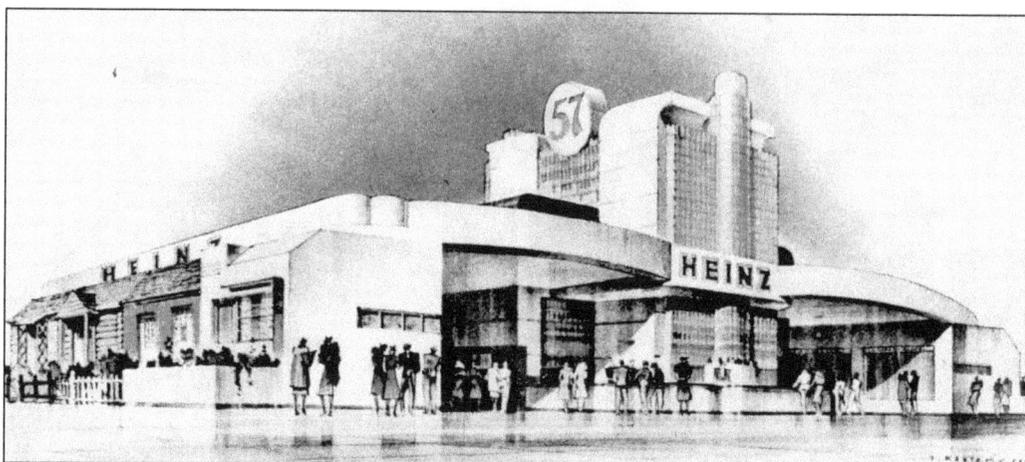

World's fairs continued to work marketing magic for the company, which sponsored major exhibits at the 1939 New York and 1940 San Francisco (above) expositions. Pickle pins abounded, and Mr. Heinz Aristocrat greeted visitors at both events.

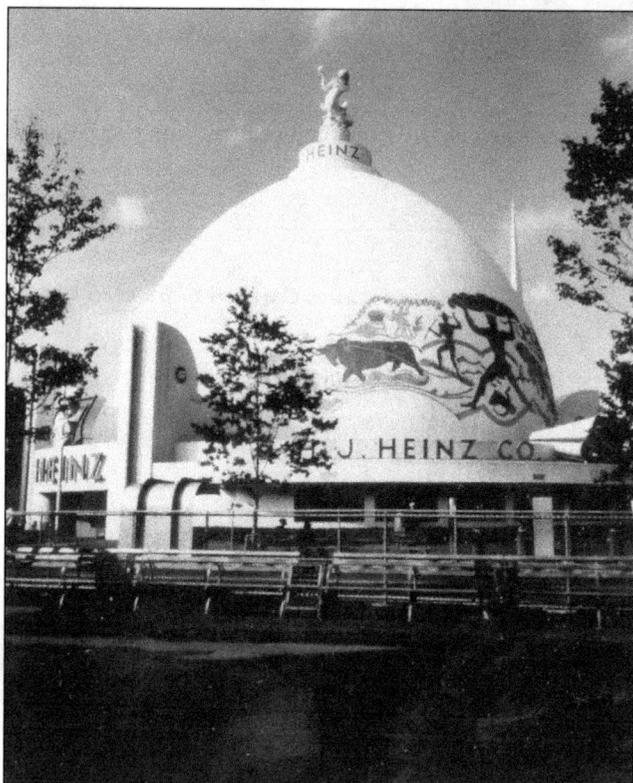

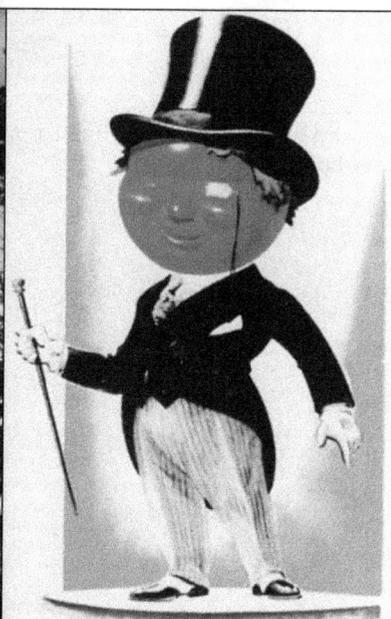

**HE IS THE HEINZ "ARISTOCRAT"
THE PRIDE OF HIS WHOLE FAMILY**

Heinz animated Aristocrat Tomato Man does a singing-talking act which is one of the most popular features of the Fair—especially with the youngsters. He tells his own story in his own way—with gestures.

Three

THE TEST OF HARD TIMES

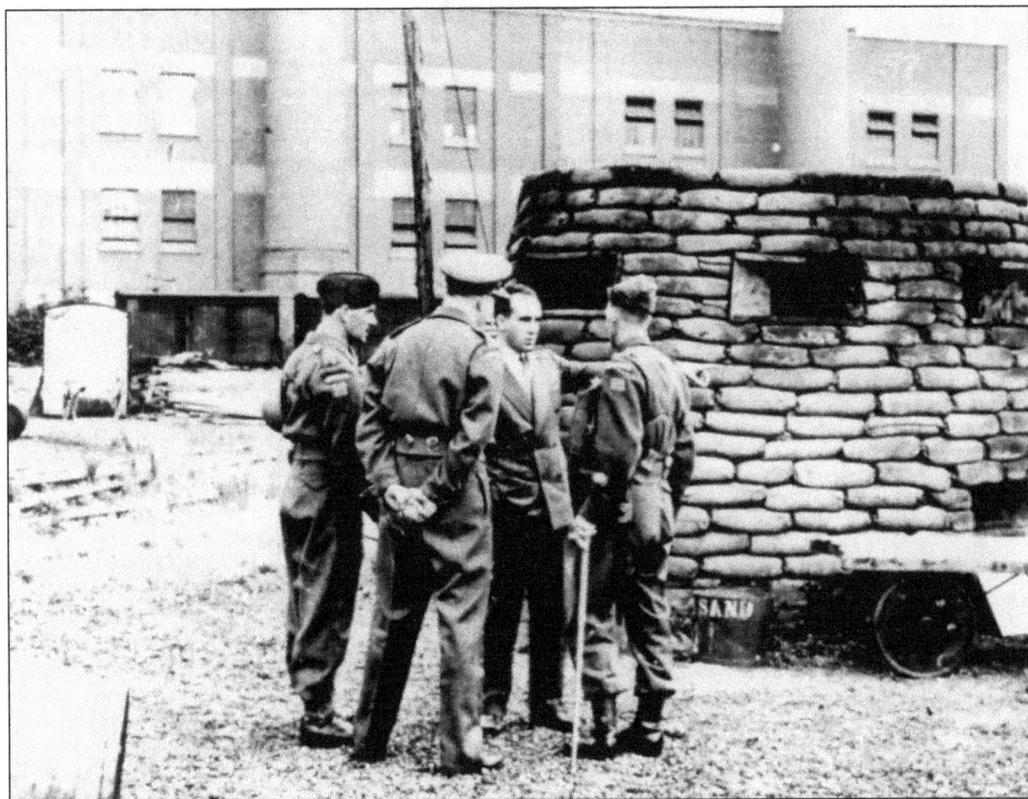

H.J. Heinz Company played a vital supporting role in the Allied effort during World War II. Jack Heinz conferred with members of Britain's Home Guard at the fortified Harlesden facility, which German bombs hit twice. In 1940, Howard Heinz sent an $80,000 check to Lord Beaverbrook on behalf of employees to purchase two Royal Air Force fighters. After Howard's death in 1941 at age 64, Jack Heinz became one of the youngest heads of any major American corporation. He was 33.

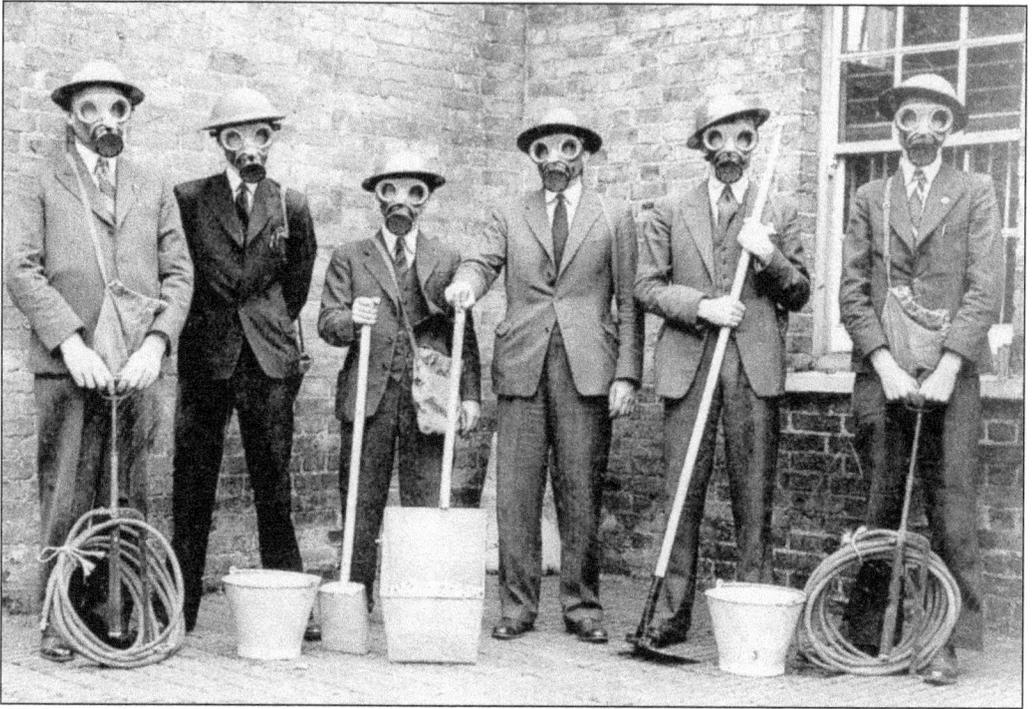

Air raid precautions were a daily British routine, and the management team in the Great Britain office was readied for action.

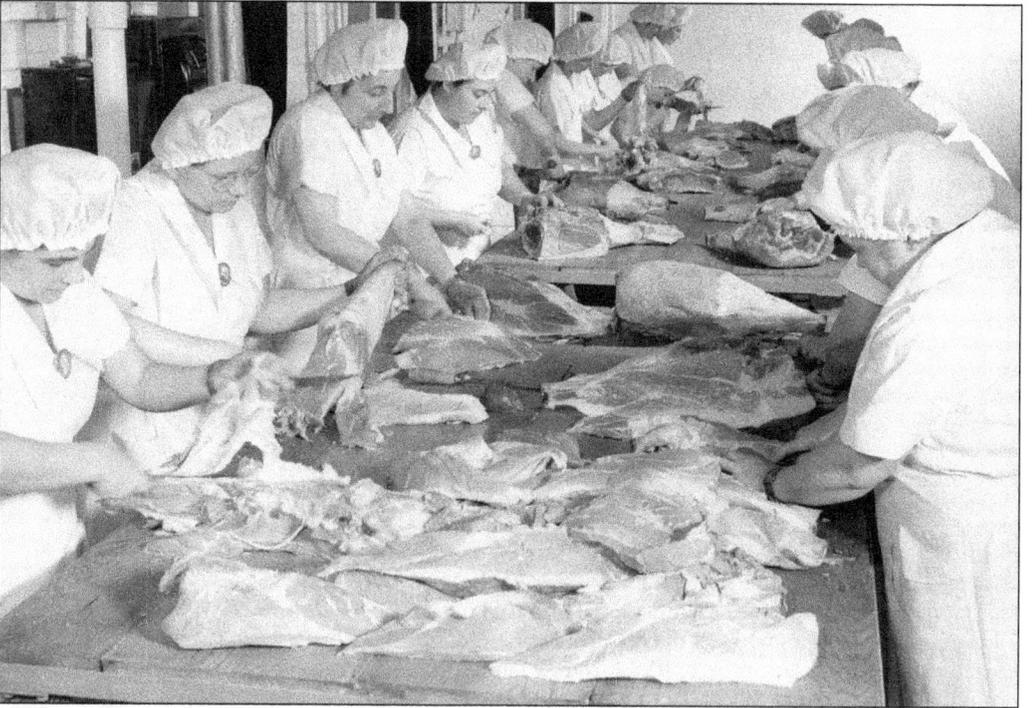

At the Pittsburgh factory, production lines were converted to crank out K and C rations, causing the plant to gear up from one shift to three.

Heinz helped create, and then manufactured, the self-heating can, which was a revolutionary innovation for the troops. Used for liquids—soups, cocoa, and malted milks—each can consisted of a metal tube filled with a smokeless chemical fuel that could be heated in just over four minutes by removing a protective cap, piercing the top, and applying a lit cigarette to the fuse.

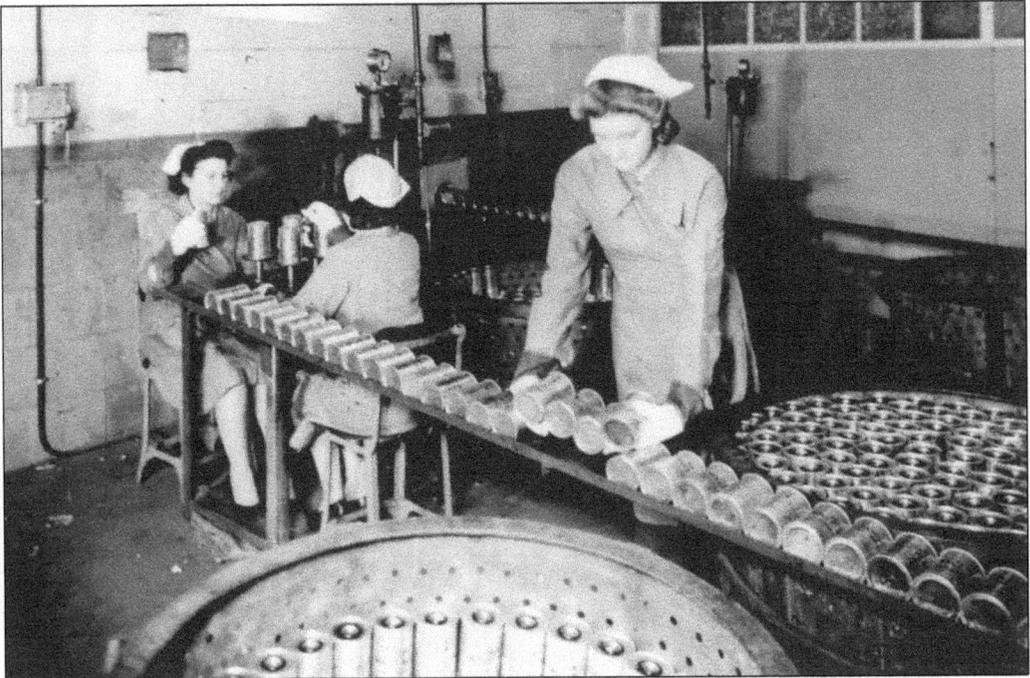

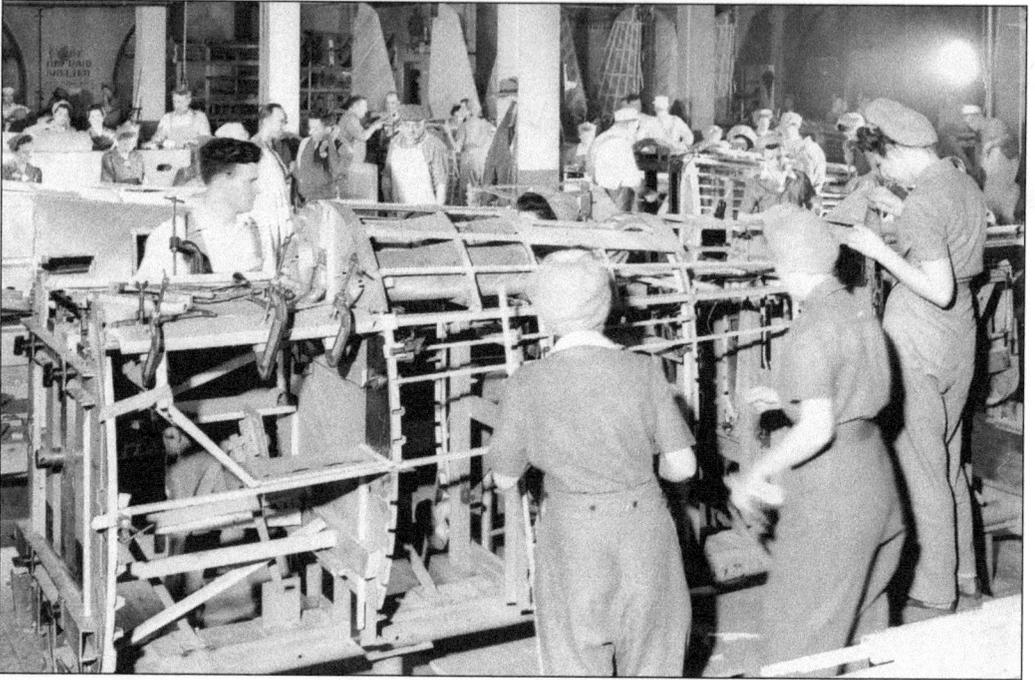

Jack Heinz shut down many of his Pittsburgh factory operations to accommodate wartime needs. The Heinz War Production Department included some 2,800 men and women who received vocational training from teachers at 12 Pittsburgh schools.

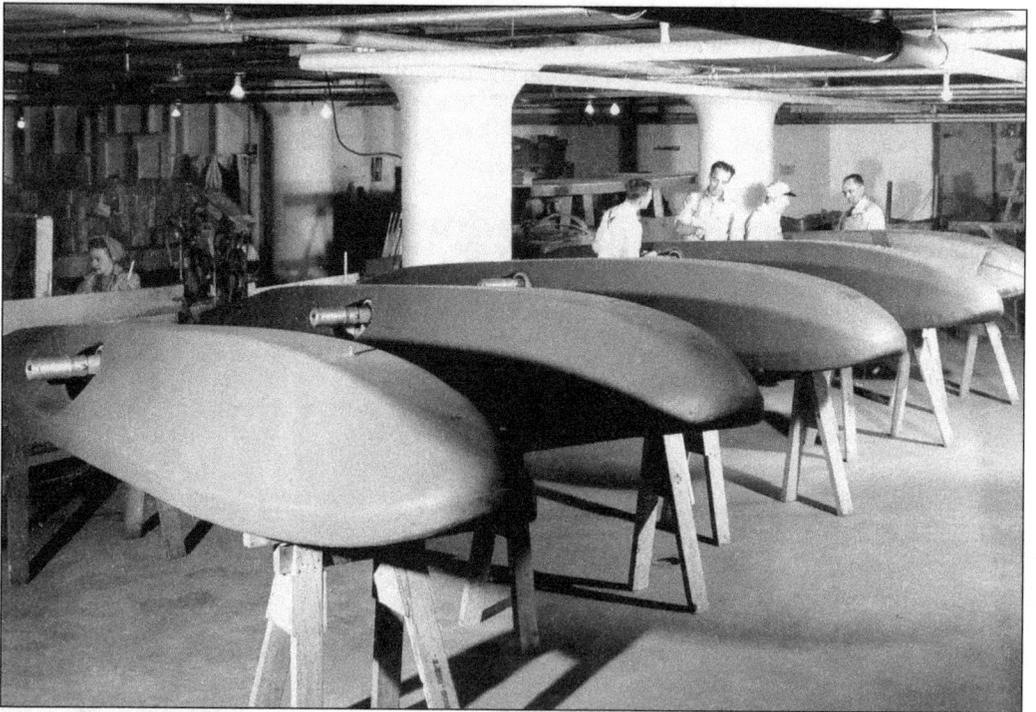

Pontoons, along with shell canisters and parts for airplanes, rolled off Pittsburgh production lines rather than baby foods.

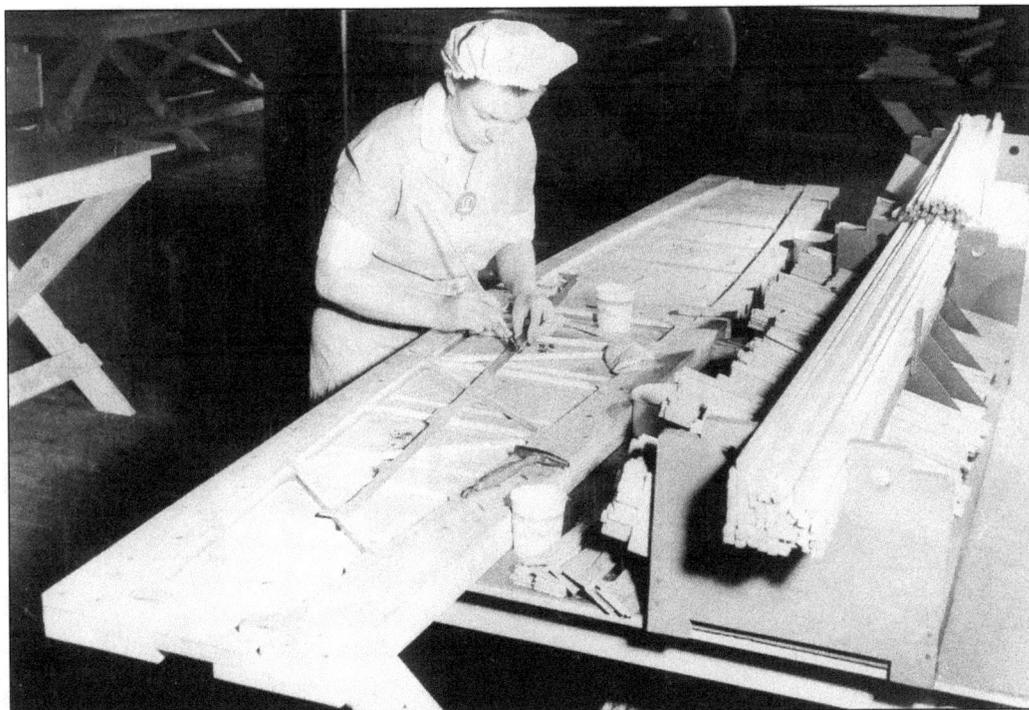

Heinz's most recognized war initiative was the construction of glider wings. The gliders, each of which could each hold up to 40 men, were crucial to many Allied missions, including the D-day invasion at Normandy.

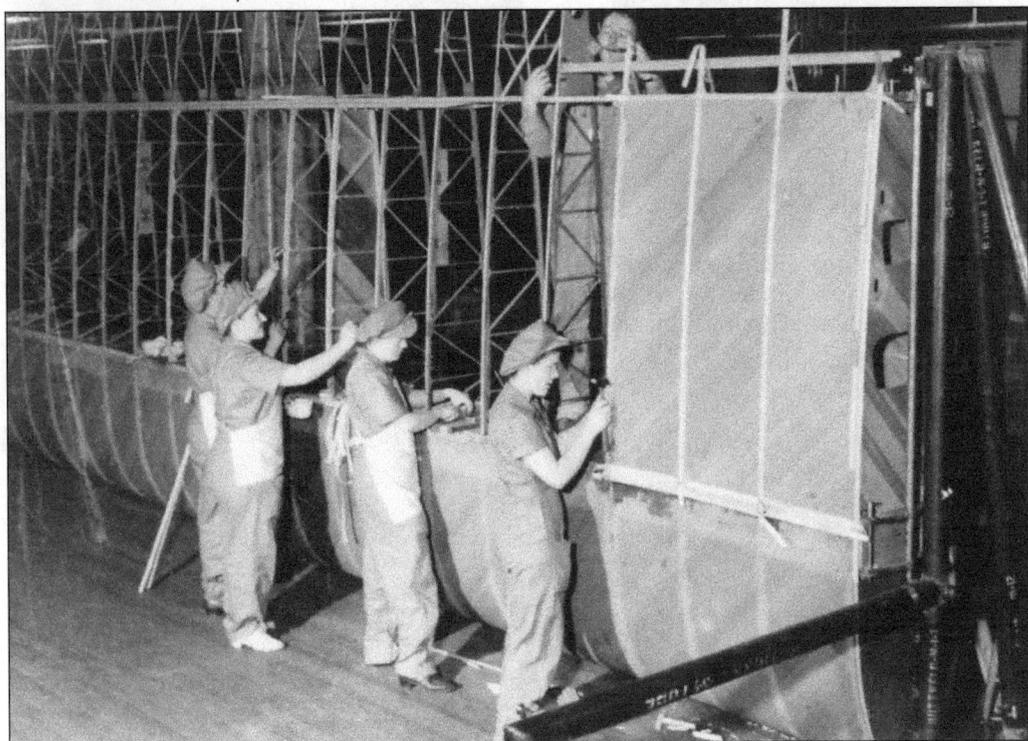

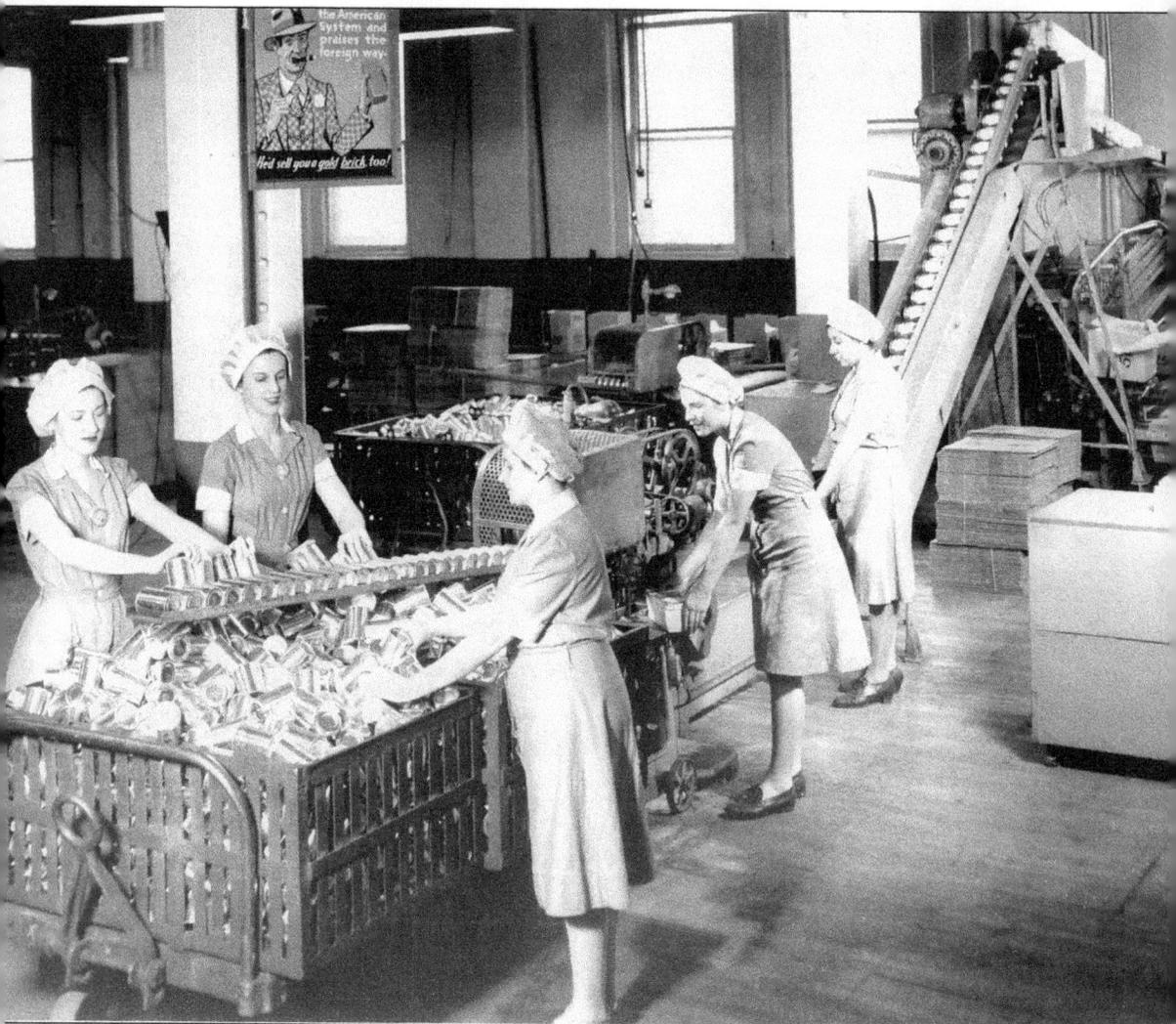

War production was highly guarded. Each worker wore a special identification button and received constant reminders of potential enemy tricks by posters displayed throughout the Pittsburgh operations. (Courtesy Historical Society of Western Pennsylvania.)

Four

THE POSTWAR BOOM

The post–World War II years saw company growth not only in scope but also in the sophistication of its management style. On November 27, 1946, Heinz became a publicly held company. On that date, shares commenced trading on the New York Stock Exchange under the ticker symbol HNZ. In *The 57 News* for employees, Jack Heinz noted, "This far-reaching decision will enable the company to carry out its planned expansion program of more factory facilities, more warehouse space and larger inventories." (Note the interest that the editors had in the numeral 57 growing on a tomato.) Jack's grandfather had incorporated the company in 1905, placing his likeness on the initial certificates and issuing the first 1,000 shares to himself.

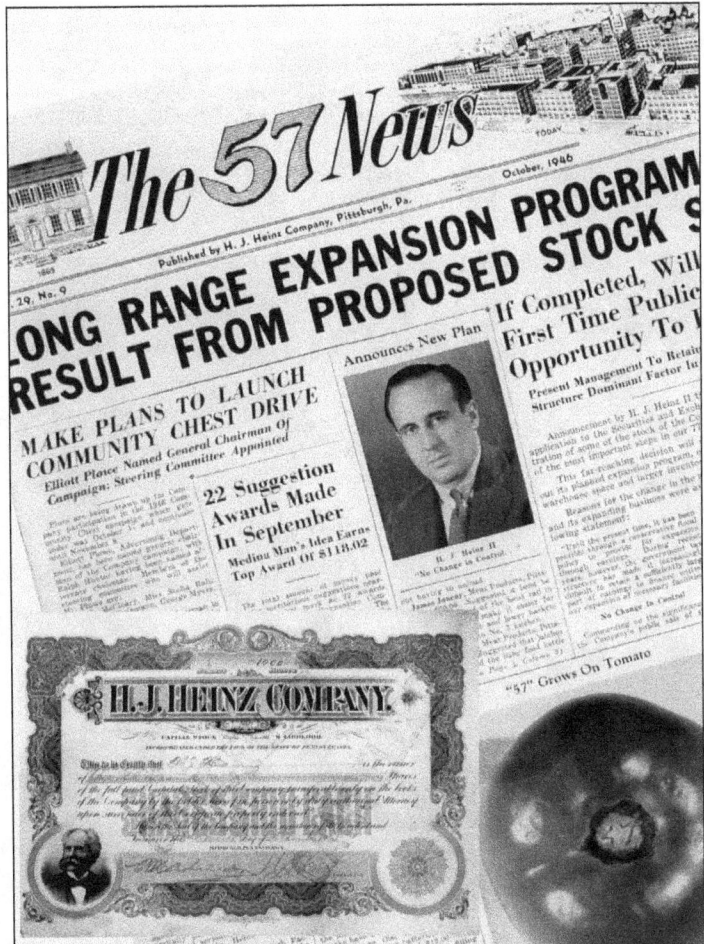

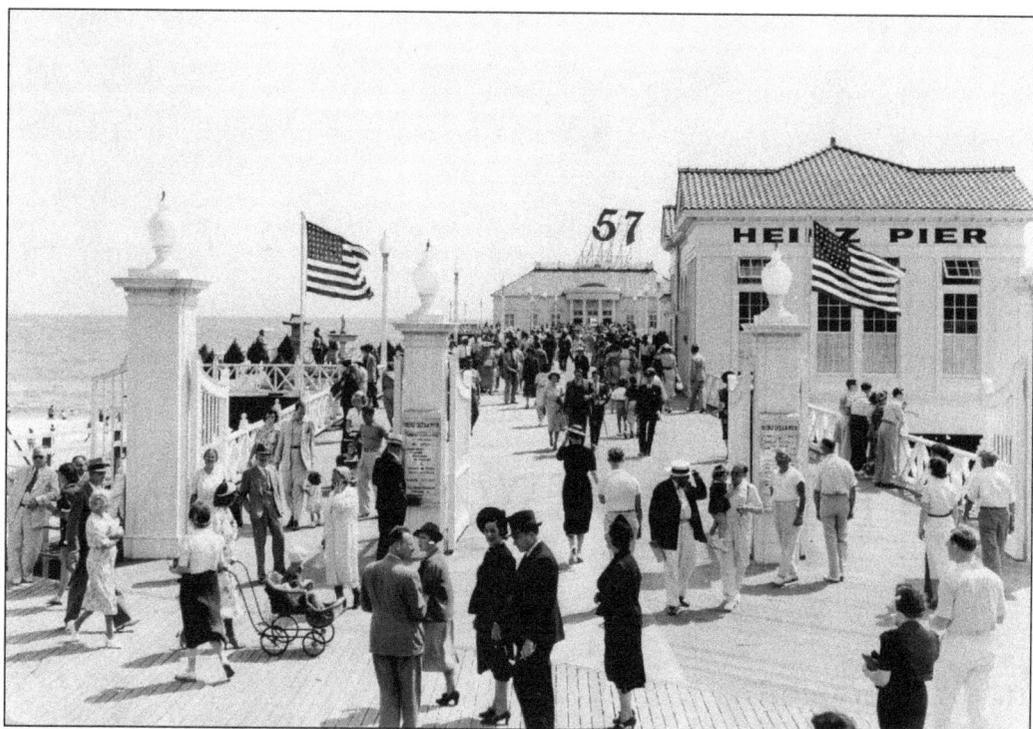

Atlantic City continued to be one of America's favorite resorts, and tourists flocked to the Heinz Ocean Pier until it was severely damaged in a 1944 hurricane that cast the landmark 57 sign into the Atlantic Ocean. Over the years, more than 50 million vacationers stopped at the "Sea Shore Home of the 57 Varieties."

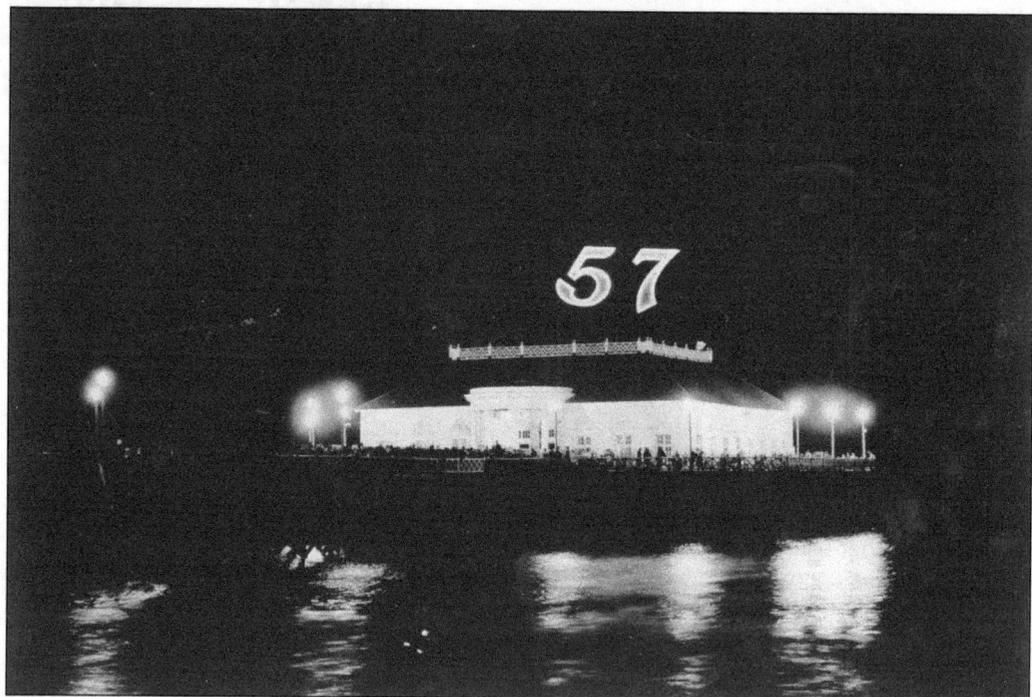

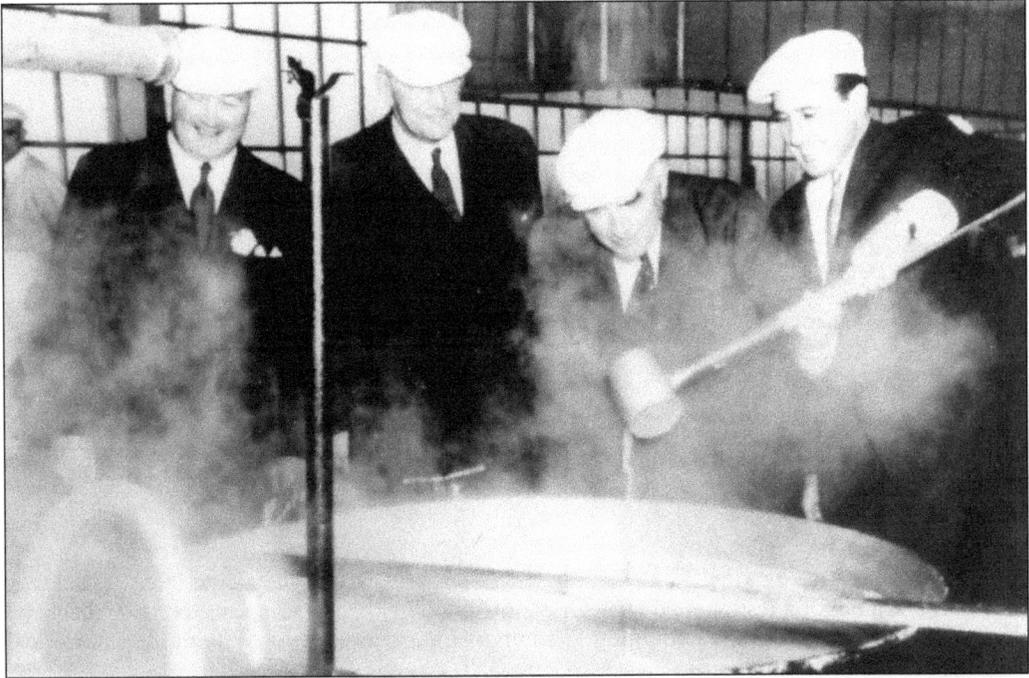

Jack Heinz personally scouted Australia for the best location for a production center. In 1955, he (right) and Prime Minister Sir Robert Menzies (second from right) ladle one of the first batches of soup to officially inaugurate the factory in Dandenong.

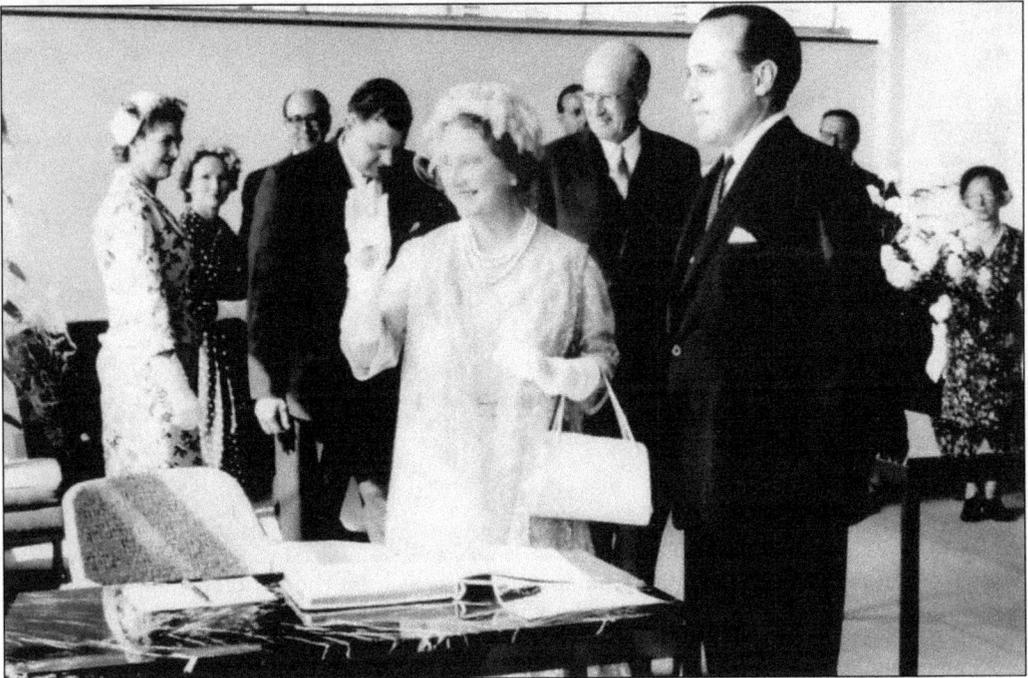

Operations in the United Kingdom grew with the addition of a gigantic factory in Kitt Green, in northern England. In 1959, the Queen Mother joined in officially opening the plant, which remains one of the largest food operations in all of Europe.

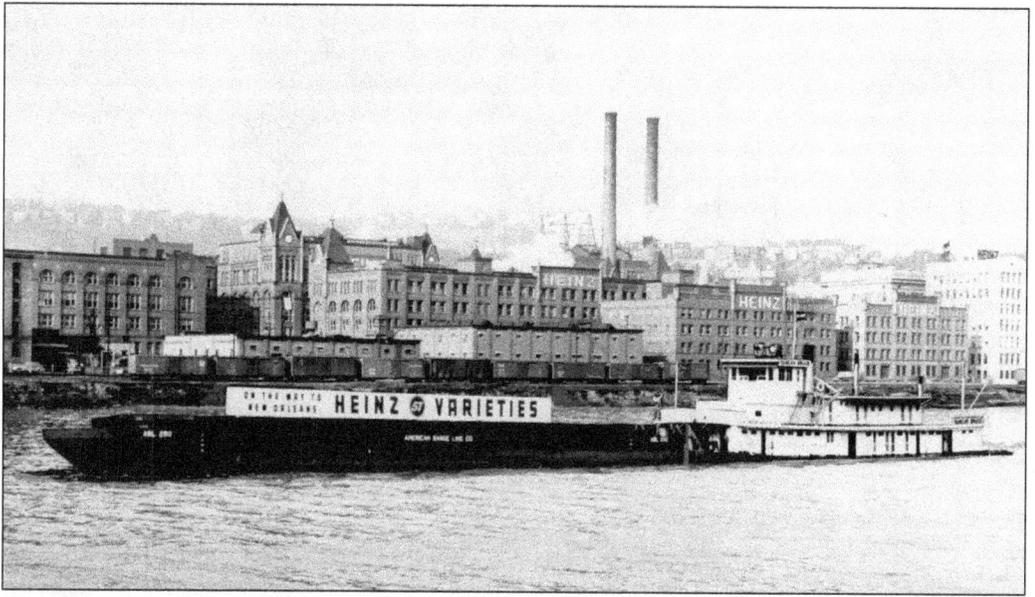

This barge, bound for a just-opened New Orleans warehouse, began its voyage on the Allegheny River in front of the company's booming Pittsburgh factory (around 1945). (Courtesy Historical Society of Western Pennsylvania.)

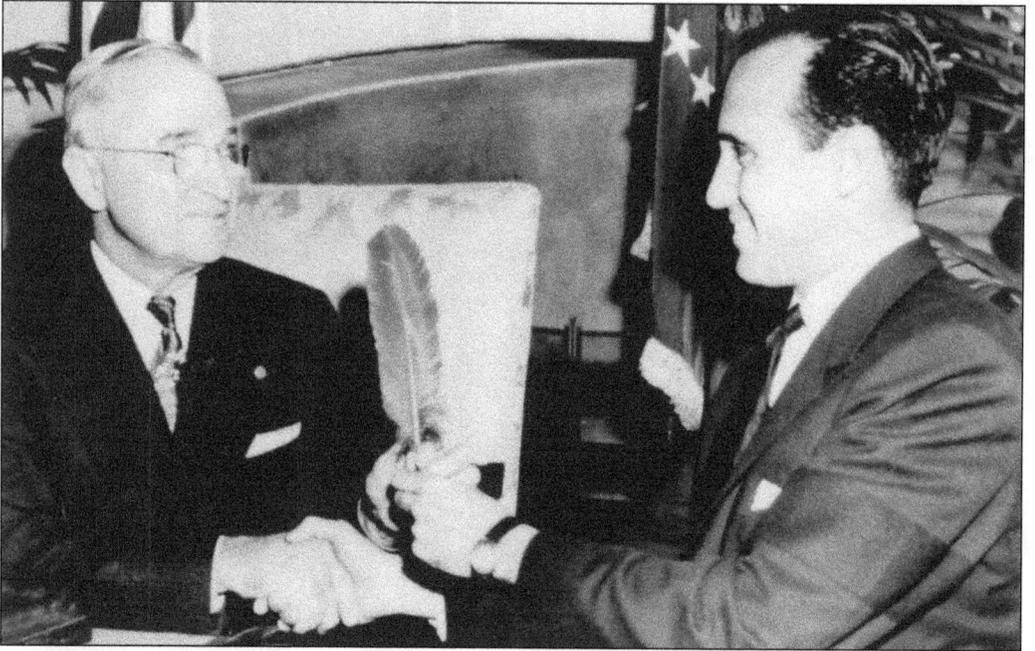

Jack Heinz visited with Pres. Harry Truman in 1947 to kick off the national campaign for the Community Chest, which later became the United Way. He credited a female designer in the company's art department with creation of the fund drive's iconic red feather symbol. The same year the company pioneered a national charitable campaign to aid babies in war-ravaged areas. In this inventive move, Heinz sent one pack of baby food to Europe for each package of Heinz baby food bought by American mothers. During one week, up to six million packages were shipped for distribution.

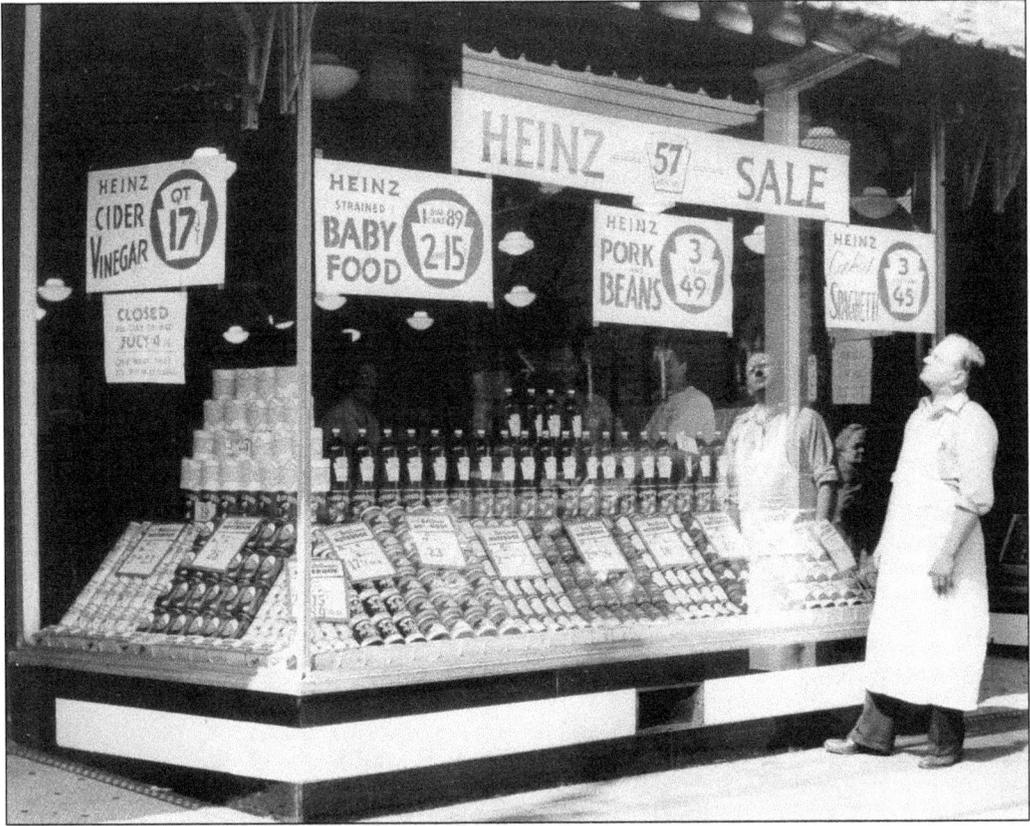

Storewide sales of the 57 Varieties were popular postwar promotions. (Courtesy Historical Society of Western Pennsylvania.)

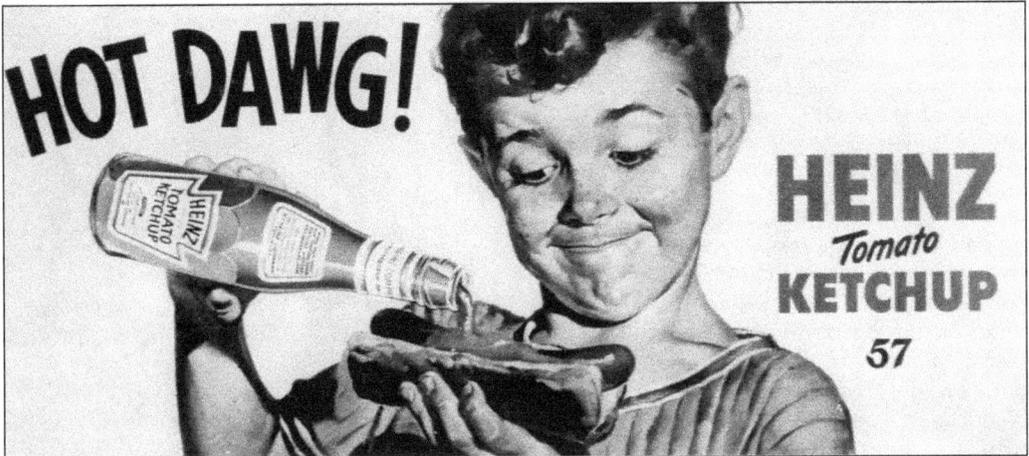

Billboards showcasing the all-American nature of Heinz Ketchup abounded.

"Skinny chickens make thin soup," says Henry Heinz. "We don't use them."

Jack Heinz became a minor television celebrity when he starred in television commercials. Magazine advertisements ran concurrently with the broadcast spots and echoed the same messages, such as "Skinny Chickens Make Thin Soup—We Don't Use Them." Another of his famous lines was, "My grandfather said a customer is a friend you have never met, and you cannot stint a friend."

Live and recorded commercials on national television networks captured the imagination of consumers. Lila Jones, Heinz's senior home economist, represented Heinz on *Studio 57* and other programs during the 1954–1955 broadcast season. She worked regularly with Joel Aldred, the company's studio announcer.

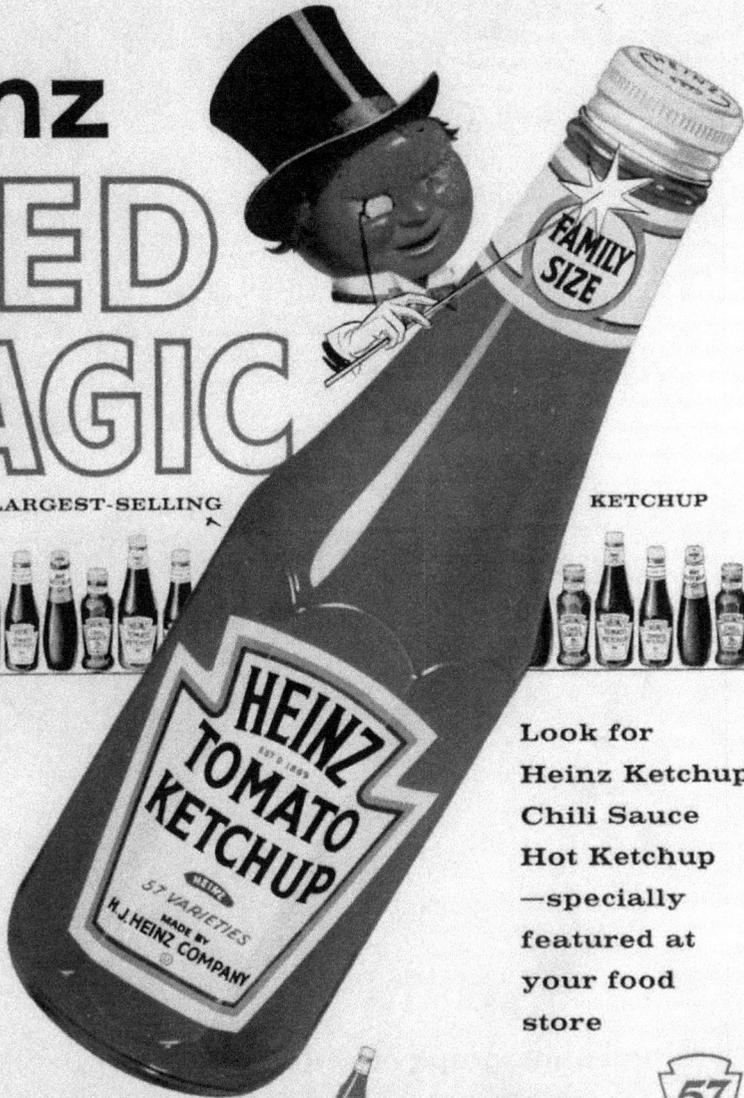

Heinz Ketchup is touted as "Red Magic" in this 1960 advertisement. It featured Aristocrat Tomato Man, the company's mascot. Sizes and varieties of ketchup were limited to the standard and family-size bottles and regular and hot recipes. Ketchup then was made from fresh tomatoes during tomato season in the summer and early fall. A large inventory followed, which explains why special values were offered in the autumn.

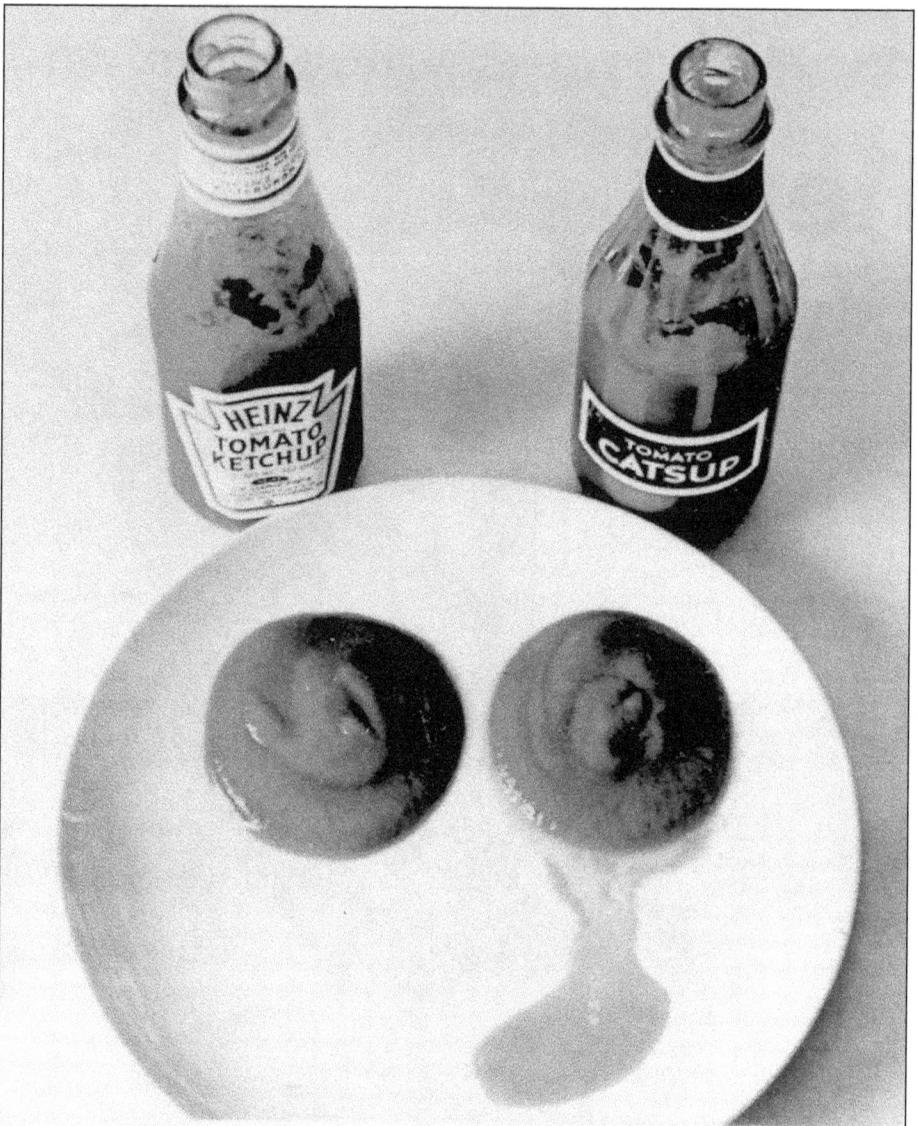

Actual photograph of water running out of other catsup, 3 minutes 39 seconds after both were poured.

One reason you may pay a little more for Heinz.

In 1964, Heinz began to pour on major initiatives to bolster not only the quality of its ketchup but also the efficiency and profitability of its "big red machine," the network for growing and processing tomatoes. Mechanical harvesters were replacing handpicking, and tomatoes were being cooked into paste for storage to provide a steady supply of raw ingredients for year-round ketchup manufacturing. The marketing team stepped up with this print advertisement and a similar television commercial. The total creative budget for the advertisement was just $8,000 at a time when most advertisement costs topped $50,000. The success of the campaign caused a ketchup shortage and an immediate boost in market share.

70

Five

NEW BRANDS AND NEW BUSINESSES

H.J. Heinz Company underwent a sea change in 1966. Jack Heinz stepped aside from day-to-day operations and ushered in professional management with the appointment of R. Burt Gookin to the position of president and CEO. Gookin became the first non–family member to run the company. A CPA by training, he had, as head of the U.S. operation, turned around the troubled business unit. With his leadership, earnings rose steadily worldwide, and the company went on a buying spree, acquiring major brands in America and abroad.

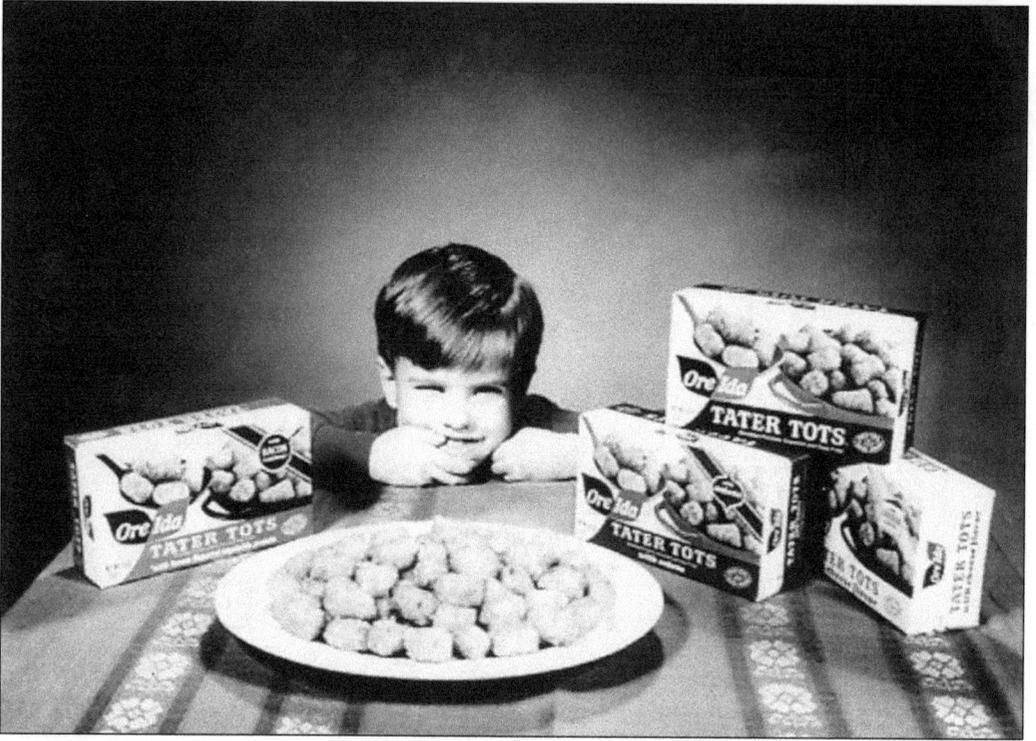

Ore-Ida frozen potatoes became part of the Heinz family in 1964. The brand was famously promoted with the catchphrase "When it says Ore-Ida, it's all-righta." In addition to processing french fries, Ore-Ida had invented Tater Tots, bite-size morsels created from wasted bits of potato with added spices.

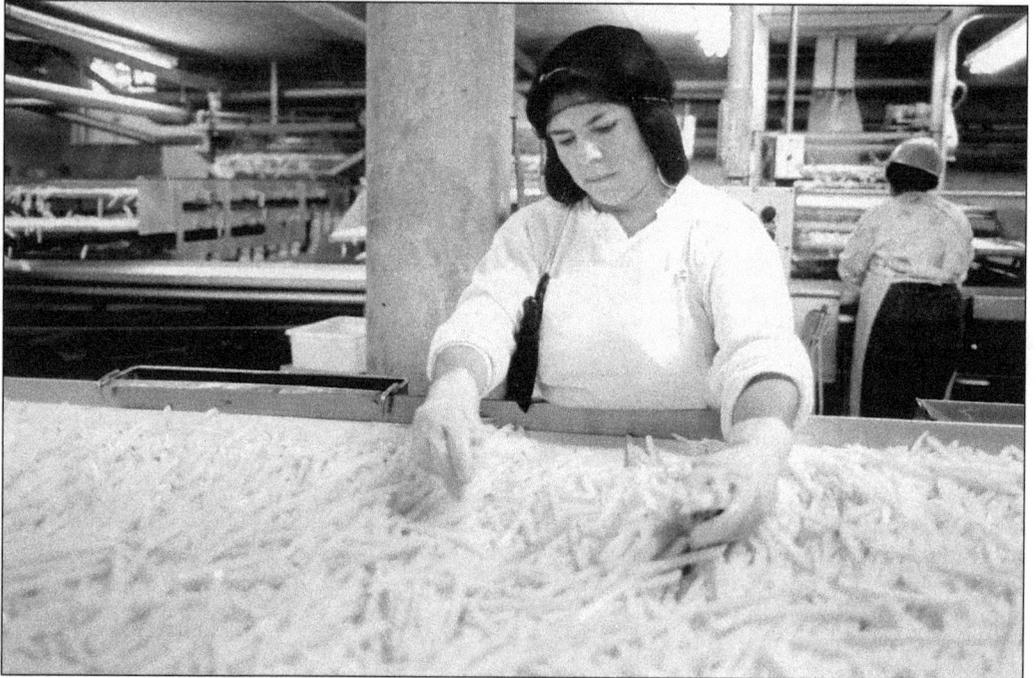

Heinz ventured to Italy in the early 1960s to study the successful Plasmon baby food company and bought the Milan-based operation in 1963. It was such an iconic brand that when Italians described a healthy baby, they called it "a Plasmon baby." The company has a strong reputation that started in 1902 when an Italian company used the milk protein derivative—known as plasmon—to fortify infant foods. In 1949, its advertisements touted the superior nutrition of Plasmon biscuits.

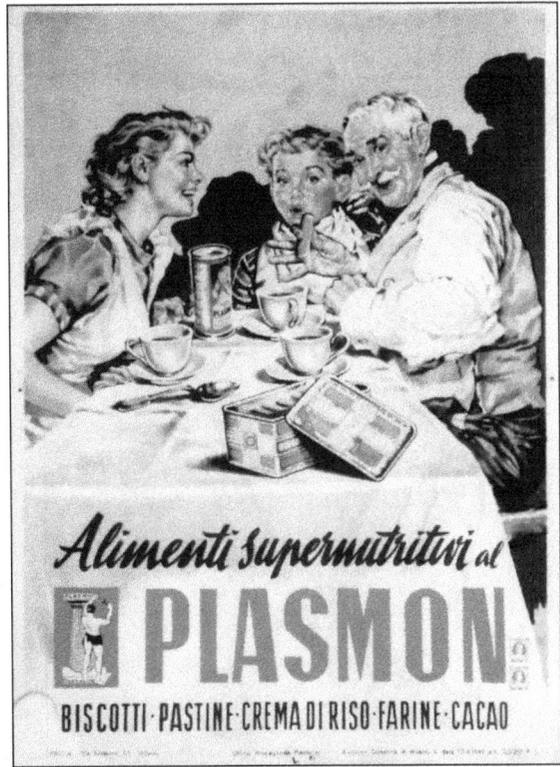

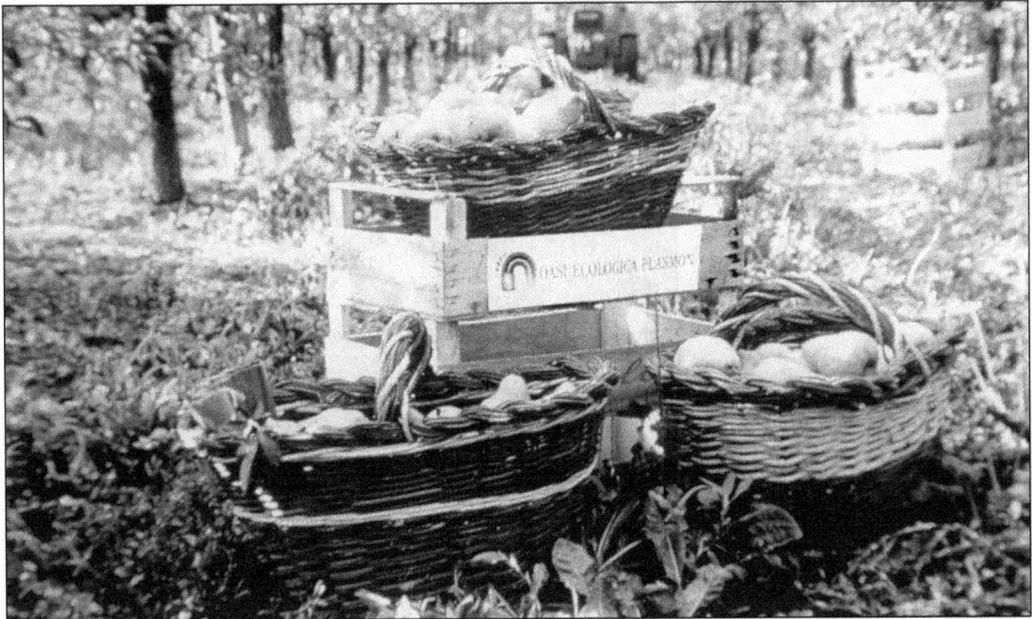

Starting in the mid-1980s, the company assured parents of the purity of its products with *Oasi Ecologica* (or "environmental oasis"), a system for following ingredients from farm to factory. The wisdom of the program was confirmed following the Chernobyl nuclear incident in the Soviet Union when Italian parents trusted Plasmon-processed baby foods over fresh produce and dairy products.

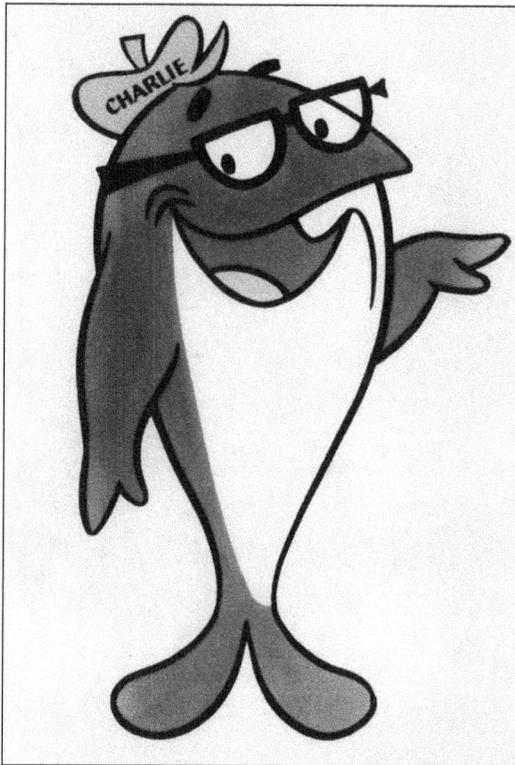

With the acquisition of StarKist Foods, Heinz gained two memorable and highly recognizable "spokes characters"—Charlie the Tuna and Morris the 9-Lives Cat. Charlie—born of a creative adman at the Leo Burnett agency in 1961—always heard the "Sorry, Charlie" line when rejected because "StarKist didn't want tuna with good taste; they wanted tuna that tastes good." Both Charlie and Morris moved on to Del Monte Foods in 2002 when Heinz spun off the seafood and pet food businesses, along with other product lines.

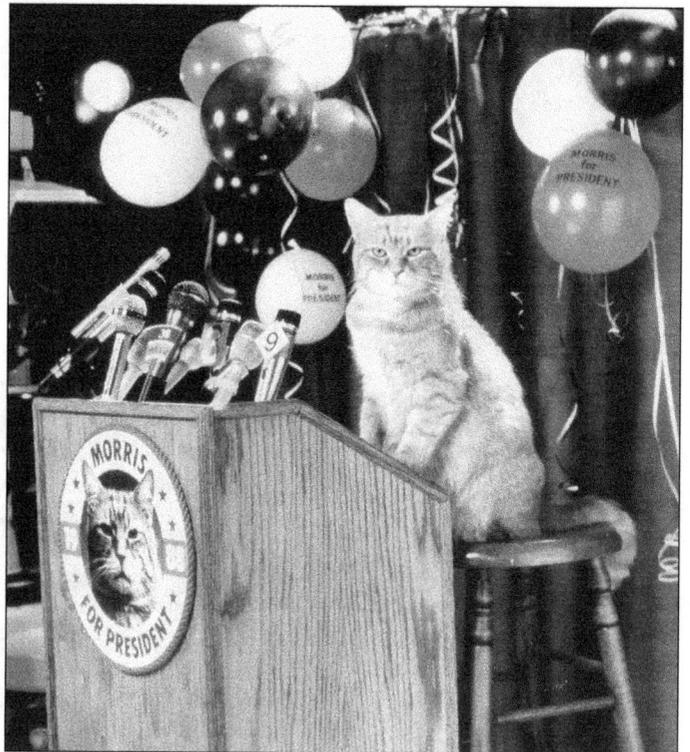

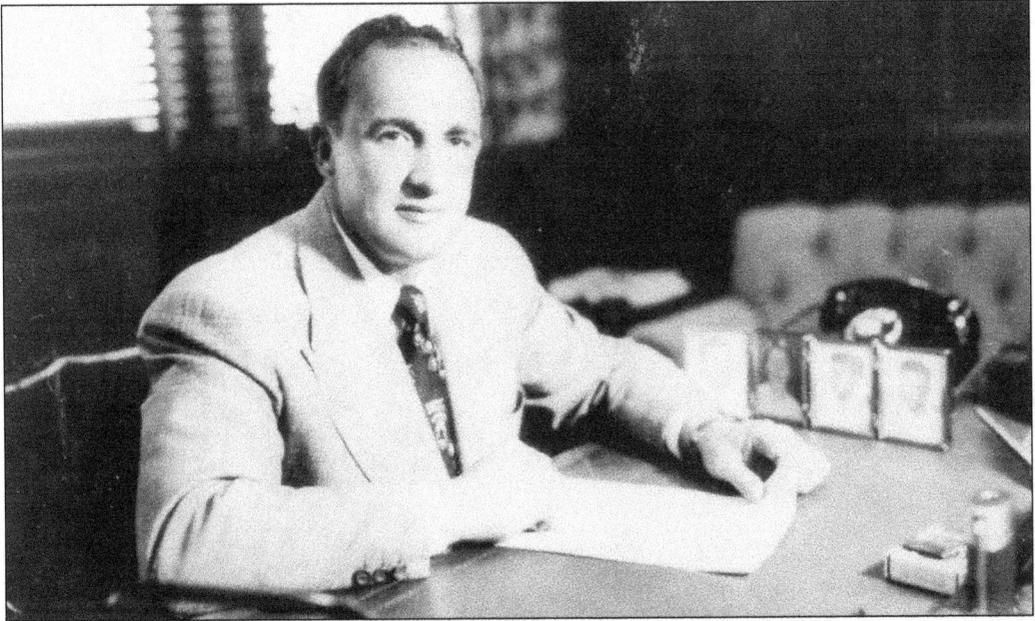

Joe Bogdanovich headed the StarKist enterprise and became a member of the Heinz board, eventually serving as its vice chairman.

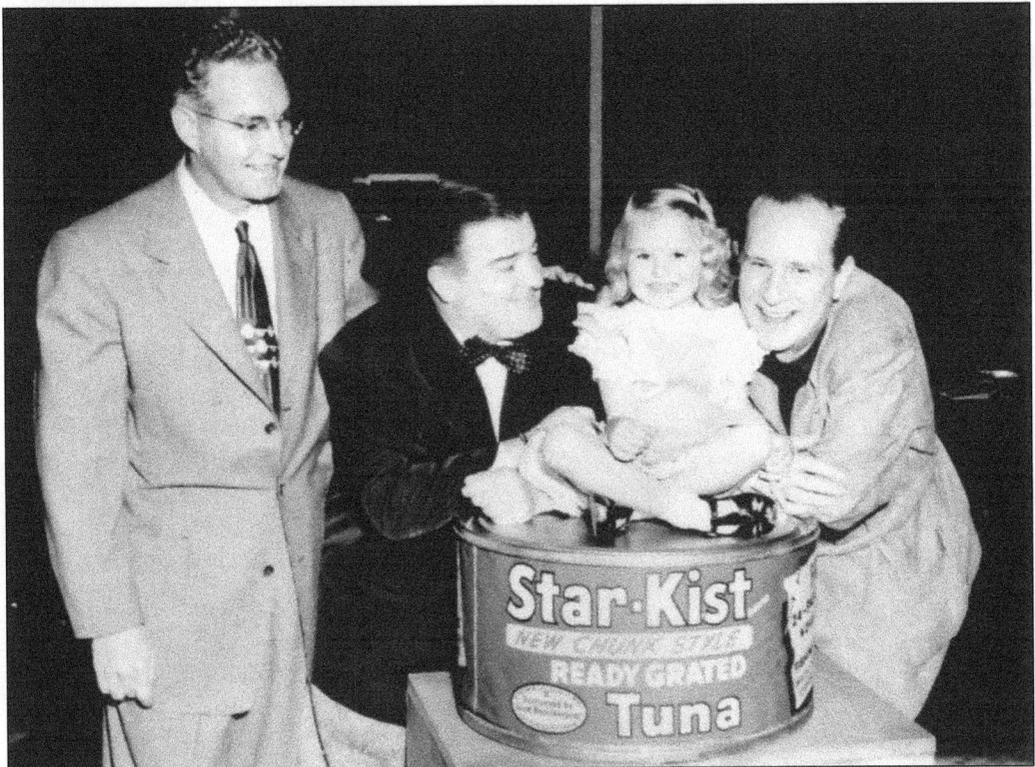

StarKist built its brands on celebrity endorsements under a Tuna of the Stars campaign and many publicity stunts staged by sales manager Jerry Scharer (left). Among StarKist's favorite Hollywood actors were Abbott and Costello.

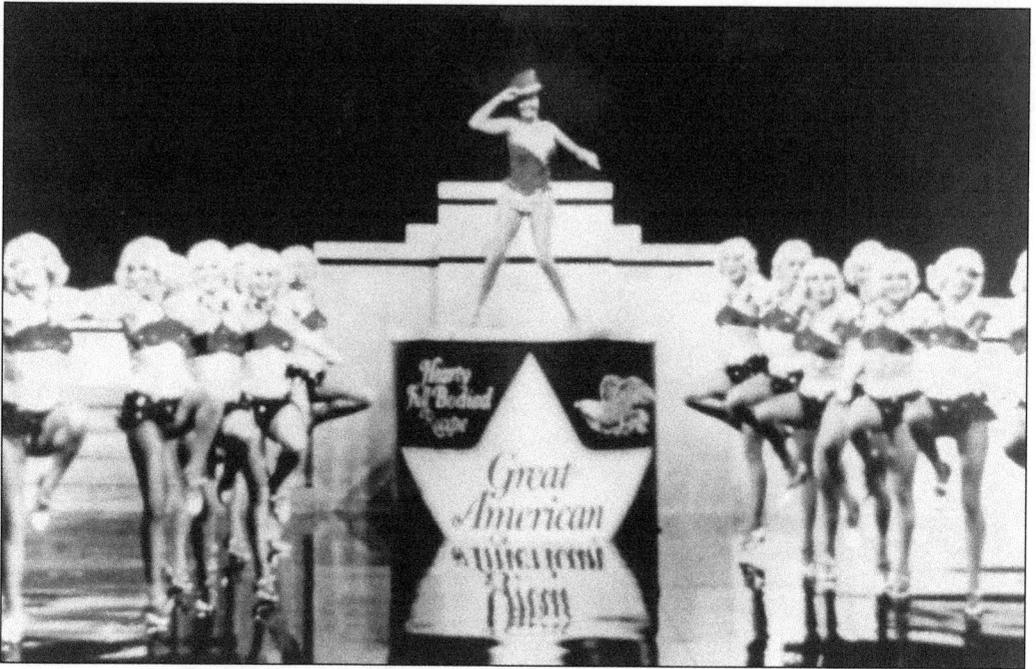

In 1970, Ann Miller danced atop a Great American soup can to promote a new upscale product line. Producer Stan Freeberg conceived this technically complex television advertisement, which involved a huge can rising from the floor and a large cast of energetic tap dancers. At the time, it was deemed the most expensive television spot ever made. Despite the campaign and excellent recipes, Great American soup never caught on and was discontinued as a retail product.

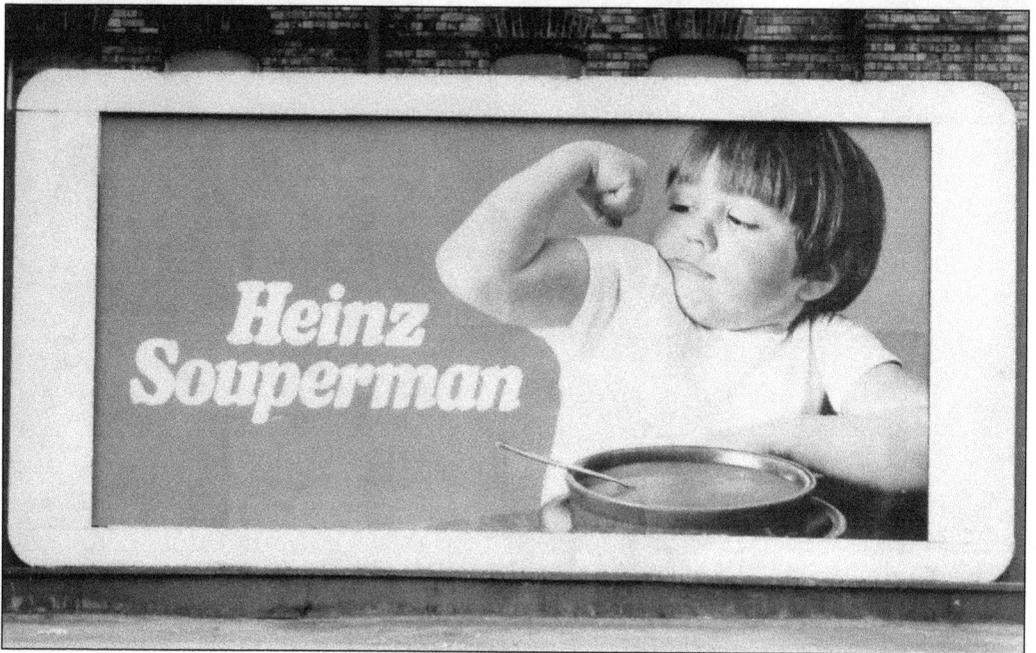

In the United Kingdom, Heinz soups became favorites thanks to inventive recipes and popular advertising, such as the "Souperman" campaign.

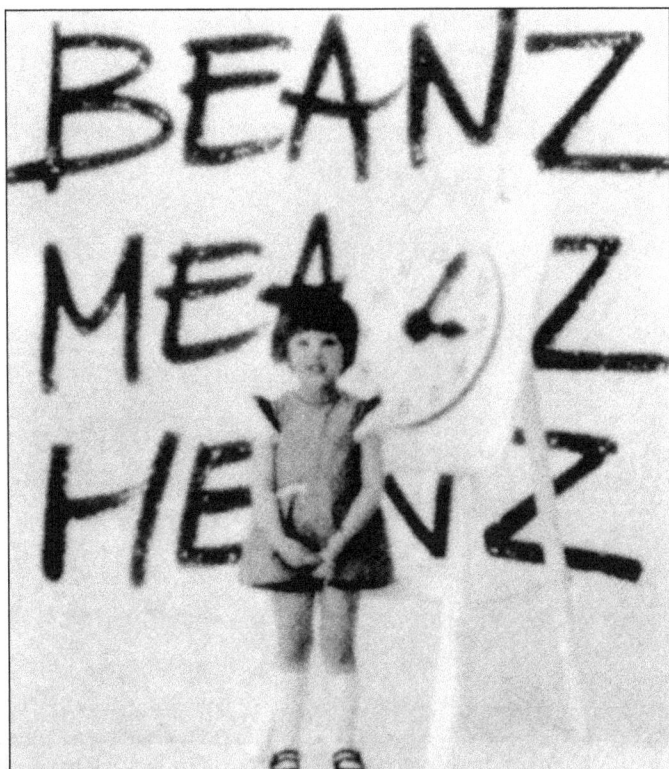

Heinz U.K. made beans popular and trendy with its memorable television advertisement and jingle, "A million housewives every day open a can of beans and say Beanz Meanz Heinz." First used in the early 1970s, the phrase continues today with many variations.

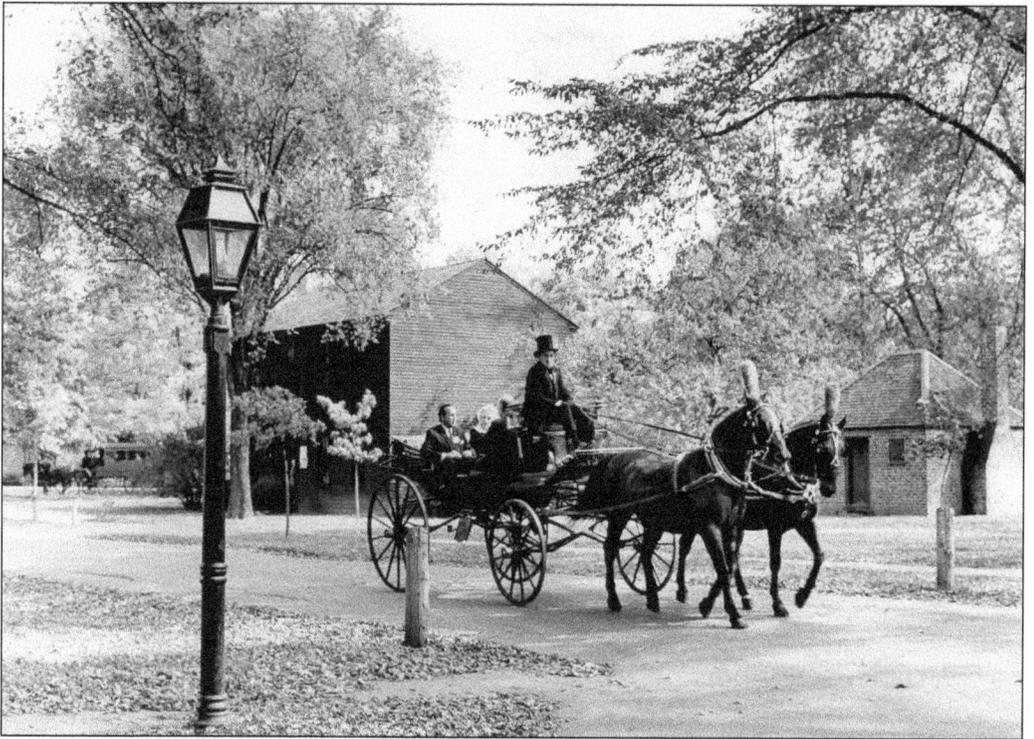

Heinz's board of directors, headed by chairman Jack Heinz and his aunt Vira Heinz (in carriage), marked the company's 100th anniversary with a gala return visit to the House Where We Began. By this time, the home had been relocated and refurbished at Greenfield Village in Dearborn, Michigan. It was moved there in 1954.

At the Pittsburgh factory, 1960s modernism and styles were on display for consumers who checked in at the visitor's center (right) for a factory tour conducted by well-groomed guides. The tours were discontinued in 1972 as operations became more mechanized and safety regulations tightened.

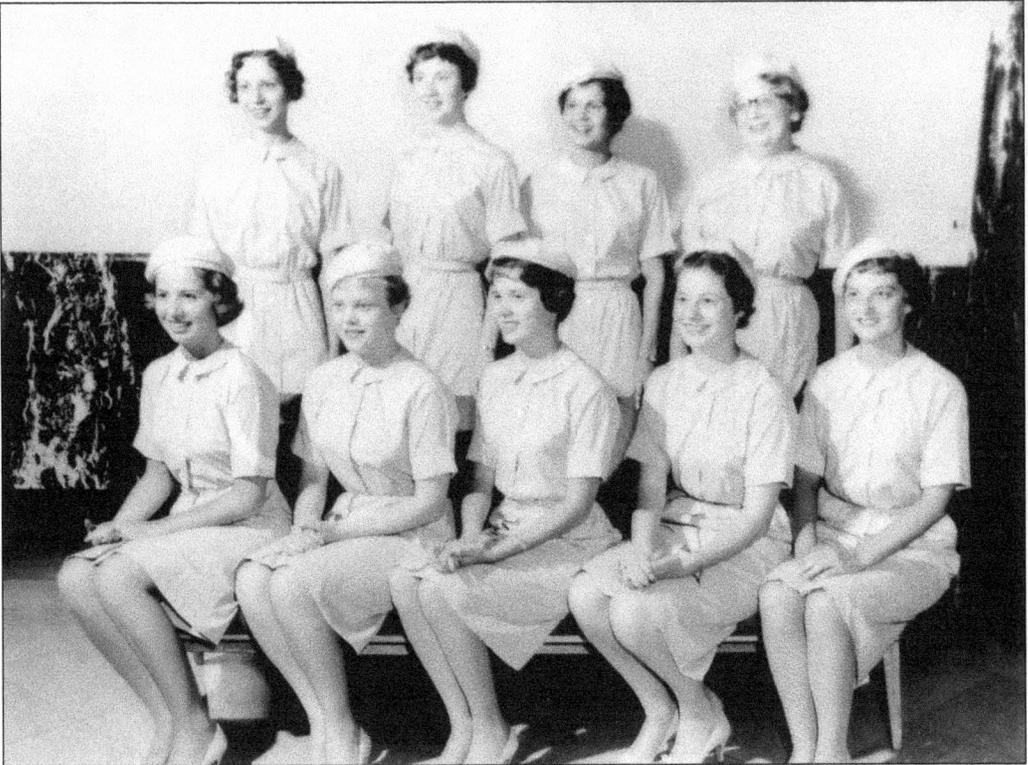

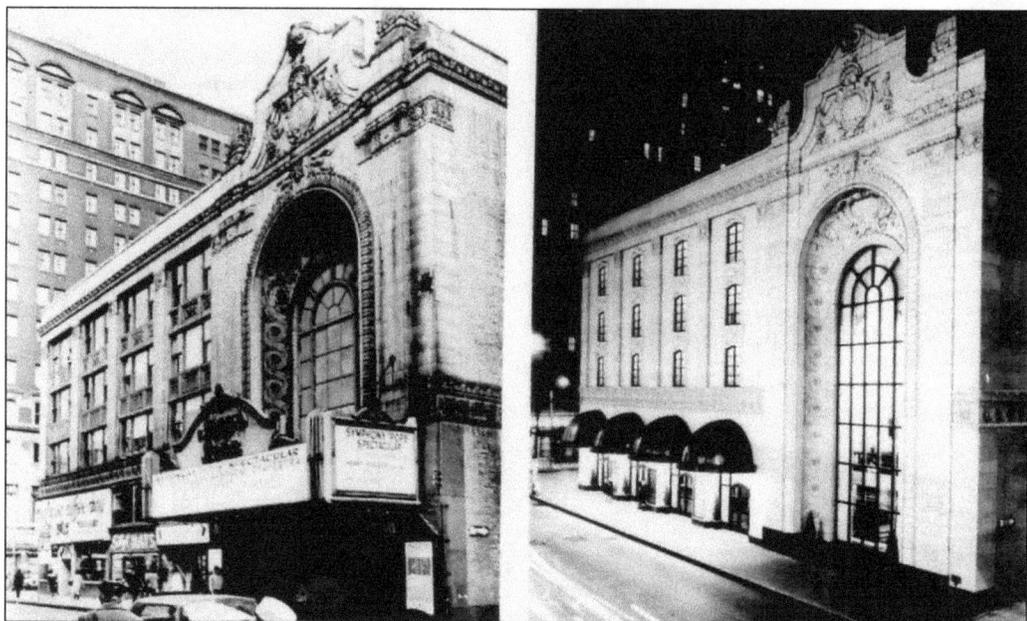

Under the watchful eye of Jack Heinz, the old Penn Theatre was renewed, restored, and reinvigorated. His charitable trusts—led by the Howard Heinz Endowment—purchased the building and underwrote its remodeling costs.

Jack Heinz was a leading patron of the arts and an architect of Pittsburgh's Renaissance, which turned a dilapidated downtown into the "Golden Triangle." Today he is still credited with fathering the city's Cultural District, which has at its heart Heinz Hall for the Performing Arts. He and his wife, Drue, attended the opening performance in 1971.

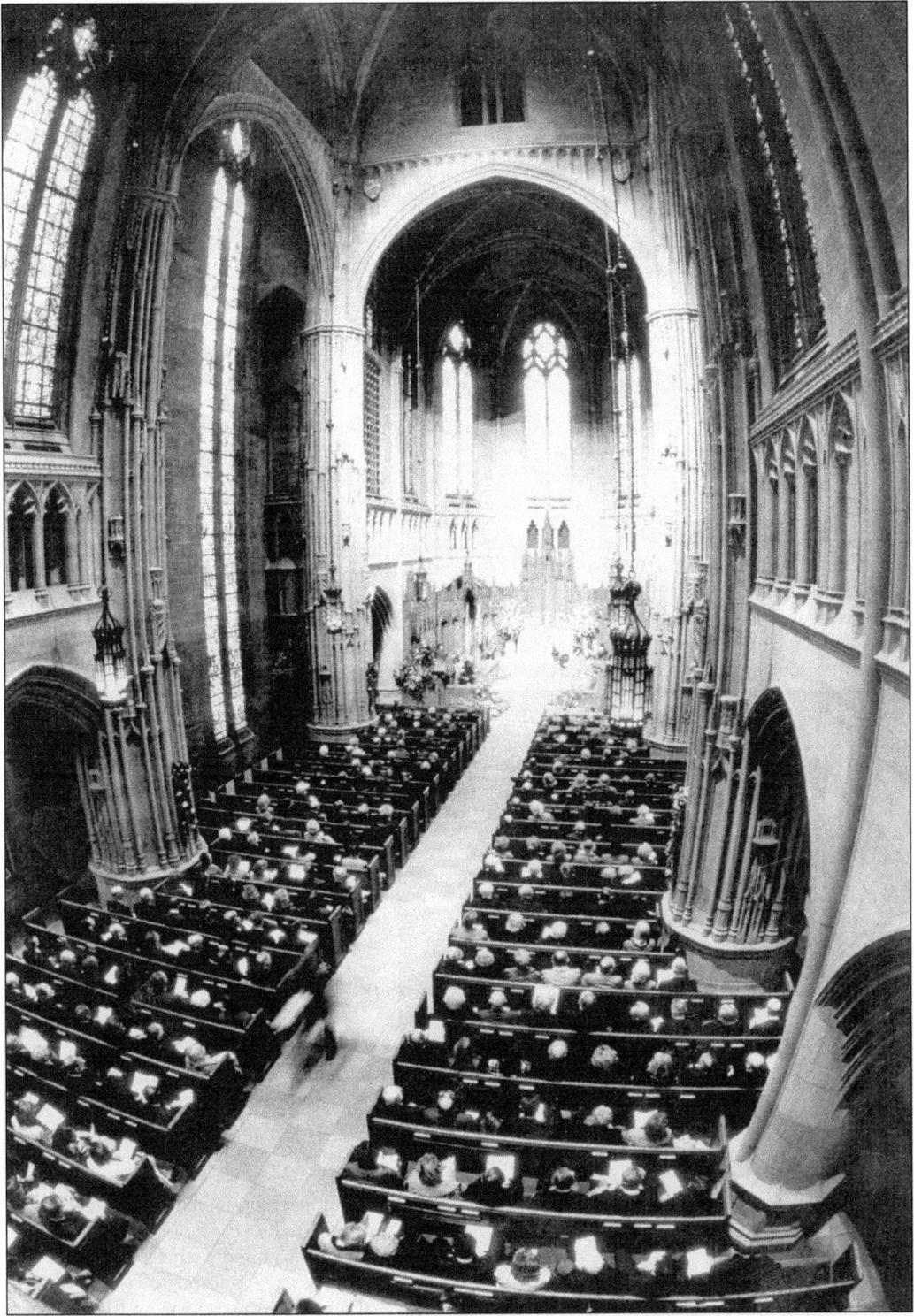

Hundreds of mourners attended the 1987 memorial service at Heinz Chapel for Jack Heinz. Four years later, it was the scene of the funeral for Sen. John Heinz.

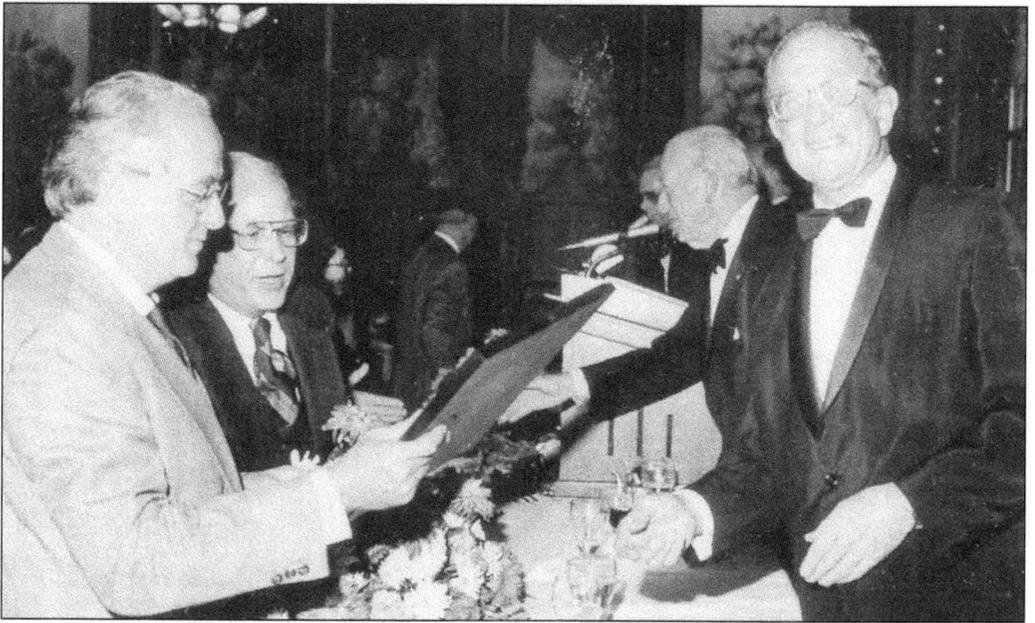

Burt Gookin (right) received Pittsburgh's 1976 Man of the Year award in recognition of his many civic contributions. With him are S. Donald Wiley (left), general counsel, and Tom McIntosh, vice president of public relations. McIntosh upgraded and transformed the company's image through beautifully designed and crafted annual reports, films, media outreach programs, and elegant presentations to security analysts at the Four Seasons restaurant in New York.

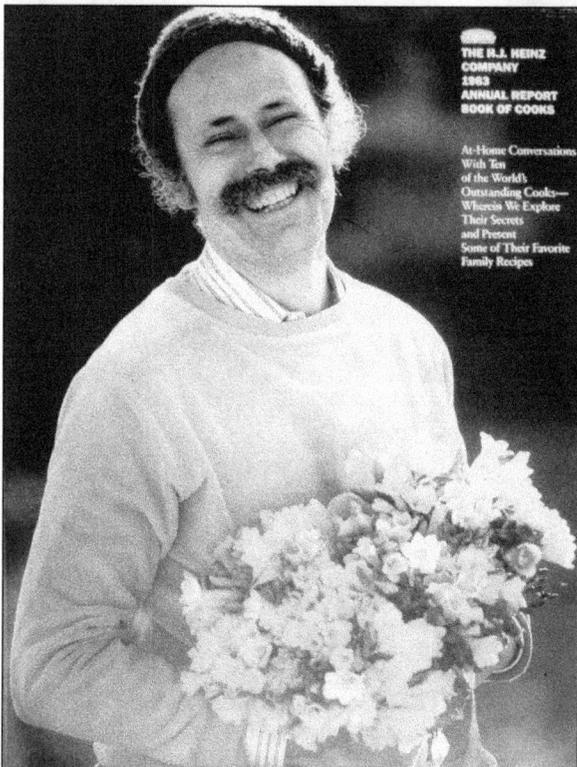

Heinz's sophisticated annual reports garnered investor attention and numerous design awards. Bennett Robinson, a noted New York artist, created the company's publications for more than 20 years. This 1983 report included *The Book of Cooks*, which was filled with recipes and interviews. The report was introduced at a gourmet reception in Manhattan attended by the likes of legendary chef James Beard.

Six

GLOBAL EXPANSION

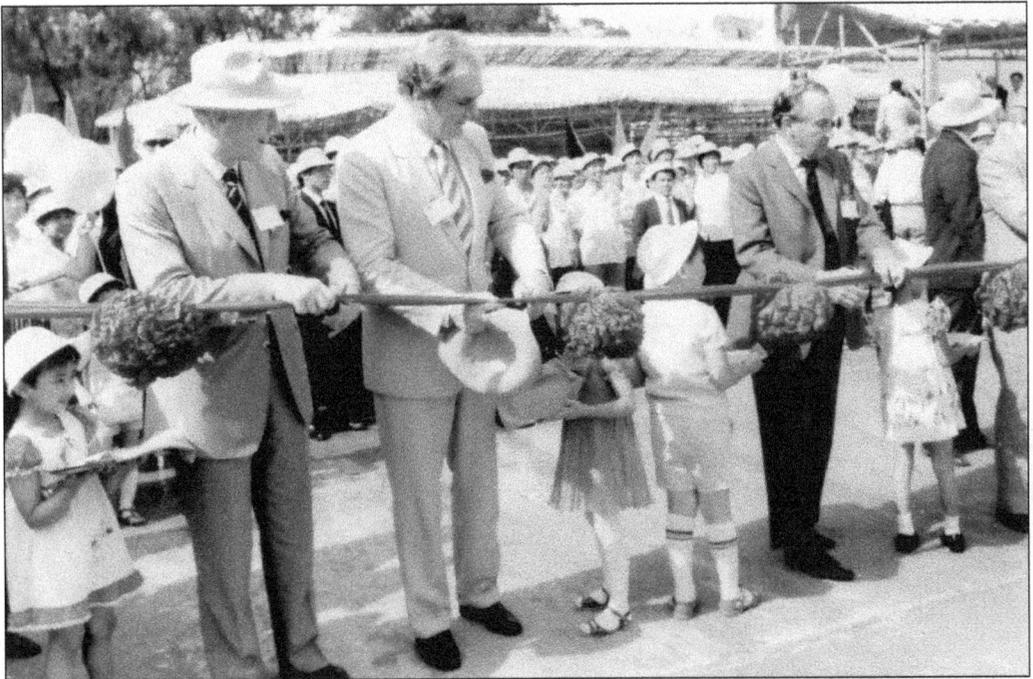

Jack Heinz (right) marked the 1986 opening of the company's plant at Guangdong, China, with an address on infant nutrition and research. He participated in traditional ribbon-cutting ceremonies with Anthony J. F. (Tony) O'Reilly (center), recently appointed president and CEO, and Derek Finlay, senior vice president. The Chinese were delighted to meet the man whose name appeared on the new factory building. The first products off the line were iron-fortified infant cereals, specially designed to meet the needs of Chinese infants. It was among Jack Heinz's final company trips, as he passed away seven months later in February 1987.

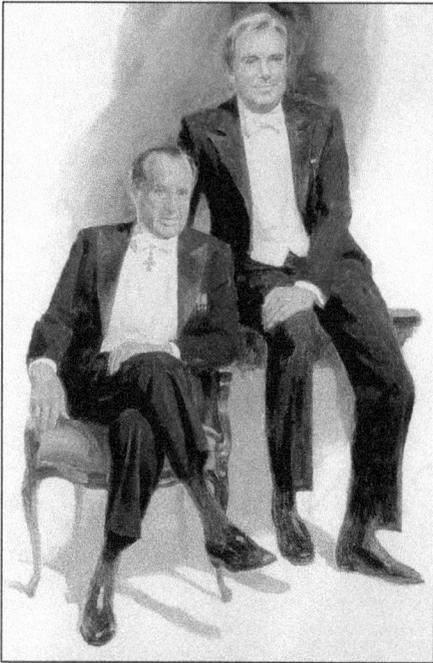

As Heinz expanded into more emerging markets, it celebrated the centenary of its British affiliate with pomp and pageantry. A lavish dinner commemorated the founder's first sale to Fortnum and Mason. It was held at the Mansion House, official residence of the lord mayor of London. Both Jack Heinz and Tony O'Reilly, then company president, hosted the gala.

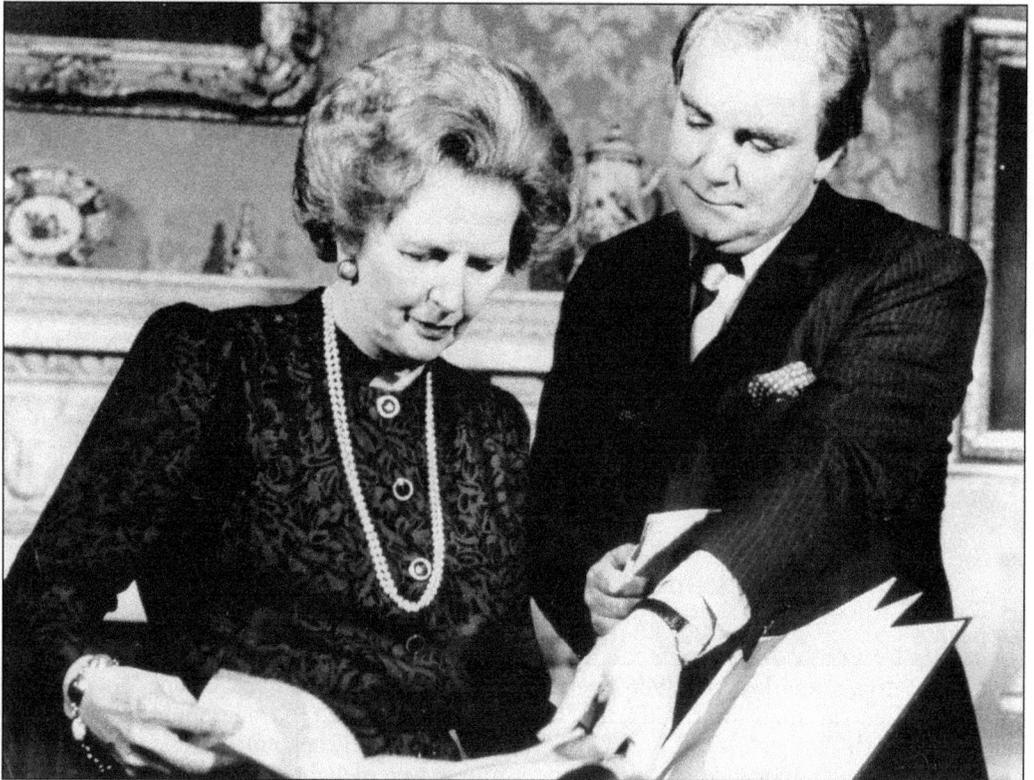

The second event took place at Downing Street, where Tony O'Reilly presented to Prime Minister Margaret Thatcher the deed to Cape Cornwell, a nature preserve that the company purchased. She immediately turned it over to the National Trust.

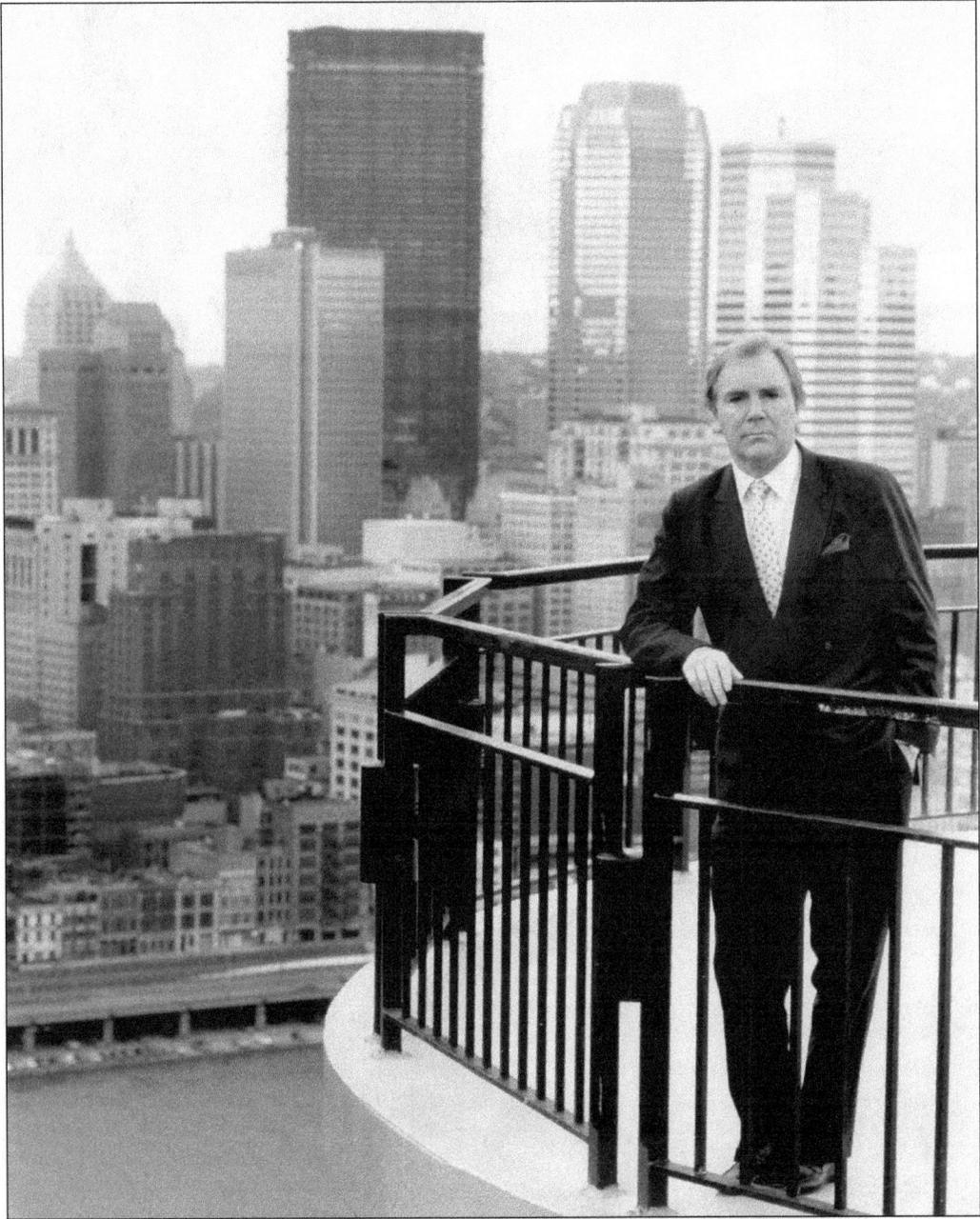

Tony O'Reilly, a native of Dublin, Ireland, became the first non–Heinz family member to become chairman when he succeeded Jack Heinz. He simultaneously held the additional titles of president and CEO. A world-class athlete, he was an all-star international rugby star and earned a doctorate in agricultural marketing. O'Reilly came to the attention of Burt Gookin, then CEO, while running the Irish Dairy Board. Gookin hired him in 1969 to head Heinz U.K. and, in 1972, moved him to Heinz World Headquarters, now located on the 59th and 60th floors of Pittsburgh's tallest skyscraper, the U.S. Steel Building, seen in the background. O'Reilly was knighted by Queen Elizabeth in 2001 in recognition of his work with The Ireland Funds, which further peace and culture.

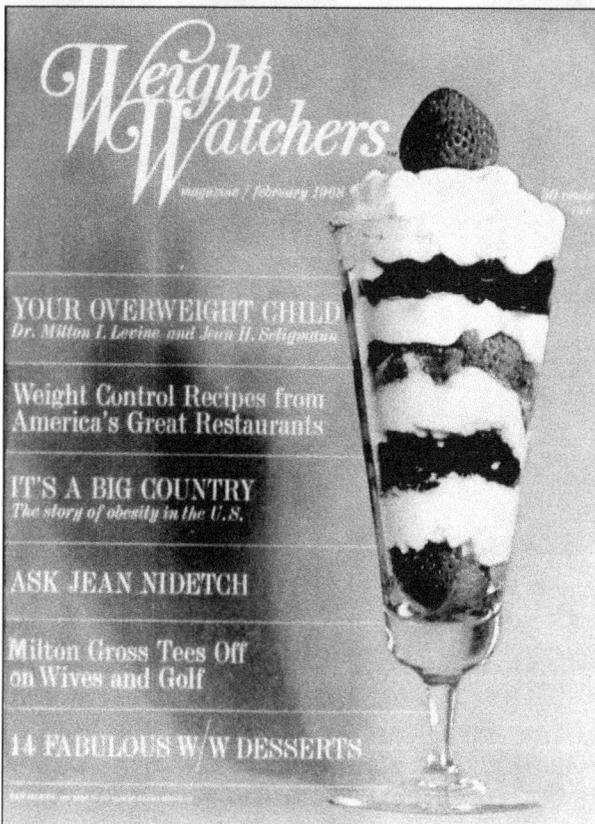

Tony O'Reilly took Heinz into new directions with the 1978 acquisition of Weight Watchers International and associated companies that made or licensed Weight Watchers brand foods and other products, including a publishing house. Al and Felice Lippert (above) cofounded the profitable meeting room business with Jean Nidetch. Food sales continued to grow, and Heinz rolled out additional great-tasting and nutritious products, including those unveiled at a black-tie party at a Manhattan automat. Heinz sold the Weight Watchers classroom business in 1999, but Weight Watchers Smart One frozen entrees and desserts have grown rapidly to become one of the company's top brands.

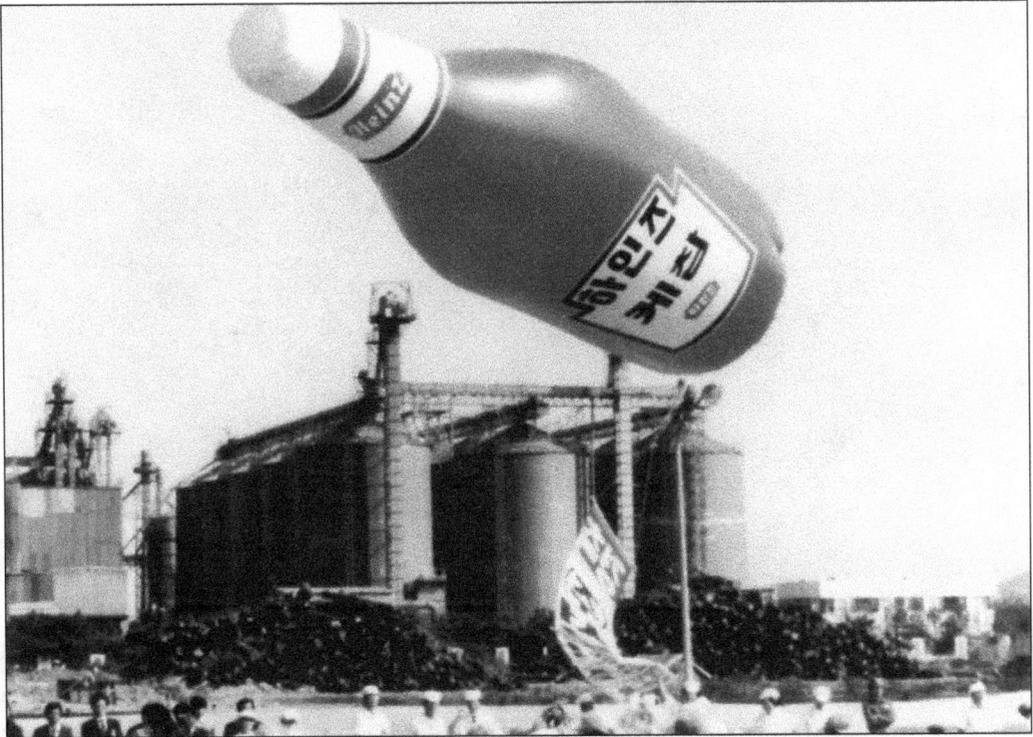

Tony O'Reilly ventured into many evolving markets from Zimbabwe to Thailand to Botswana to India. Contract signings and factory openings proved to be colorful events rooted in local traditions. One such affair was the grand opening of the Seoul Heinz factory and headquarters complex at Inchon. Today Heinz concentrates its emerging markets strategy on Russia, India, China, Indonesia, and Poland.

Heinz opened its first Russian factory in 1996, two years after it began selling products there. But the relationship between Heinz and Russia began many years earlier. In 1983, a 51-year-old Russian and the youngest member of the politburo visited the company's Leamington, Ontario, factory. Mikhail Gorbachev (left), who went on to lead the Soviet Union, was accompanied on the tour by former Canadian minister of agriculture Eugene Whelan.

H. John Heinz III died tragically, at age 53, in an airplane accident in April 1991 near Philadelphia. He was the great-grandson of the founder and son of Jack Heinz. John Heinz was active in state and national politics and served in a number of elected positions. In 1976, he was elected to the United States Senate. His only direct involvement with the company was as a product manager at Heinz U.S.A. in the mid-1960s. Politics and public service were a powerful draw, and he left the House of Heinz to further his advocacy for the underprivileged and disadvantaged and the environment. His campaigns were endorsed by Heinz workers.

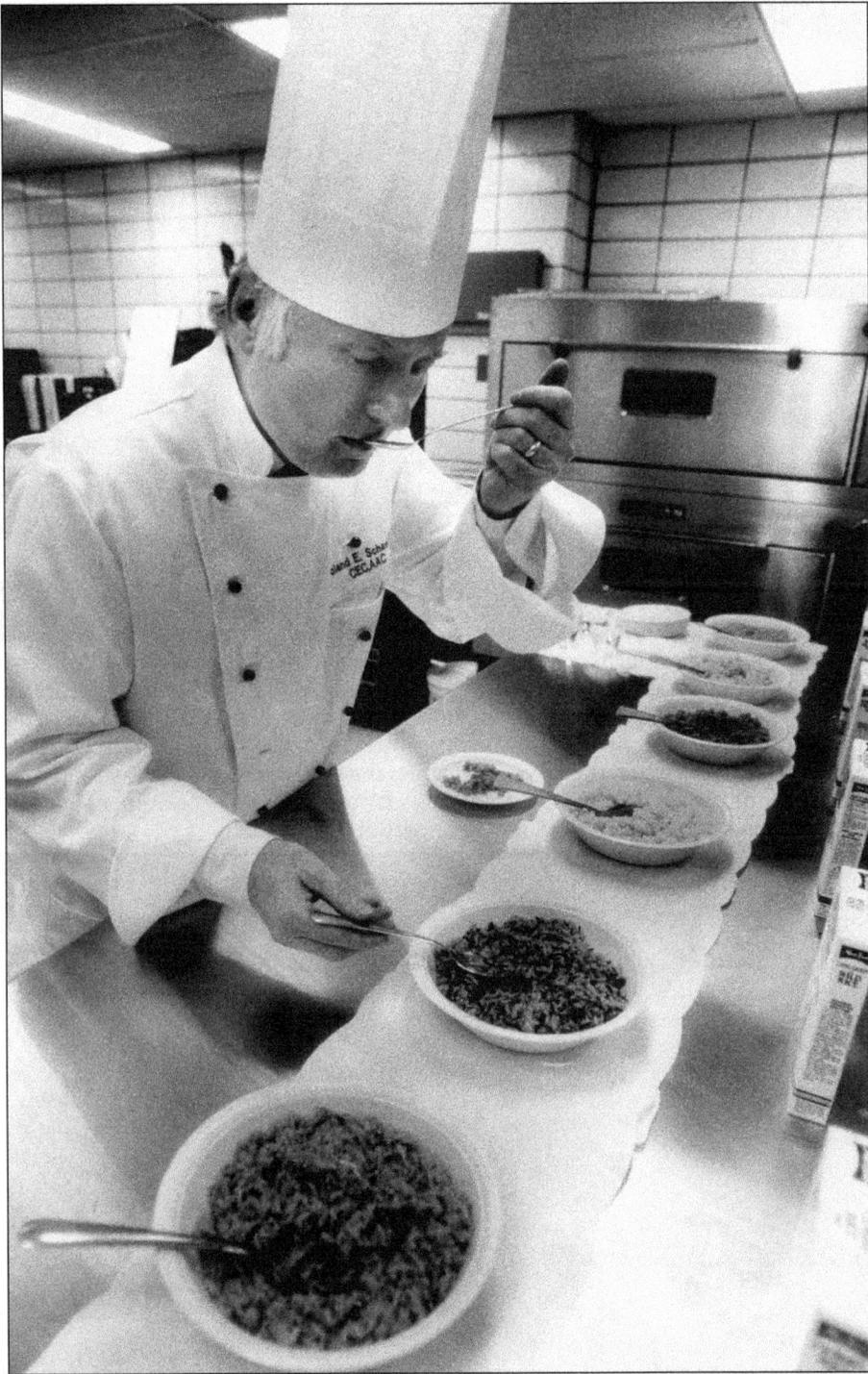

Heinz chefs made national headlines as gold-medal winners on the U.S. Culinary Olympics teams during the 1970s through 1990s. Heinz U.S.A. experimental chef Roland Schaeffer was a frequent team member and coach. Schaeffer also was named 1991 Chef of the Year by the American Culinary Federation.

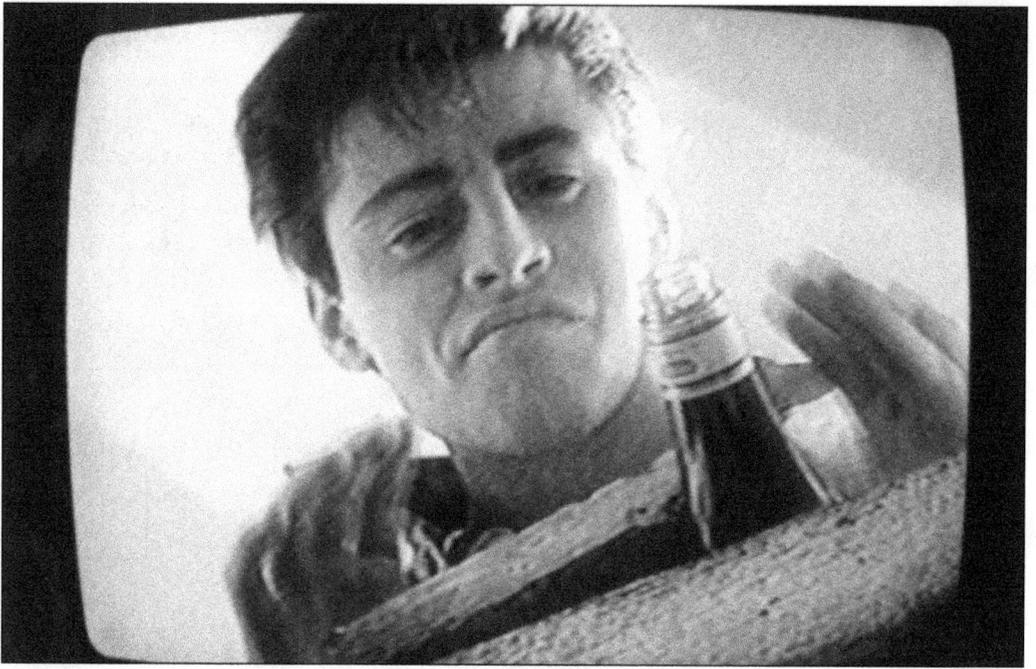

For baby boomers, the most memorable Heinz advertisement of all time might be "Anticipation," which emphasized the slow, thick goodness of Heinz Ketchup and featured the work of chart-topping songwriter Carly Simon. For those a bit younger, it is "Rooftop," a slice-of-life spot in which a young man balances a ketchup bottle on a roof ledge, runs down the stairs, purchases a hot dog from a street vendor, and catches the slow-pouring ketchup just in time. The spot—which Heinz translated into many languages for use worldwide—featured Matt LeBlanc, who went on to garner television stardom in the network hit *Friends*.

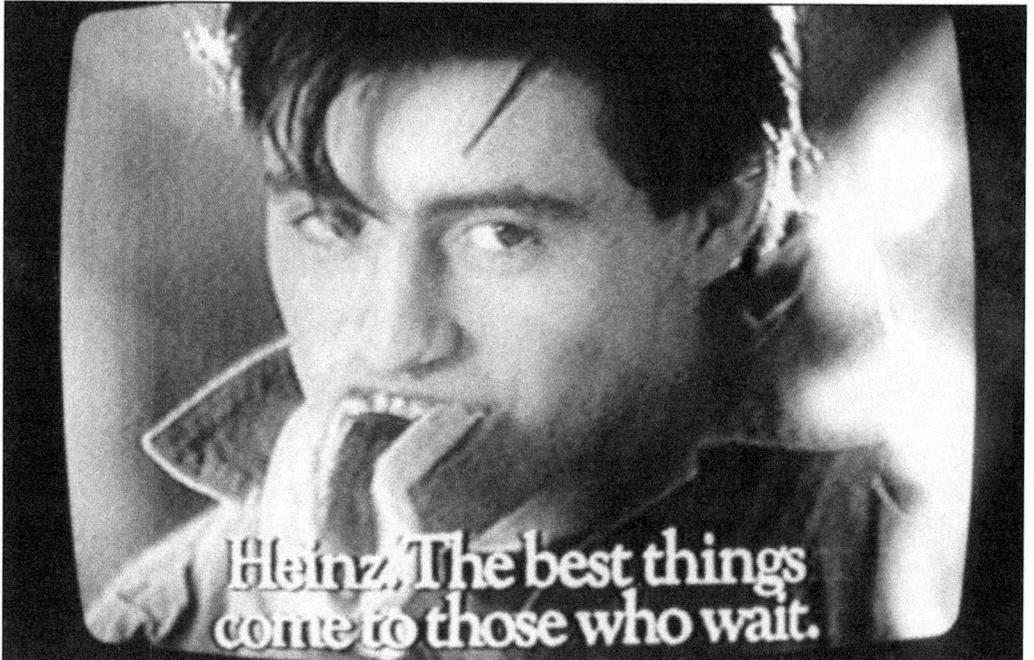

Heinz. The best things come to those who wait.

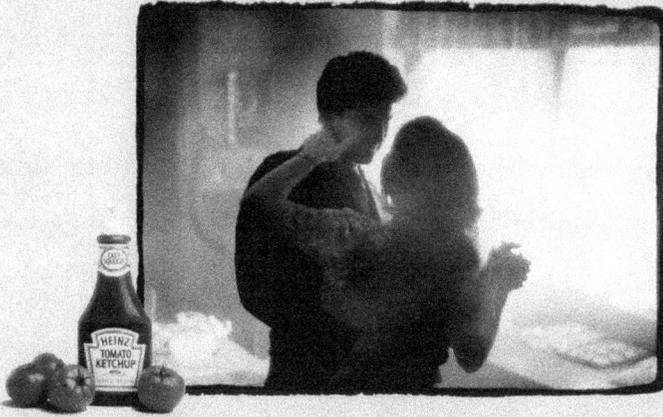

"As Long As There's Been Slow Dancing"

"There's Been Slow Heinz"

"Slowness" continued to be a virtue, even after the company, in 1983, introduced the squeezable plastic bottle to help consumers speed up the wait. This advertising series won a Silver Lion at the Cannes Film Festival.

Heinz U.S.A.'s burgeoning "foodservice" business broadly expanded its array of ketchup packaging. Large Vol-Pak varieties offered operators easy-to-handle and quick-to-open bags. Another clever new alternative was the elegant 2.5-ounce room service size, perfect for premium restaurants and hotels.

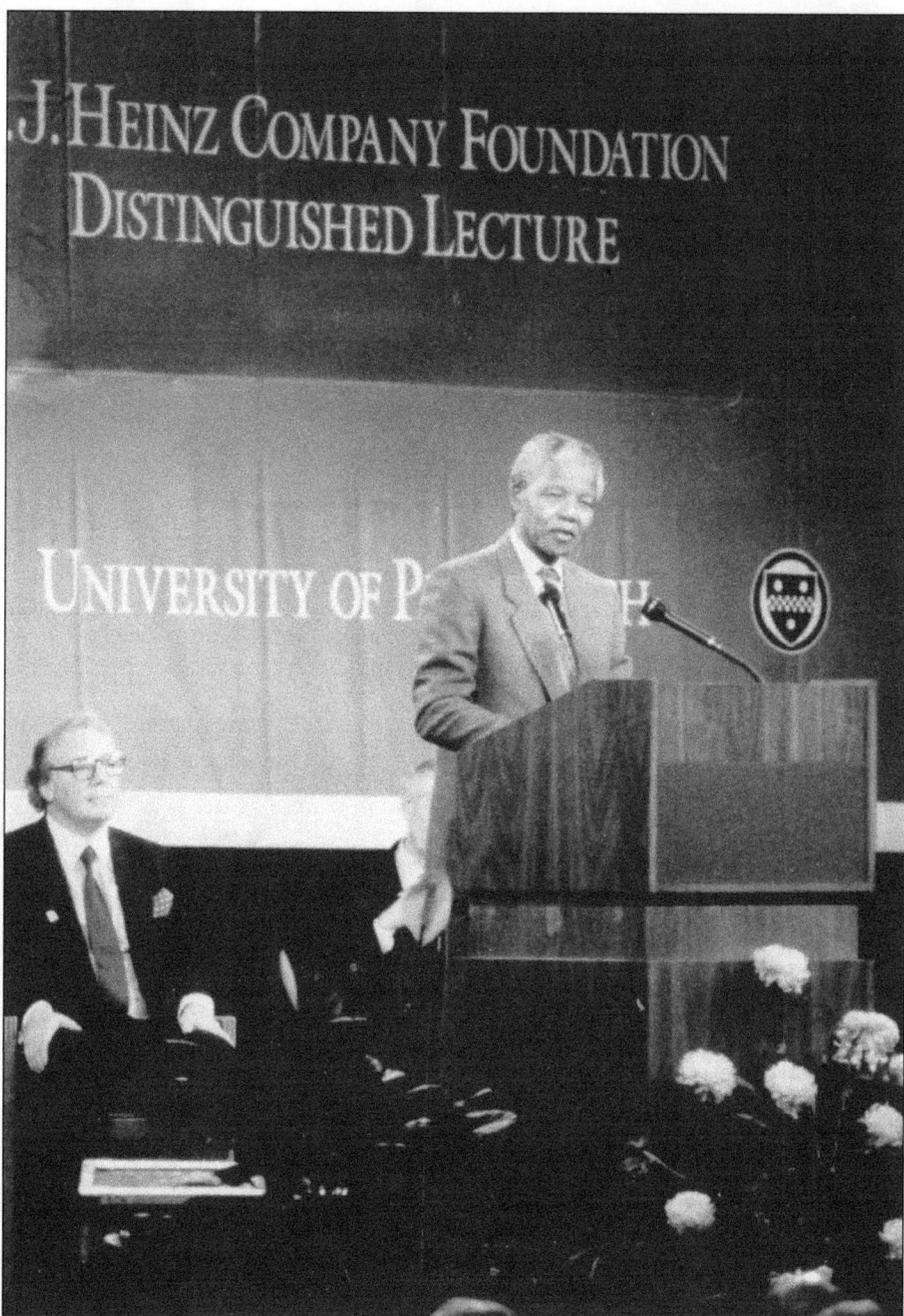

H.J. Heinz Company Foundation sponsored a series of distinguished lectures at the University of Pittsburgh with outstanding speakers of international stature. Among them were former secretary of state Henry Kissinger, French president Valery Giscard d'Estaing, and German chancellor Helmut Schmidt. Perhaps most memorable was the 1991 presentation by Nelson Mandela, then president of the African National Congress. It was only Mandela's second visit to the United States and his first time to address a business audience. An invitation-only crowd packed Pittsburgh's Soldiers and Sailors Memorial Hall. The lecture was carried live via Voice of America and various radio and television stations.

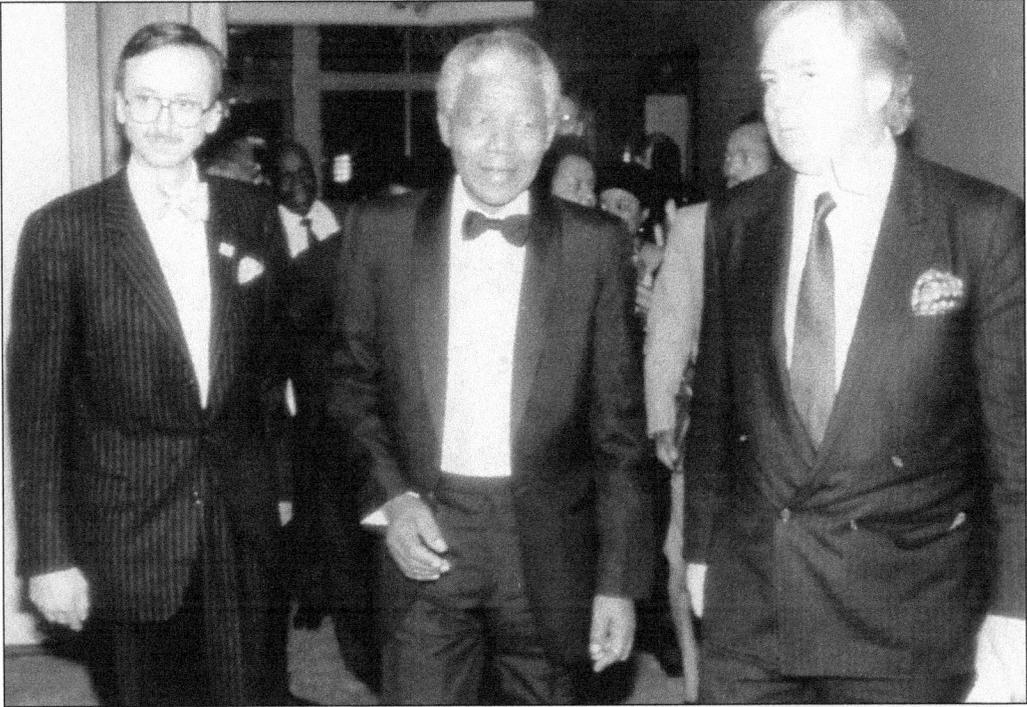

Nelson Mandela (center) also was feted at a formal dinner in Pittsburgh. It was hosted by Tony O'Reilly (right). Many of the arrangements for the visit were made by Ted Smyth, now Heinz's senior vice president of corporate and government affairs and chief administrative officer.

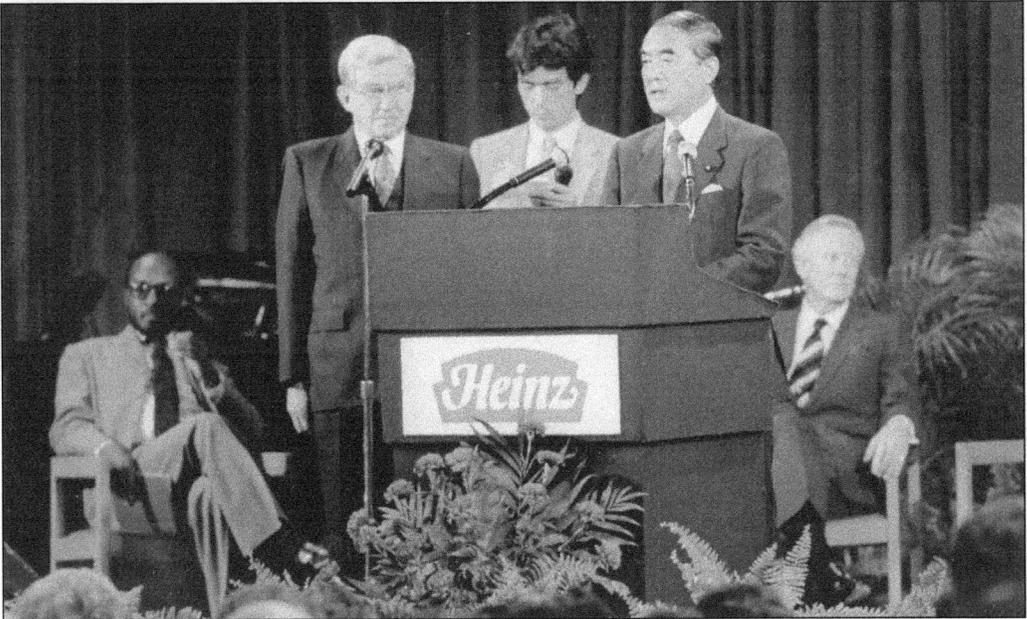

Japanese prime minister Yasuhiro Nakasone (second from right) offered the distinguished lecture in 1988. He was aided by his interpreter (center) during the question-and-answer period. University of Pittsburgh president Wesley W. Posvar (second from left) and Heinz senior vice president R. Derek Finlay introduced Nakasone to local leaders.

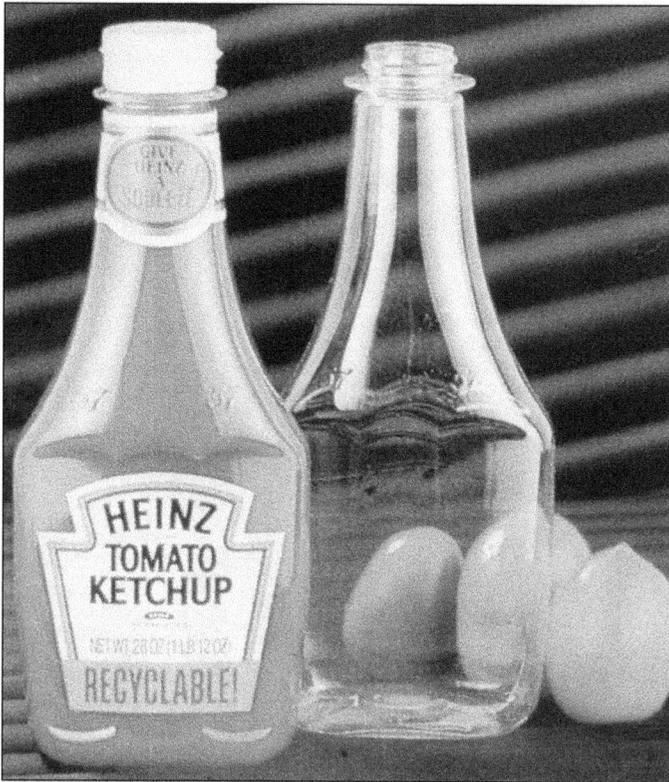

Heinz, in the spring of 1990, earned praise for two significant environmental initiatives announced the same week. The first was the development of a recyclable plastic bottle for ketchup, which was the result of a multiyear, multimillion-dollar research program. Additionally Heinz became the very first company to adopt a worldwide policy to protect dolphins from death, injury, or harassment in association with tuna fishing. It was a landmark decision for the world's largest tuna canner. Environmentalists, consumers, and legislators all endorsed the move, which received international media coverage and was the top story on network newscasts.

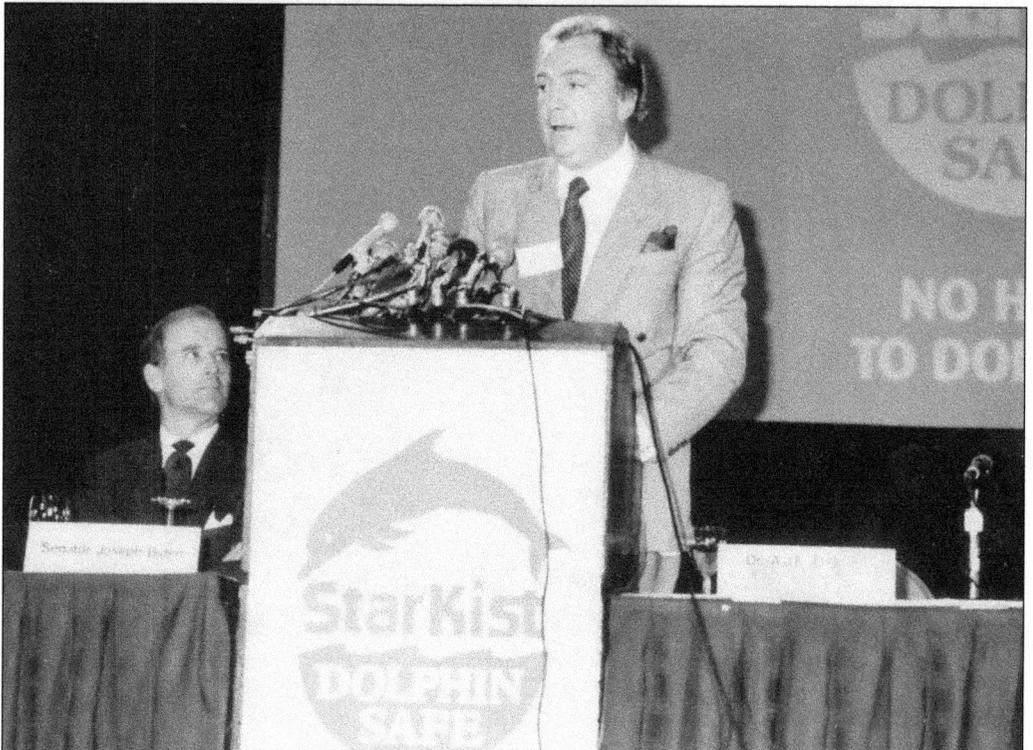

In 1992, Heinz purchased Wattie's, the most recognized brand in New Zealand. The $300 million transaction was the largest overseas acquisition the company had ever made. As a result of its addition to the Heinz portfolio, U.S. and combined foreign units stood roughly equal in sales for the first time. Wattie's operated 15 factories and was a leader in the Southern Hemisphere.

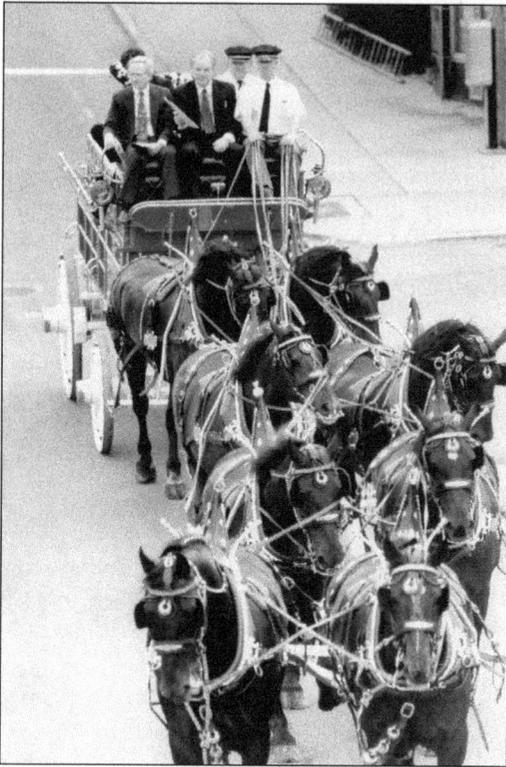

To mark the company's 125th anniversary, the Heinz Hitch carried Pittsburgh mayor Tom Murphy (left) and Tony O'Reilly from the Heinz World Headquarters in downtown Pittsburgh to ceremonies at the original manufacturing complex on the city's North Side. Also aboard were Andre Heinz (partially shielded from view), great-great-grandson of the founder. Driving the hitch is Bryan Craig, accompanied by hitch general manager John Dryer.

During the 125th anniversary employee celebration, Tony O'Reilly and retired CEO Burt Gookin placed memorabilia in a time capsule that was sealed in the cornerstone of the Service Building. It was a gesture similar to that of Howard Heinz when the building was constructed.

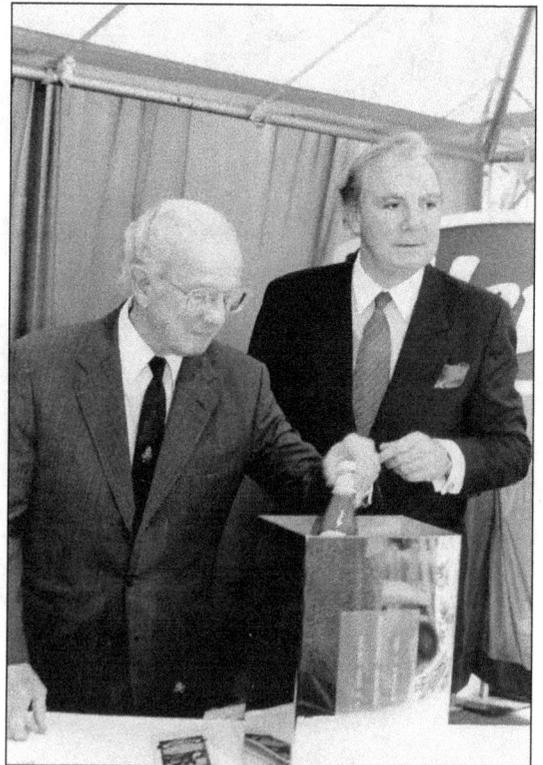

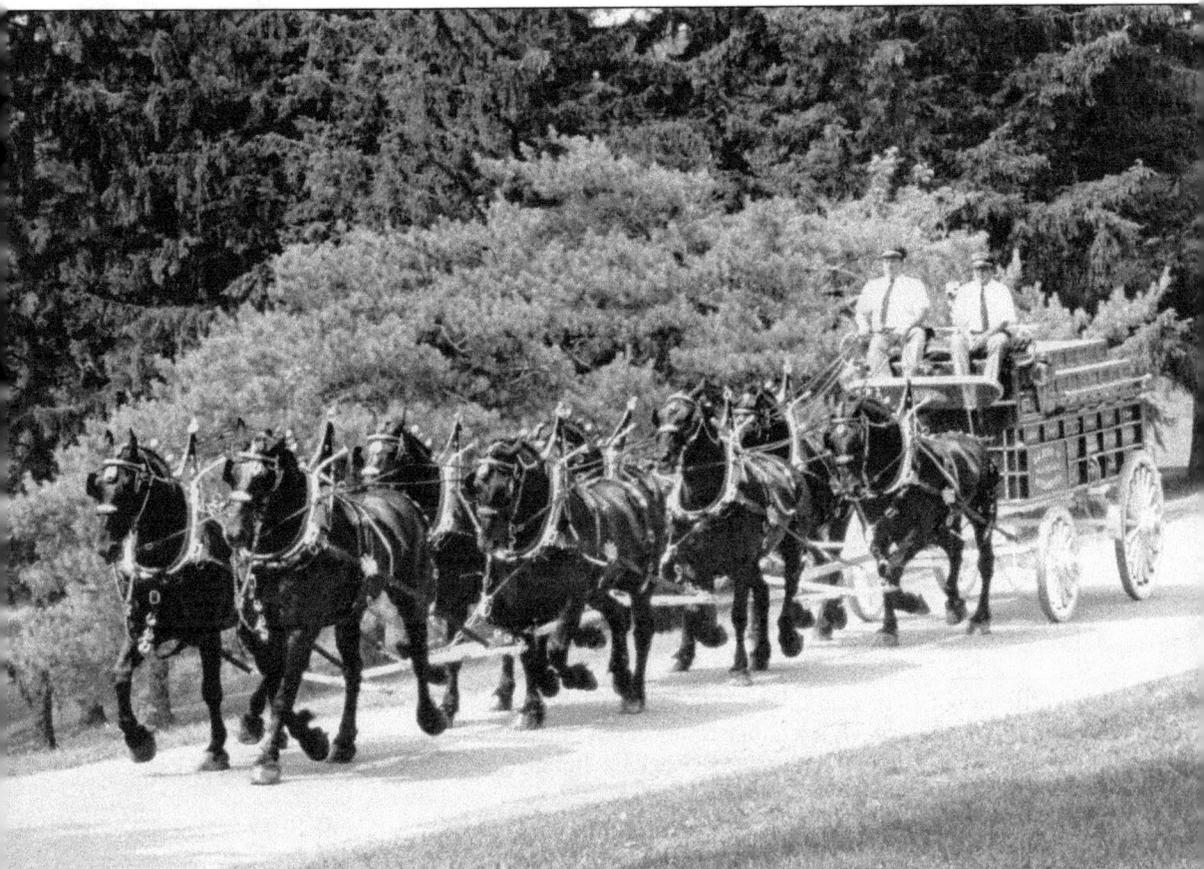

The Heinz Hitch, which operated from 1986 to 2006, traveled roughly 5,700 miles a year and participated in parades, fairs, and festivals across North America. It was the brainchild of retired Heinz quality assurance executive John Dryer, who took up the reins as a retirement hobby. He called the hitch a "living history lesson" as it incorporated a large red Heinz delivery wagon and eight black Percherons, the same breed preferred by Henry Heinz.

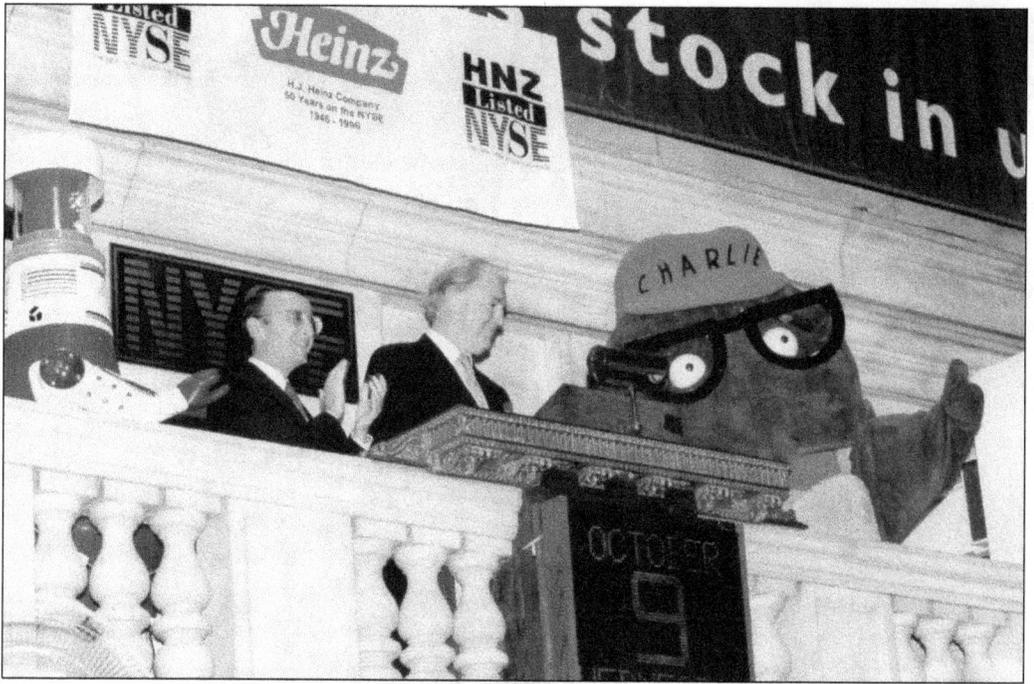

H.J.the Robot (left) and Charlie the Tuna (right) helped Tony O'Reilly ring the opening bell at the New York Stock Exchange to mark the 50th anniversary of the company listing in 1996. Also on the podium was New York Stock Exchange executive Dick Grasso.

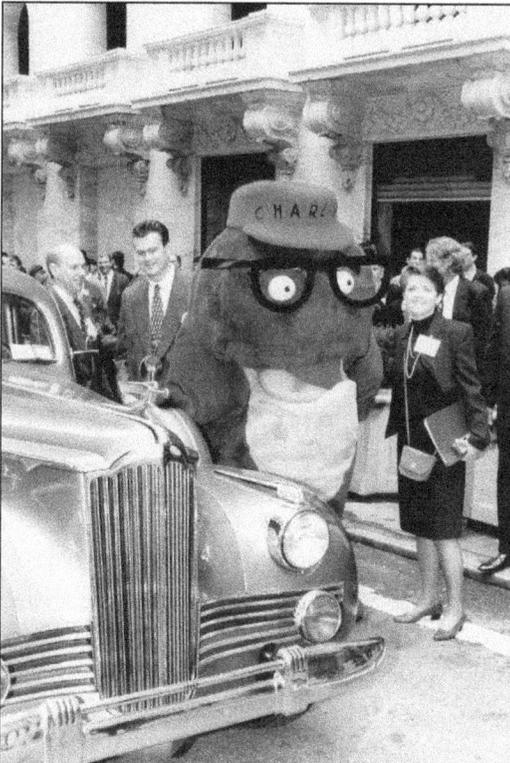

No strangers to arranging media briefings and special ceremonies, the Heinz Corporate Affairs Department orchestrated the New York Stock Exchange event, complete with a vintage Packard that delivered Heinz executives—and Charlie the Tuna— to Wall Street. The team included Jack Kennedy (left), director of strategic communications; Michael Mullen (center), director of global corporate affairs; and Debbie Foster, vice president of corporate communications.

During the summer of 1995, Pittsburgh's skyline welcomed a new landmark, a 42-foot-tall Heinz neon sign atop the Service Building. Nearly 30 seconds are required for the entire sequence of the sign to be completed, about the same amount of time it takes for a drop of Heinz Ketchup to pour from the bottle.

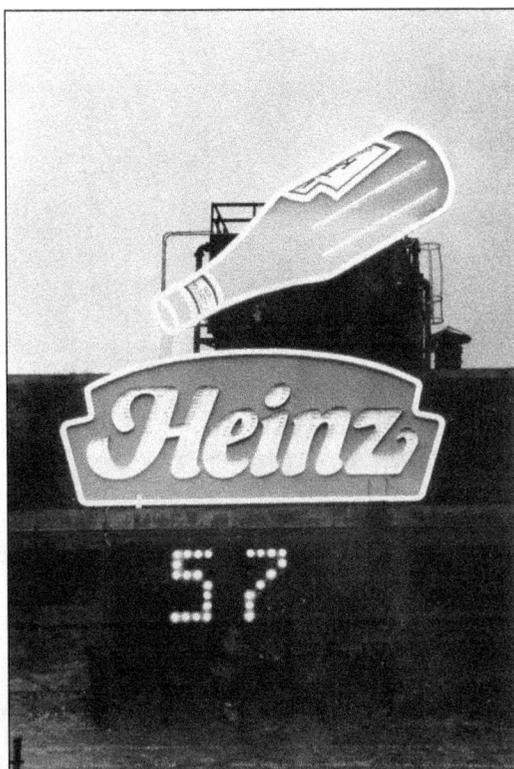

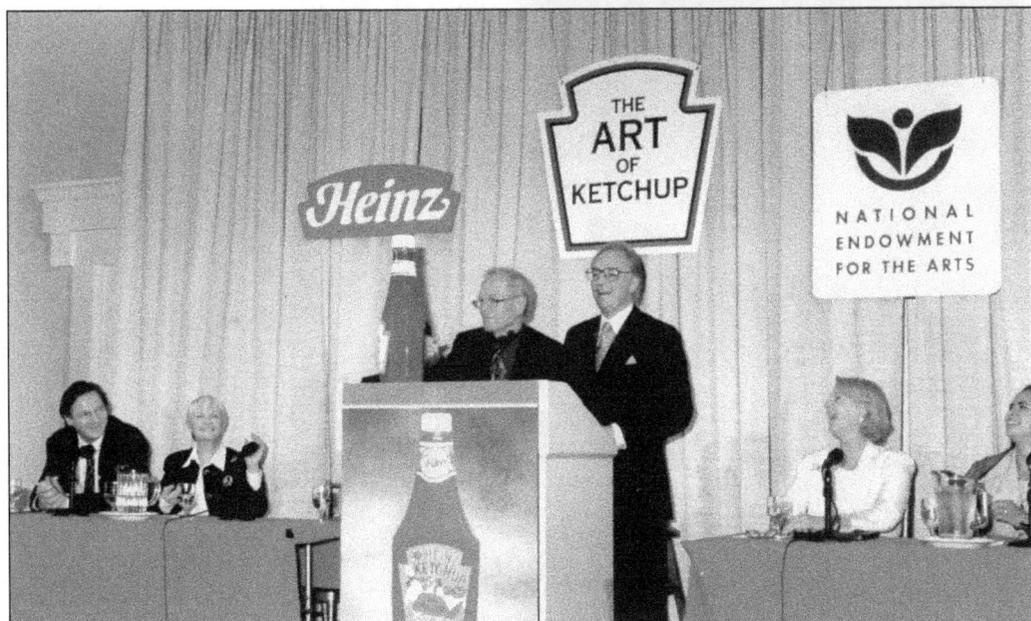

Charitable programs have remained front and center in Heinz marketing programs. One example was 1997's ArtSTART, a Heinz Ketchup promotion that provided more than $450,000 to the National Endowment for the Arts. Tony O'Reilly was congratulated by actors (from left to right) Liam Neeson, Joanne Woodward, and Paul Newman, National Endowment for the Arts chair Jane Alexander, and writer Esmerelda Santiago.

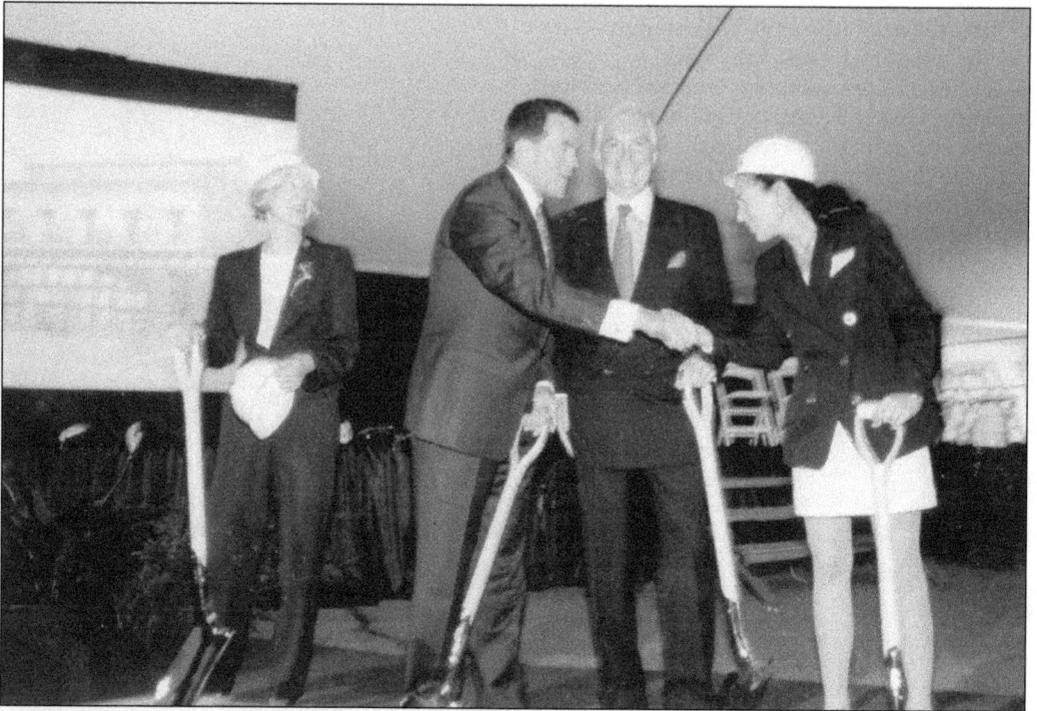

Then-governor Tom Ridge (second from left) congratulates Chryss O'Reilly and Tony O'Reilly at the groundbreaking ceremonies for the O'Reilly Theater, situated in the heart of Pittsburgh's Cultural District. "The O'Reilly," designed by noted architect Michael Graves, is home to Pittsburgh's Public Theater. Assisting with the ceremony was Cultural Trust CEO Carol Brown.

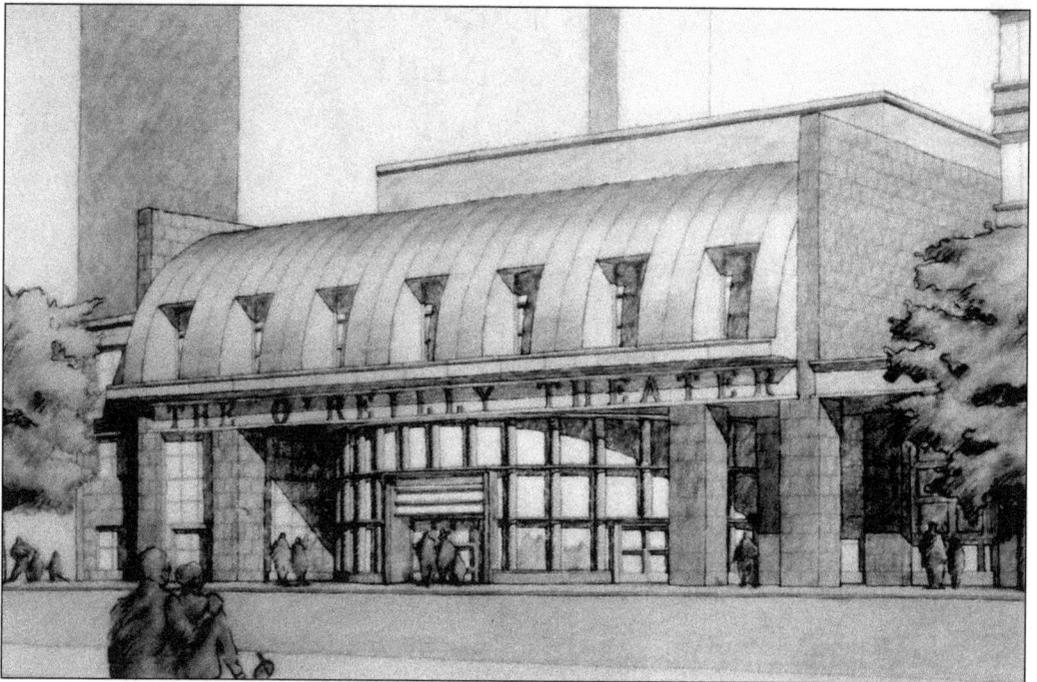

Seven

THE PREMIER GLOBAL FOOD COMPANY

William R. (Bill) Johnson is the fourth chairman of the H.J. Heinz Company and the second non–family member to fill the post. He took the helm in 2000, after earlier holding the titles of president and CEO. Johnson has led Heinz into new markets and focused the company for faster growth. In 2002, he oversaw the historic transaction with Del Monte Foods in which Heinz spun off its pet food, tuna, private label soup, and baby food businesses to Del Monte. This included the transfer of the Heinz North Side complex. Johnson drives innovation, and as a result, record numbers of new products flow from company research and development pipelines in the United States and abroad. Much of his emphasis has been on improving European operations. As chairman, Johnson has spent significant time in the field routinely conducting store checks to understand consumers and their buying patterns. One such foray was in Italy (right) where he evaluated store displays of Plasmon baby foods. Johnson's strategic plan focuses on the categories of ketchup and sauces, meals and snacks, and infant foods.

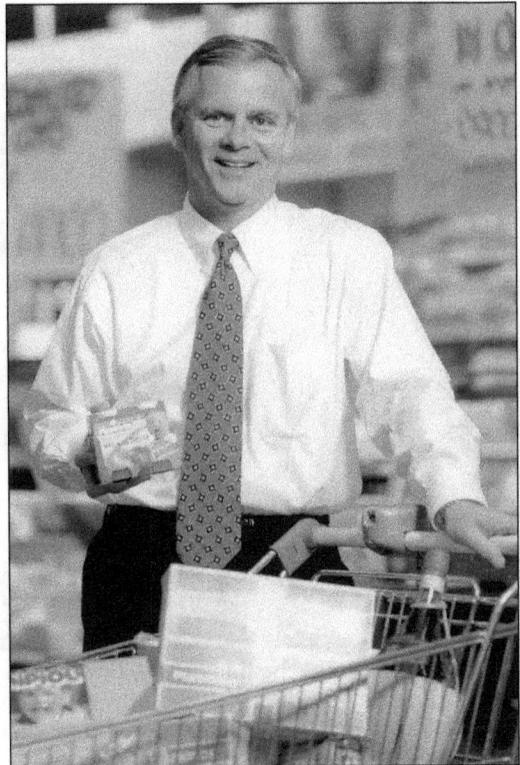

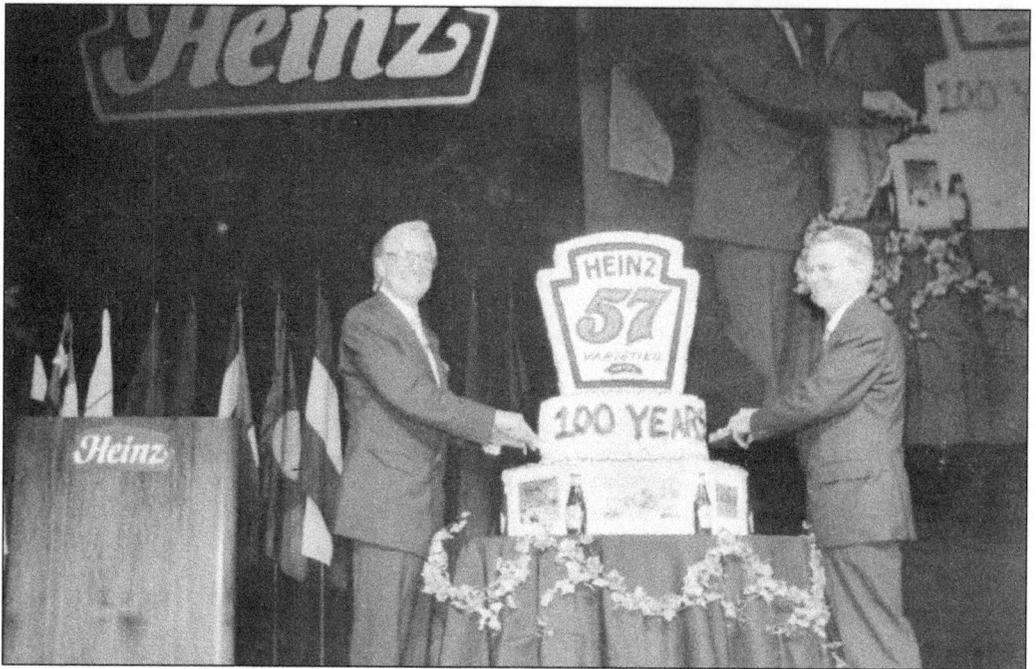

Saluting the creativity and durability of the 57 Varieties—and the slogan's 100th birthday—stood out as the highlight of the 1997 shareholders meeting. The 1,200 attendees enjoyed a five-foot-seven-inch cake, which was cut by Tony O'Reilly (left) and Bill Johnson.

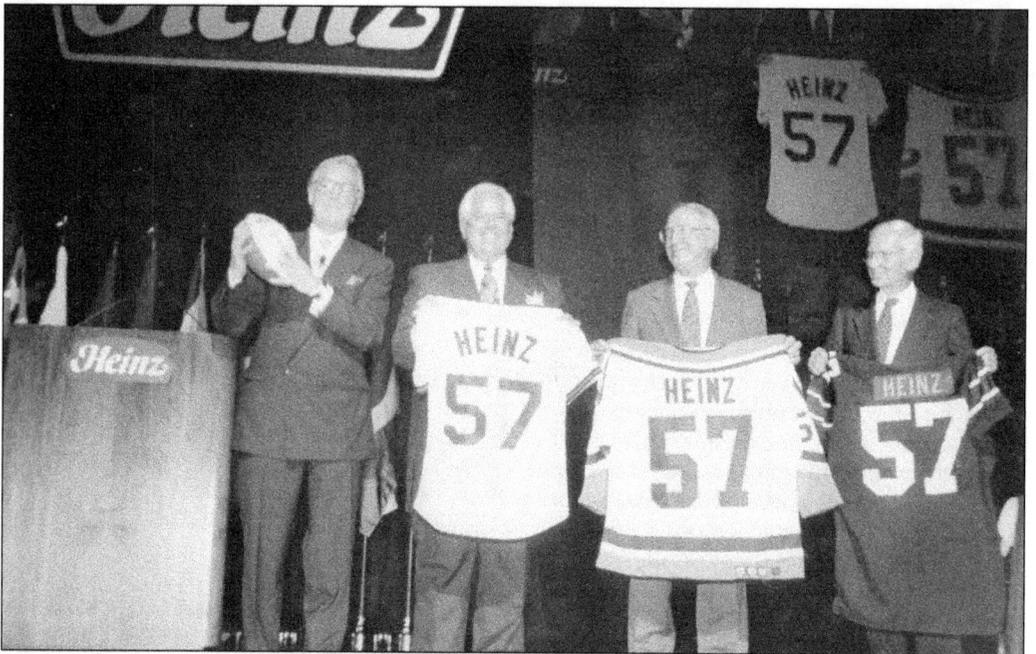

To further celebrate the number 57, Pittsburgh's three championship teams participated in the meeting by presenting Tony O'Reilly with commemorative jerseys. Team representatives are (from left to right) Nellie Briles, world champion pitcher for the Pirates; Jack Kelly, president of the Penguins; and Dan Rooney, president of the Steelers.

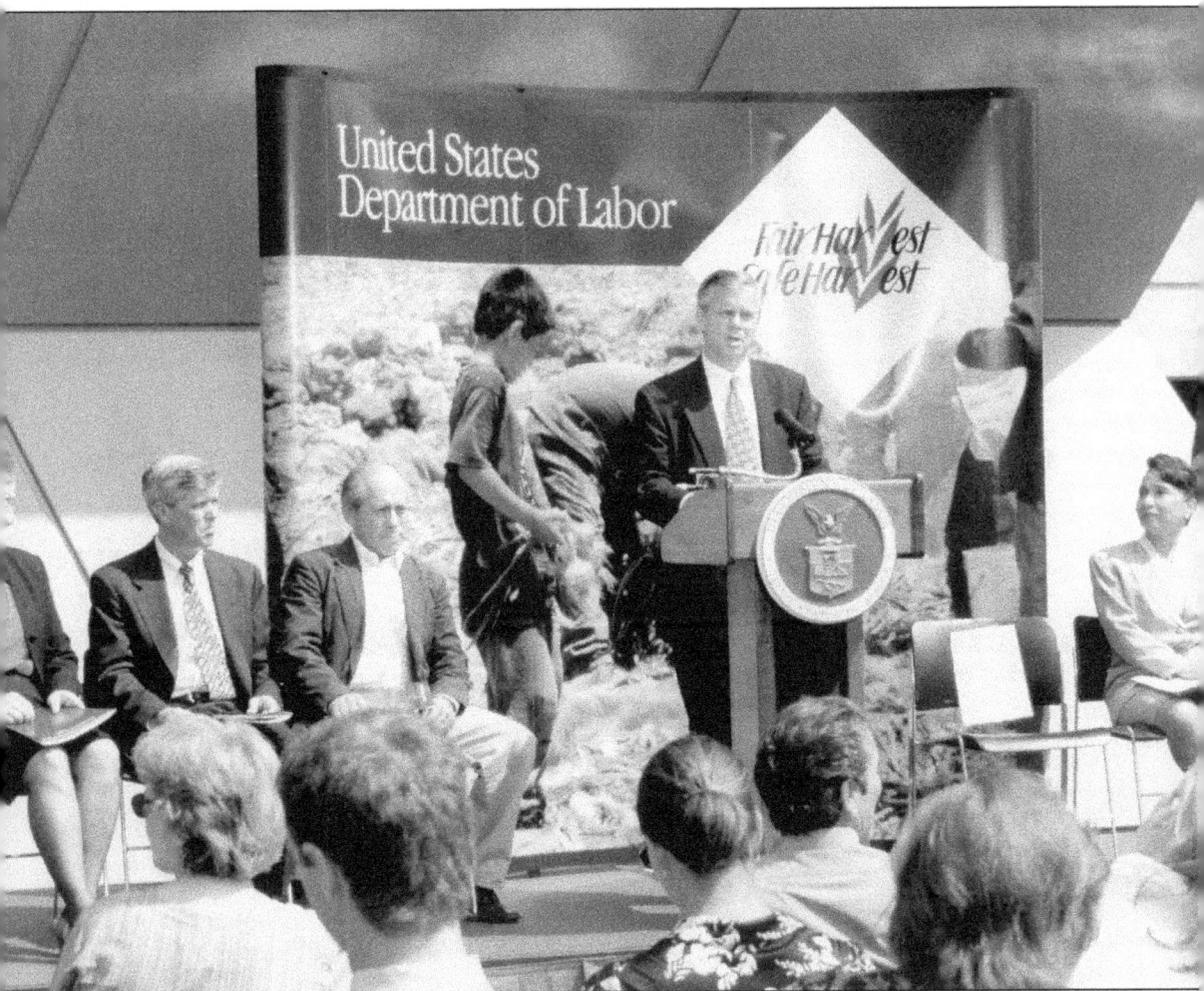

"Fair Harvest/Safe Harvest" was the descriptive slogan for a program developed by Secretary of Labor Alexis Herman (right). At a Washington, D.C., news conference Bill Johnson announced Heinz's partnership with the government to provide farmworkers with information about job rights and their children with educational programs. Heinz's assistance went to workers employed by Midwest cucumber growers.

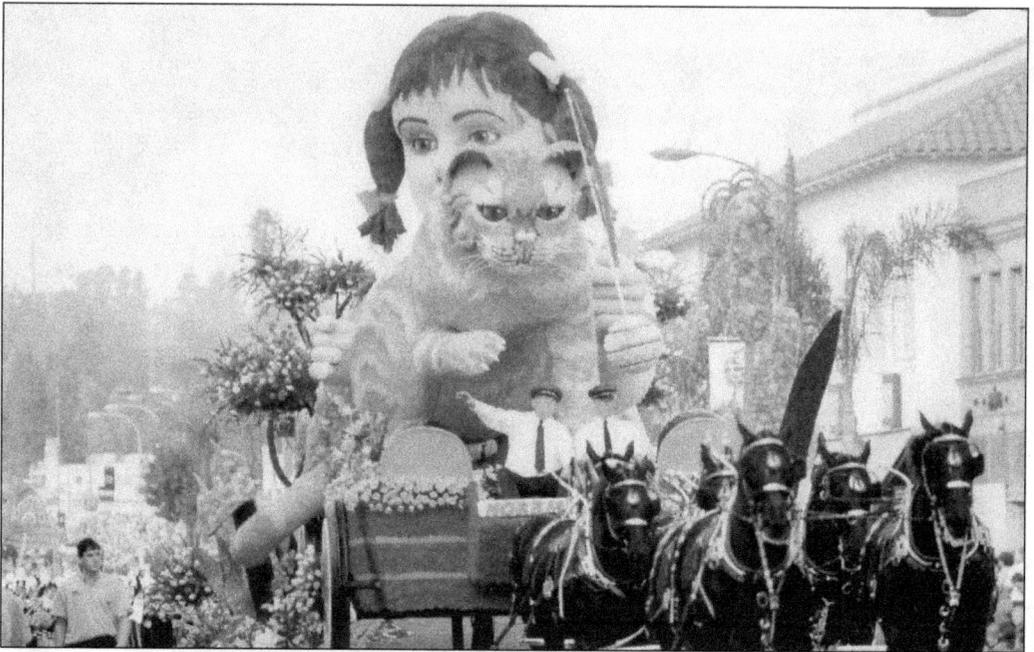

Heinz participated in five Tournament of Roses parades in Pasadena, California, starting with January 1, 1997. The first entry was "Morris, I'm Home," which promoted 9-Lives cat food. Between Christmas and New Year's Eve, employees from Heinz plants and offices in the Los Angeles area decorated the floats. Tradition requires every inch to be covered with flowers or other organic materials.

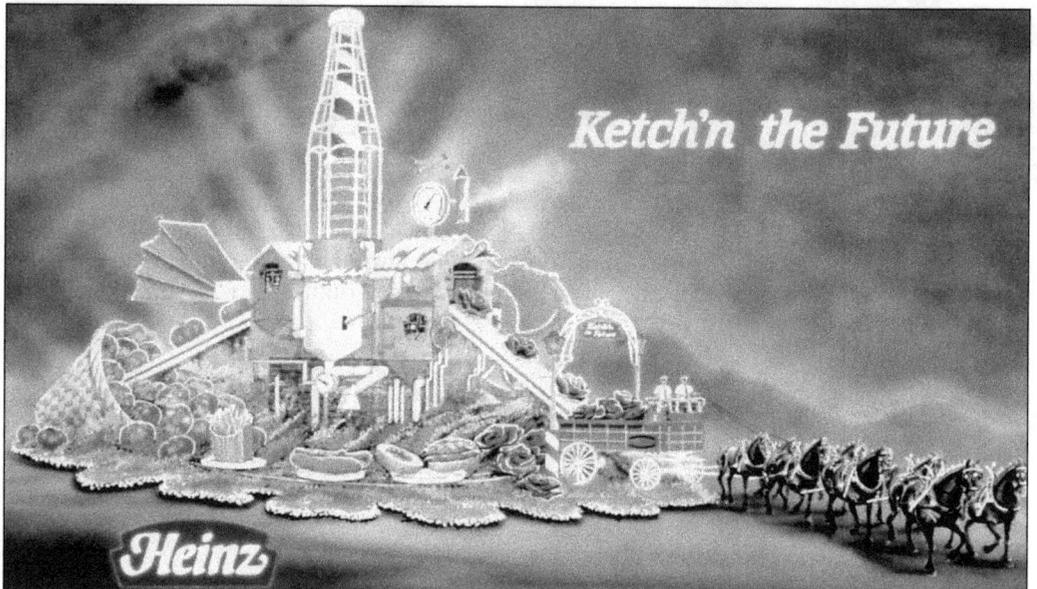

Other Tournament of Roses floats were "Sorry, Charlie!," a whimsical chariot in 1998; "Celebrating Women's Success," a salute to Weight Watchers members in 1999; "Ketch'n the Future" (above), a floral-covered ketchup factory and delivery wagon in 2000; and Nature's Best, a bountiful baby food display in 2001. In 2000, Heinz also introduced a Heinz ketchup pin, the millennial partner to the pickle pin.

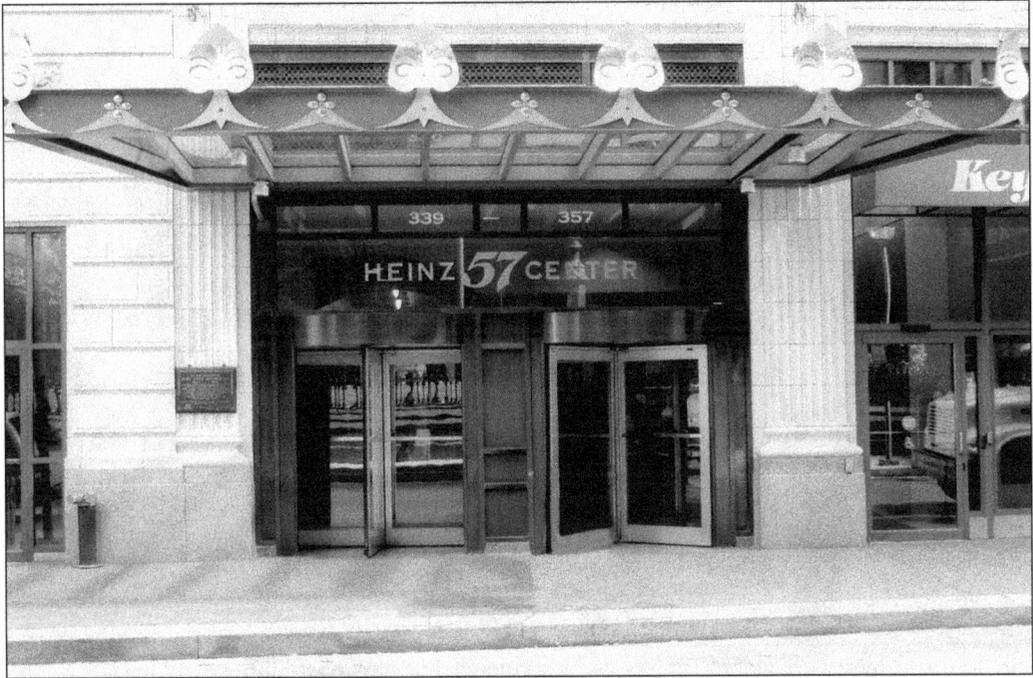

Heinz moved its North America headquarters in 2001 to the former Gimbels Department Store building in downtown Pittsburgh and renamed the landmark the Heinz 57 Center. The renovation received plaudits from environments for its "green" roof, which includes grasses and plantings. Among the artifacts transferred to the new location was a life-size statue of Henry J. Heinz, which had been commissioned by employees just after his death and which formerly stood sentry in the lobby of the Administration Building in the North Side complex.

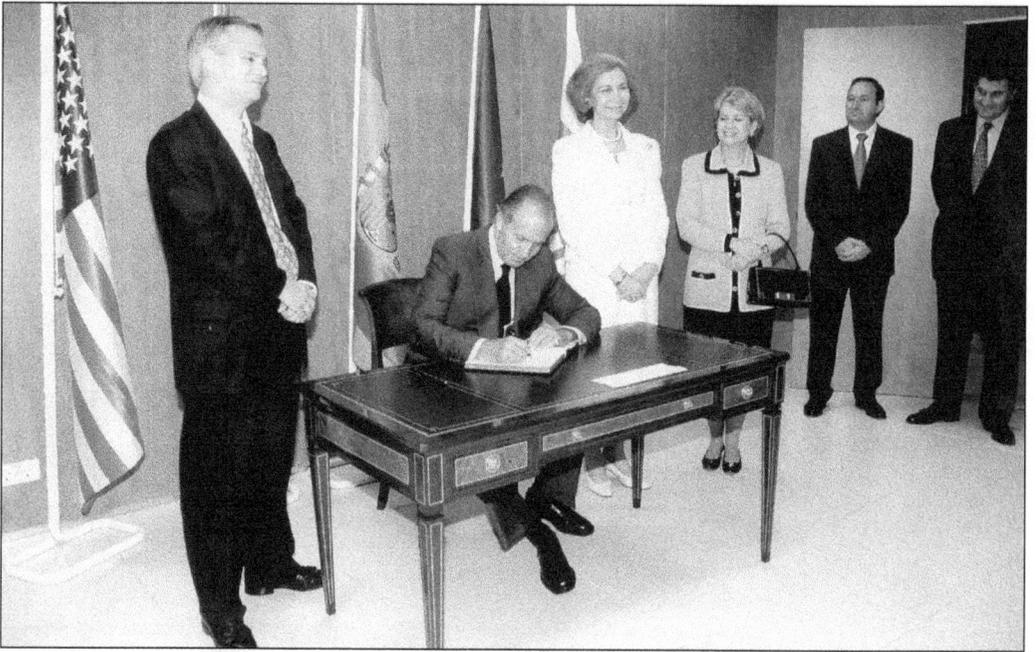

Bill Johnson met with global leaders as he explored business possibilities worldwide. At the opening of the just-constructed tomato products factory in Alfaro, Spain, he and King Juan Carlos (seated) signed a declaration officially opening the facility. On hand for the celebration were Queen Sophia (fourth from right) and Bill's wife, Susie.

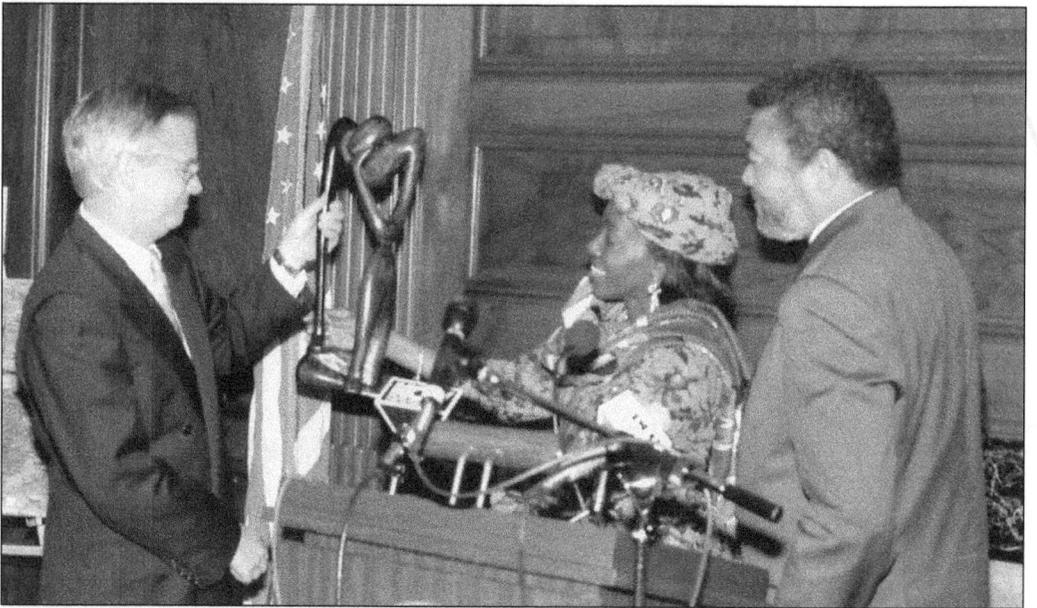

His Excellency Flight Lt. Jerry John Rawlings (right), president of Ghana, and his wife presented Bill Johnson with a traditional carving in recognition of Heinz's grants and gifts to their African nation. Much of the aid was distributed by Heinz employees there and by the Brother's Brother Foundation, a Pittsburgh nonprofit organization.

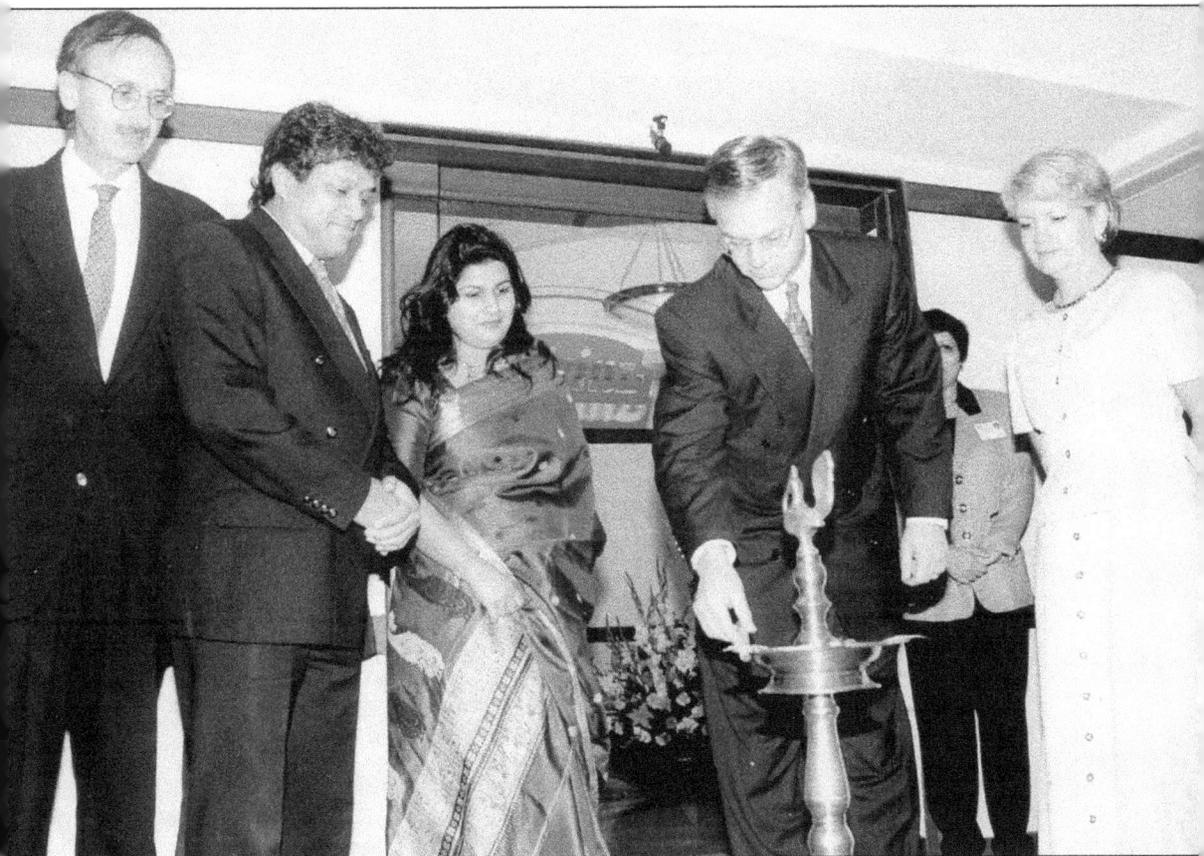

Bill and Susie Johnson lit a delicately sculptured "auspicious" lamp to open business meetings at Heinz's ultramodern, paperless office in Mumbai. They were accompanied by Ted Smyth (left), senior vice president for corporate and government affairs and a veteran of international travel. Welcoming the headquarters entourage were Mr. and Mrs. Pradeep Poddar of Heinz India.

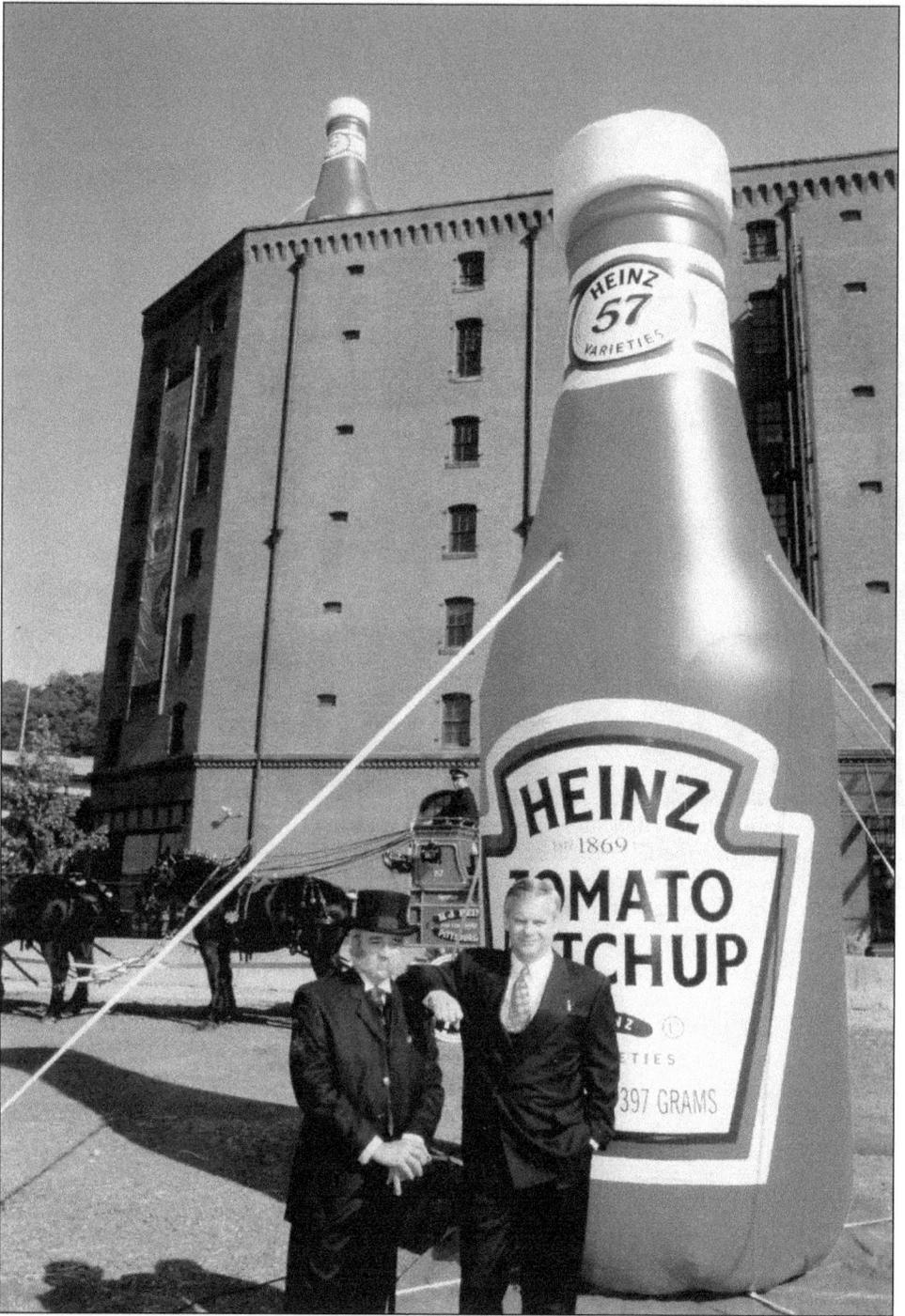

Two 57-foot inflatable ketchup bottles welcome both the first and the fifth chairmen of the H.J. Heinz Company to the opening of *Heinz 57*, a permanent exhibit at Pittsburgh's Senator John Heinz Regional History Center. Founder Henry Heinz (also known as actor Bruce Hill) welcomed Bill Johnson to the showcase, which includes displays of international products, early television commercials, and even Henry's original hand-written ketchup recipe.

Susie and Bill Johnson congratulated Ed Lehew on his initiative in making the History Center exhibit become a reality. Lehew, a retired advertising executive, personally preserved thousands of artifacts as the company's unofficial historian.

Andy Masich (center), History Center president, delighted in the many hands-on activities at the *Heinz 57* gallery. Youngsters are encouraged to learn about pickle packing and advertising art through simulated work tables.

The upside-down pack originated during visits to consumers' homes where Heinz market researchers spotted folks storing ketchup in their refrigerators with the cap down. This made it easy to instantly squeeze ketchup from the bottle. The innovation proved so popular that it quickly migrated to the United Kingdom and across Europe, where it is known as "top down."

Global Nutrition director David Yeung, Ph.D., hosted an international symposium in Washington, D.C., which was attended by researchers from 13 different countries. The topic was lycopene, the antioxidant that gives tomatoes their rich red color and that helps protect against certain cancers and a host of other maladies. Counter to conventional wisdom, processed or cooked tomatoes are a better source of lycopene than the fresh vegetable. Yeung presented an autographed copy of *Great Tomato*, one of several books he coauthored on the subject, to former senator Robert Dole, who spoke at the 2002 event.

Henry Heinz's mantra of quality continues to influence the company. Heinz U.K. embarked upon an advertising campaign to emphasize the unparalleled nature of its products. The theme was "Good Food, Every Day," which is now used by Heinz worldwide to inform consumers—and employees—of this enduring commitment.

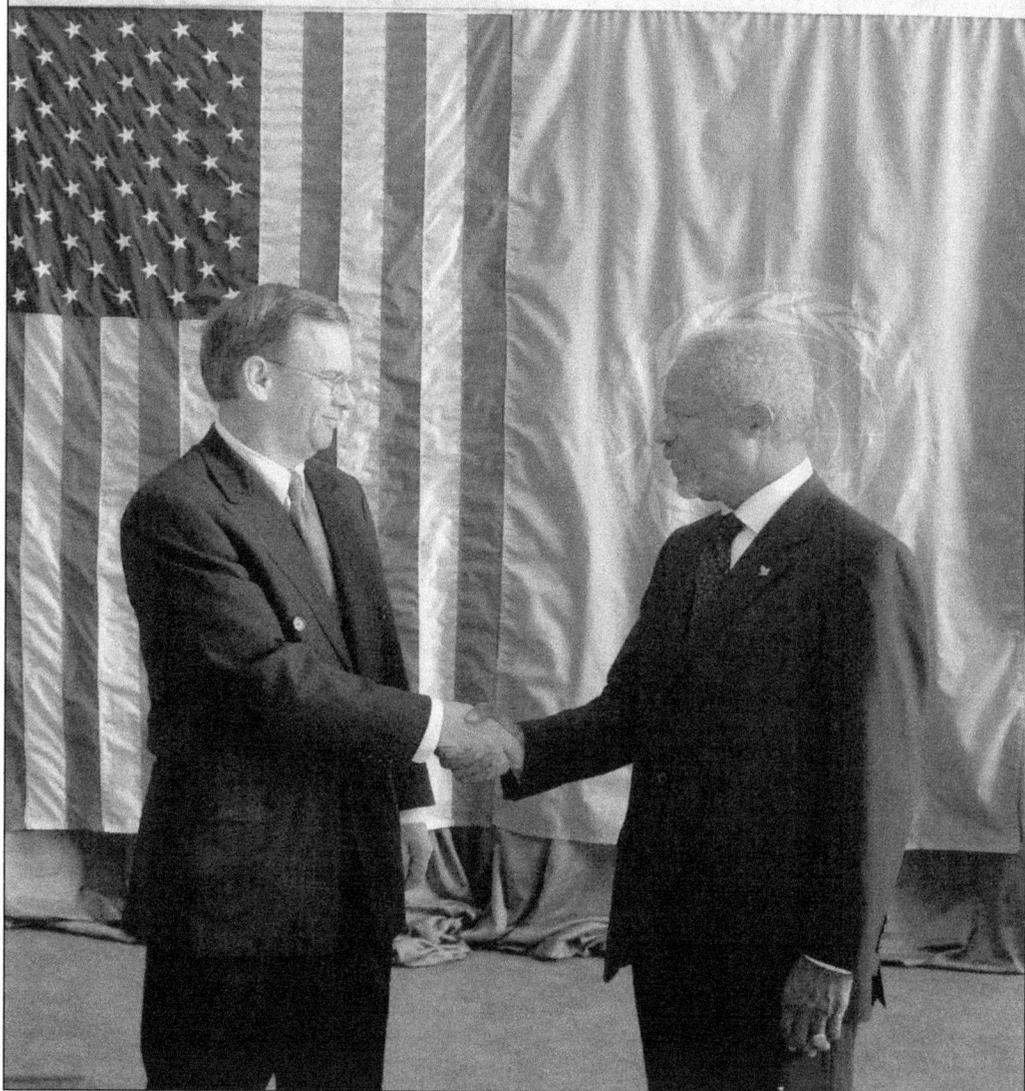

PITTSBURGH WELCOMES U.N. SECRETARY - GENERAL KOFI ANNAN

Secretary General Kofi Annan of the United Nations met with Bill Johnson prior to the ninth H.J. Heinz Company Distinguished Lecture in 2003. During the visit, Johnson also presented Annan with the H.J. Heinz Company Foundation Humanitarian Award for his efforts in leading United Nations programs to alleviate malnutrition, particularly micronutrient deficiencies among children in the developing world.

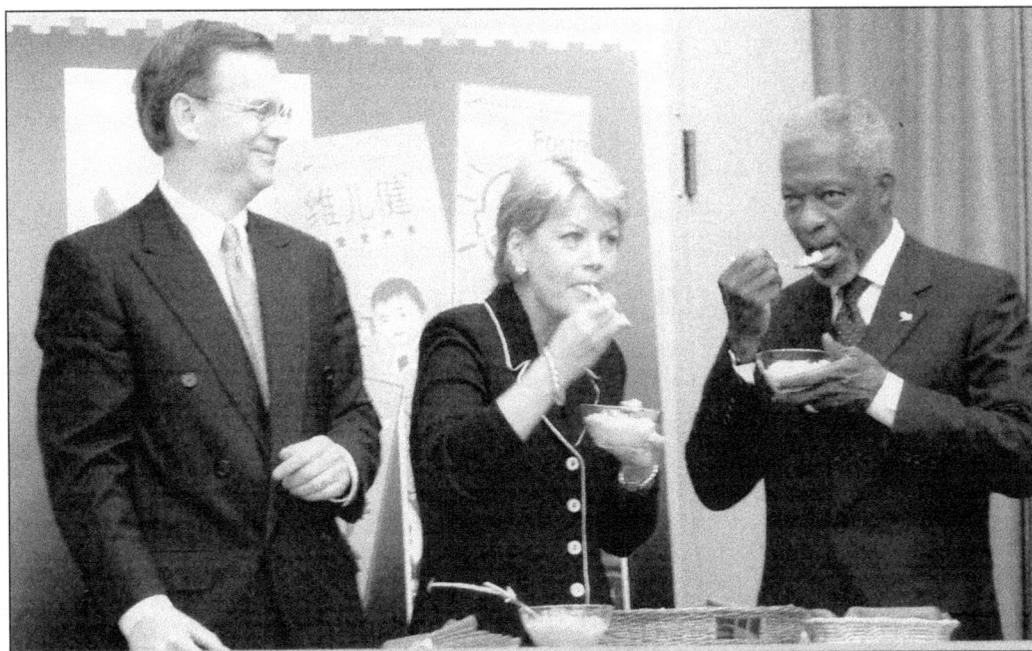

Secretary General Kofi Annan sampled a bowl of rice topped with Sprinkles, a tasteless and colorless powdered nutrient that can be sprinkled on foodstuffs, such as rice or congee. The iron-rich supplements have been proven more effective than liquid drops in combating anemia. Annan was joined by Bill and Susie Johnson.

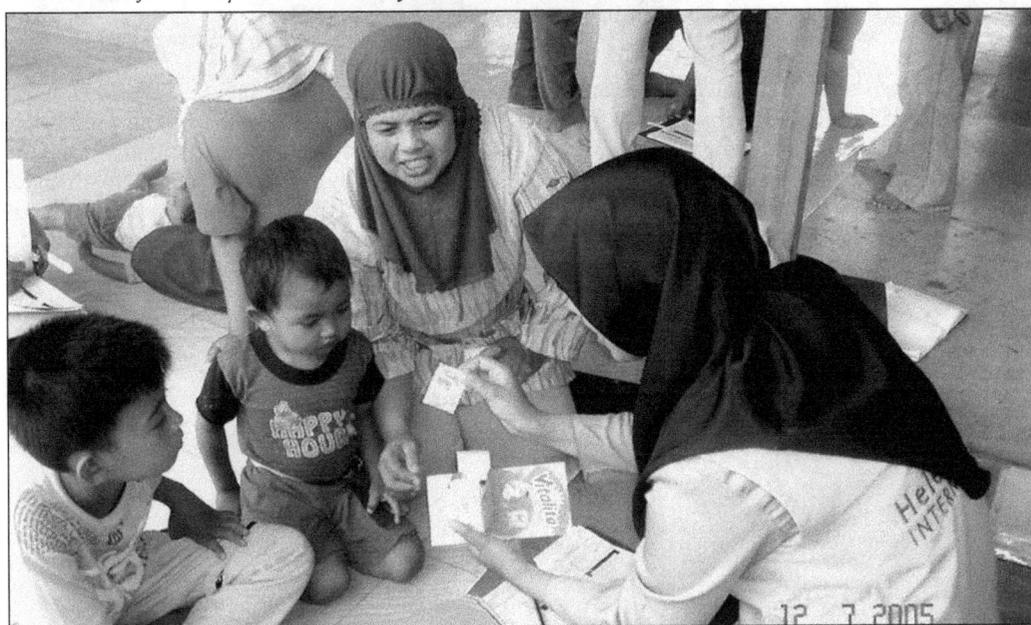

The H.J. Heinz Company Foundation expanded support for its micronutrient supplement program with a pledge of $5 million to help reduce malnutrition and the scourge of anemia. The centerpiece of the program is distribution of vitamin and mineral packets to families, particularly those in the emerging markets of China, India, and Indonesia. Helen Keller International assisted with giving children in Indonesia Vitalita nutrient supplements following the 2004 tsunami.

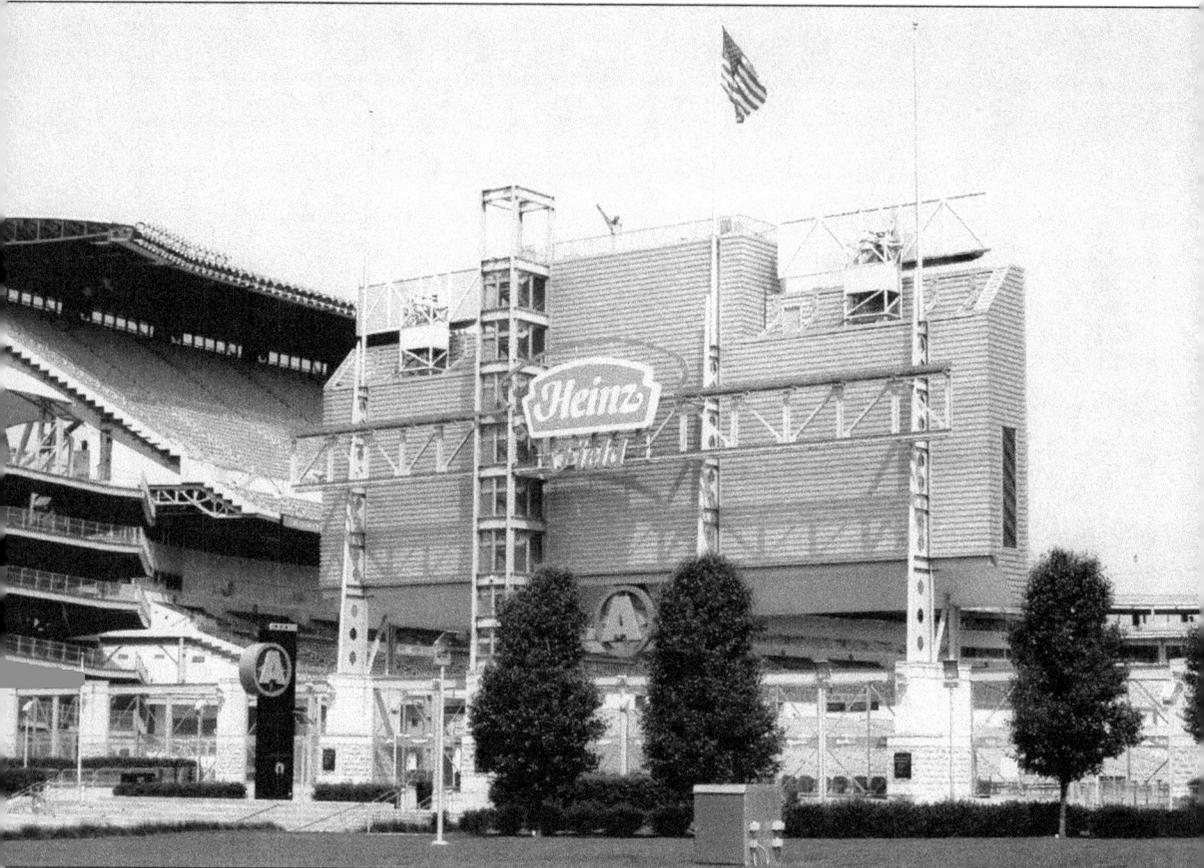

Heinz paid $57 million for the 20-year naming rights to Heinz Field, home of the Pittsburgh Steelers. Announced just prior to the 2001 season, the partnership and marketing arrangement was hailed as the pairing of two city icons, both of which originated on the city's North Side. The program proved quite cost-effective and represented just three-tenths of one percent of the company's global marketing budget. In return, Heinz benefits from football mania and the accompanying marketing blitz of the National Football League.

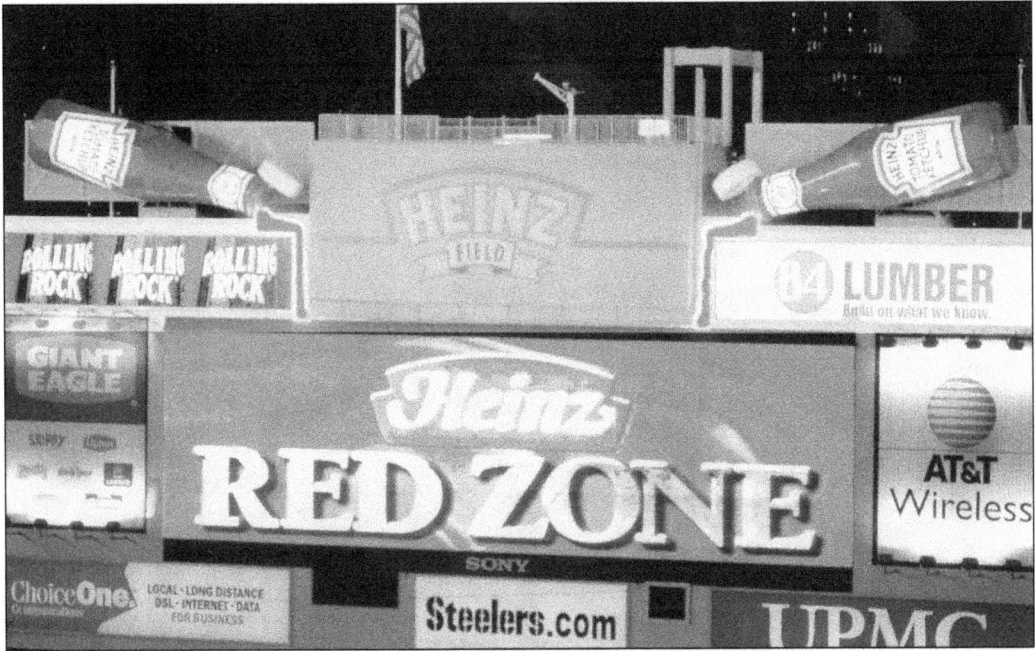

Two of the world's largest ketchup bottles rest atop the Heinz Field scoreboard display. The 35-foot, 8,000-pound neon and fiberglass bottles "pour on" excitement when the home football team enters the aptly named Red Zone. If filled with ketchup, each bottle would contain 1,664,000 ounces or enough for 3.2 million hot dogs.

NFL commissioner Paul Tagliabue (left) joined Bill Johnson and Steelers executive Art Rooney II in announcing the naming rights, which Tagliabue called a "partnership between one of professional sports' most respected families and one of America's leading brands."

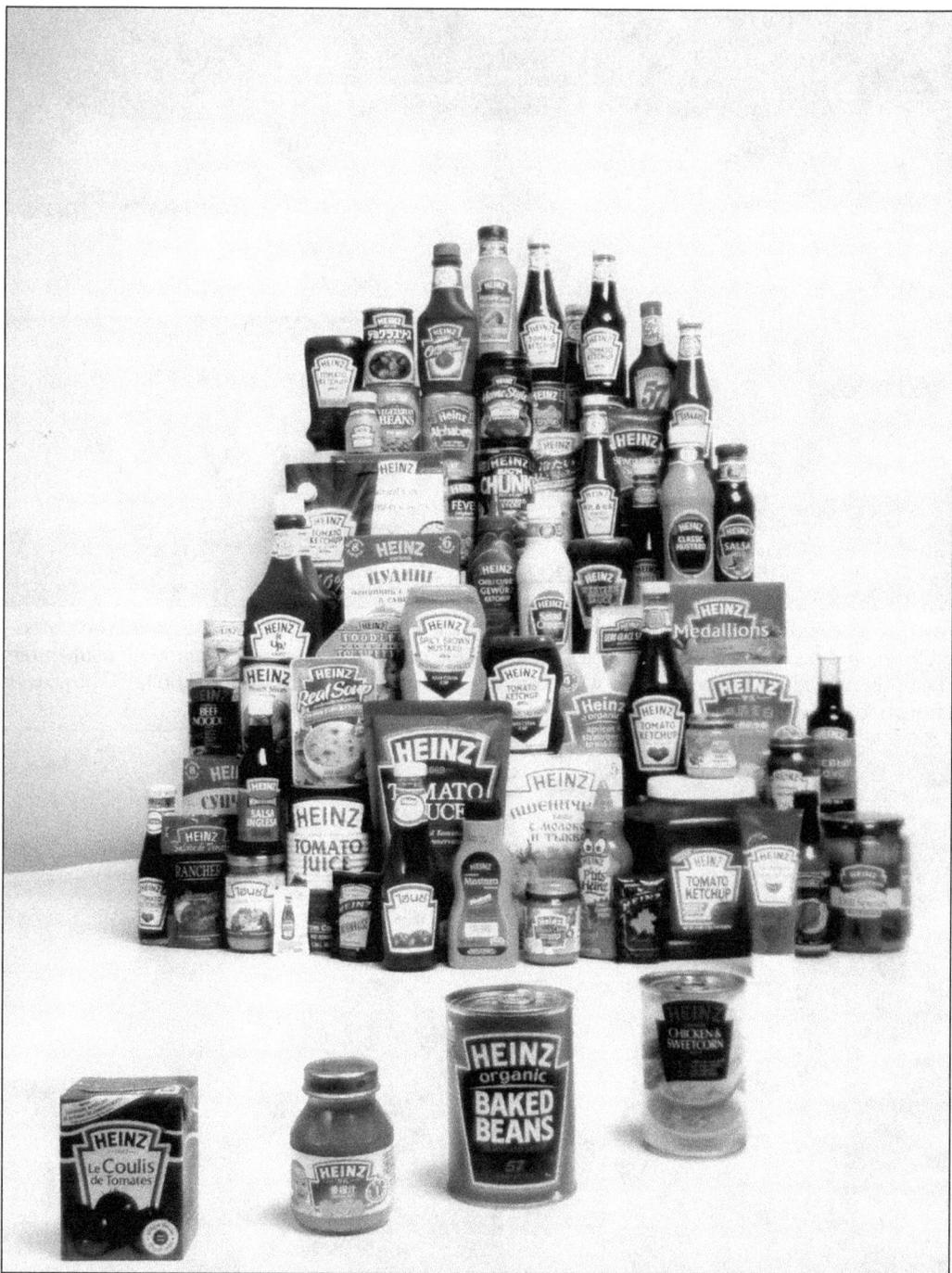

H.J. Heinz Company remains one of the very few international companies built on a singular eponymous brand. The Heinz brand name is the company's most valuable asset. According to a survey by New England Consulting Group in 2005, the Heinz brand stands as one of the most versatile in the world and holds a lifetime brand value exceeding $20 billion. The Heinz name is beloved worldwide and recognized on an ever-broadening array of products served at all meal times. It is defined by the terms trust, premium quality, great taste, and wholesome nutrition.

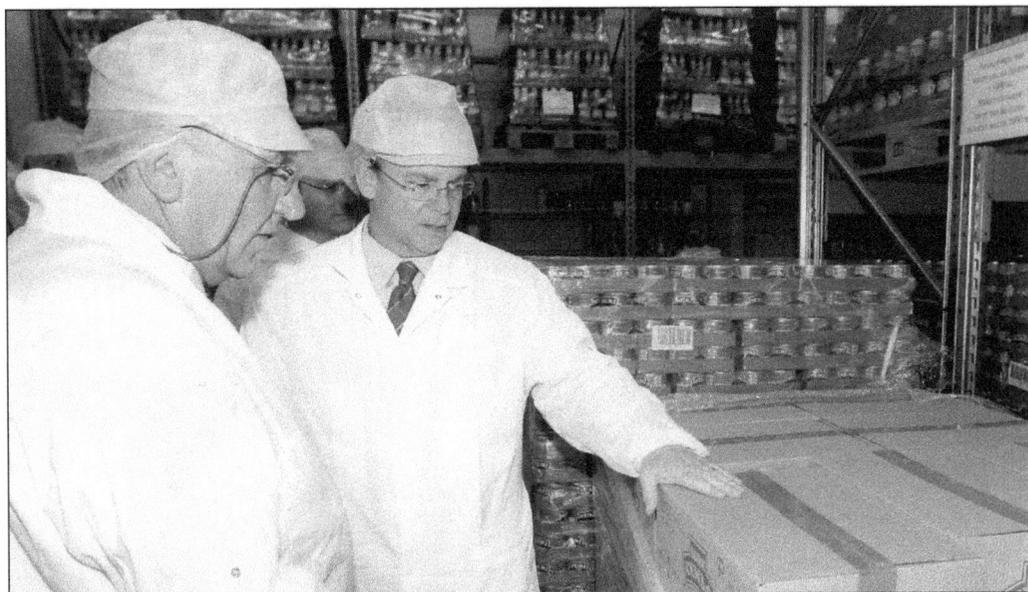

In emerging markets, Heinz often partners with local companies that understand their consumers and that hold important brand names. Such is the case in Russia, where Heinz signed a 2005 joint venture agreement with Petrusoyuz, a top producer of mayonnaise, spreads, and ketchup. Bill Johnson toured the Petrusoyuz factory, which puts out Picador brand ketchup. In Poland, Heinz sells ketchup under the local Pudliszki name. Polish consumers enjoy it on top of pizza.

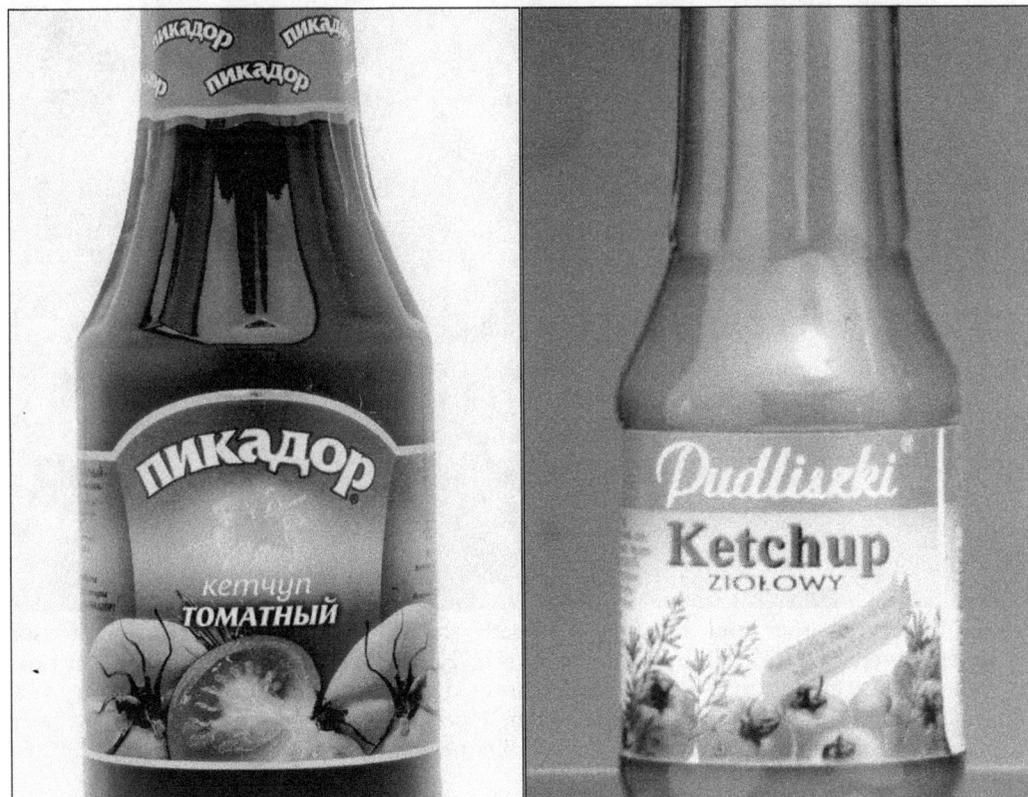

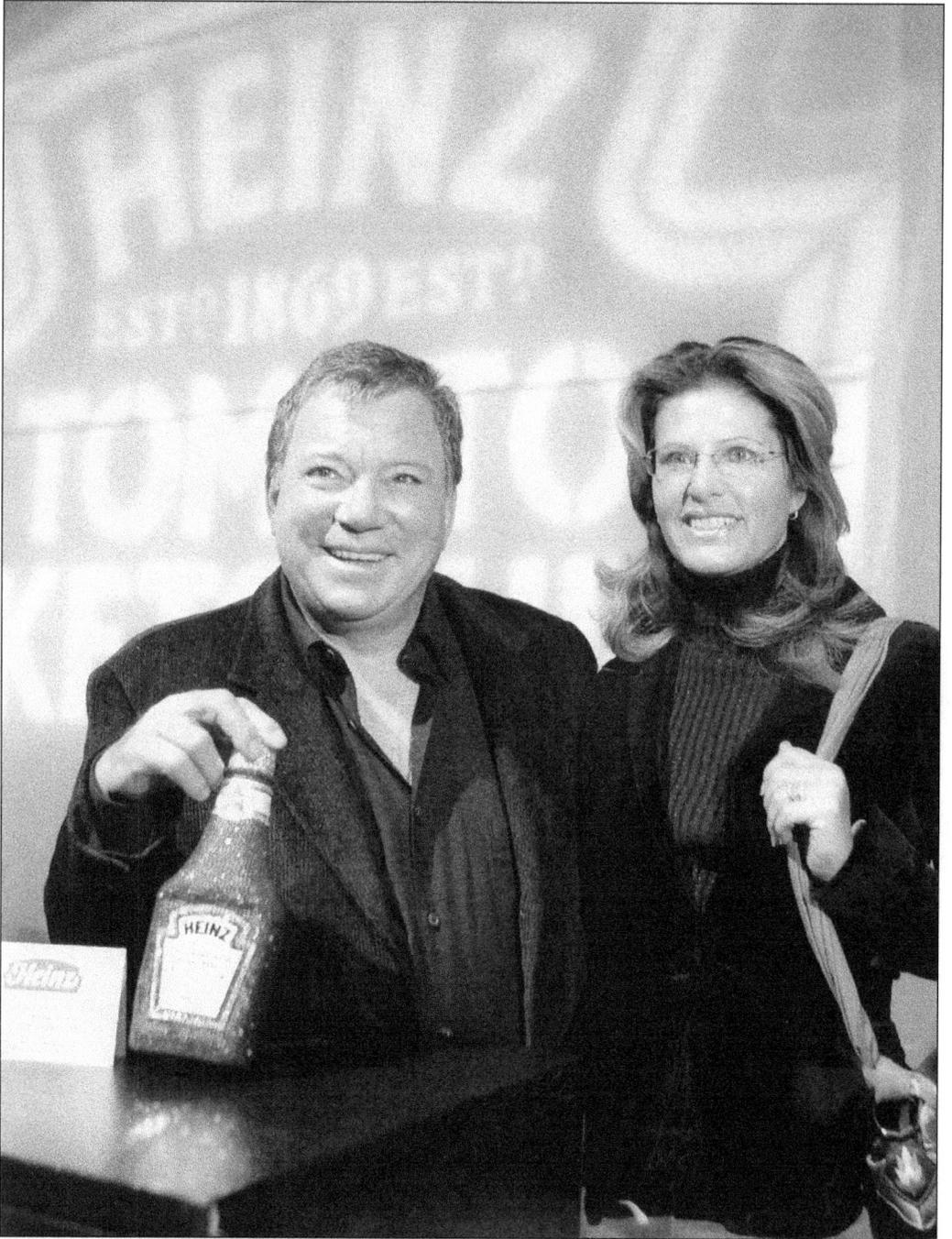

Actor William Shatner and his wife Elizabeth showed off a one-of-a-kind Swarovski crystal-encrusted Heinz Ketchup bottle before the "Heinz Pours It On for Charity" auction at Sotheby's in Manhattan. The 2004 sale garnered donations to the favorite charities of participating celebrities—soccer star Mia Hamm, football hall of famer Terry Bradshaw, teen sensation Lindsay Lohan, and television legend Shatner.

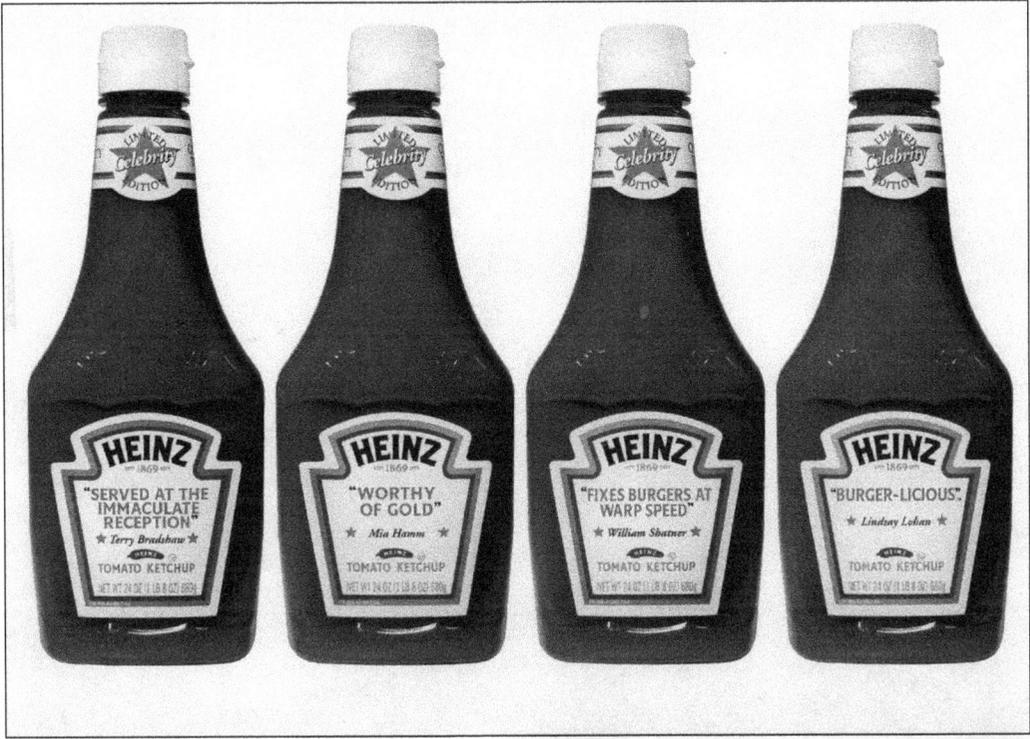

One of the most enduring and clever packaging promotions has been "talking" ketchup labels. Clever and evocative slogans or jingles are printed on the labels, thus talking to consumers, often with a quip or rhetorical question. The idea reached new heights with the celebrity talking labels. And in mid-2006, consumers were offered the opportunity to create their own labels by ordering customized bottles through a Heinz Web site.

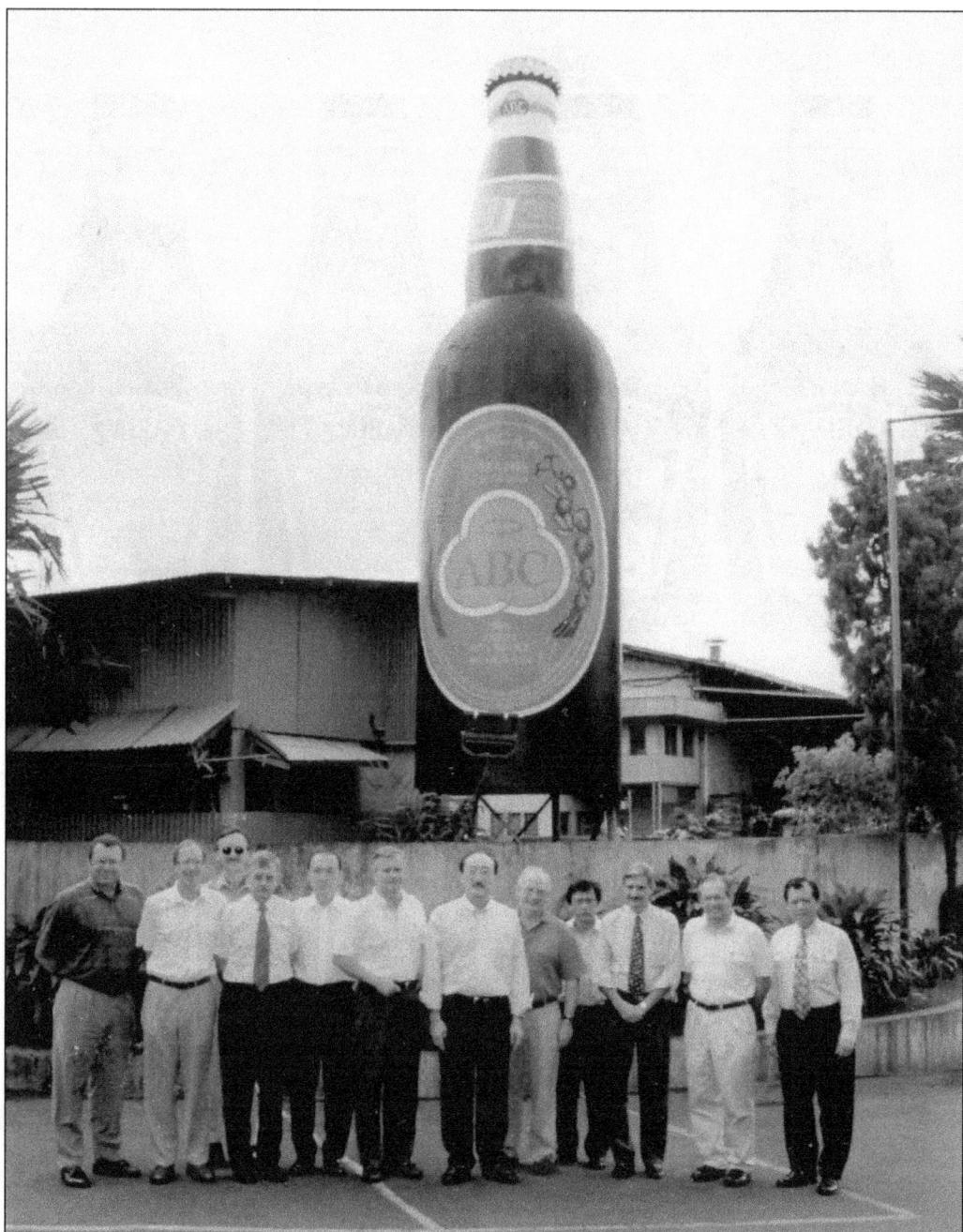

As the world's leading sauce maker, Heinz continues to expand its offerings not only through new varieties created by its product developers but also through acquisitions. Two major acquisitions significantly expanded Heinz's global reach and added three iconic names. In 1998, Bill Johnson (sixth from left) led Heinz into Indonesia with the acquisition of ABC, the world's number-two soy sauce and an Asian powerhouse. ABC brands include *kecap*, a sweet soy sauce with a name similar to *ketsiap*, the brine-based condiment brought by 17th-century sailors to America from Asia and the forerunner to ketchup. Heinz's global executive team was welcomed at the ABC factory shortly after the acquisition.

120

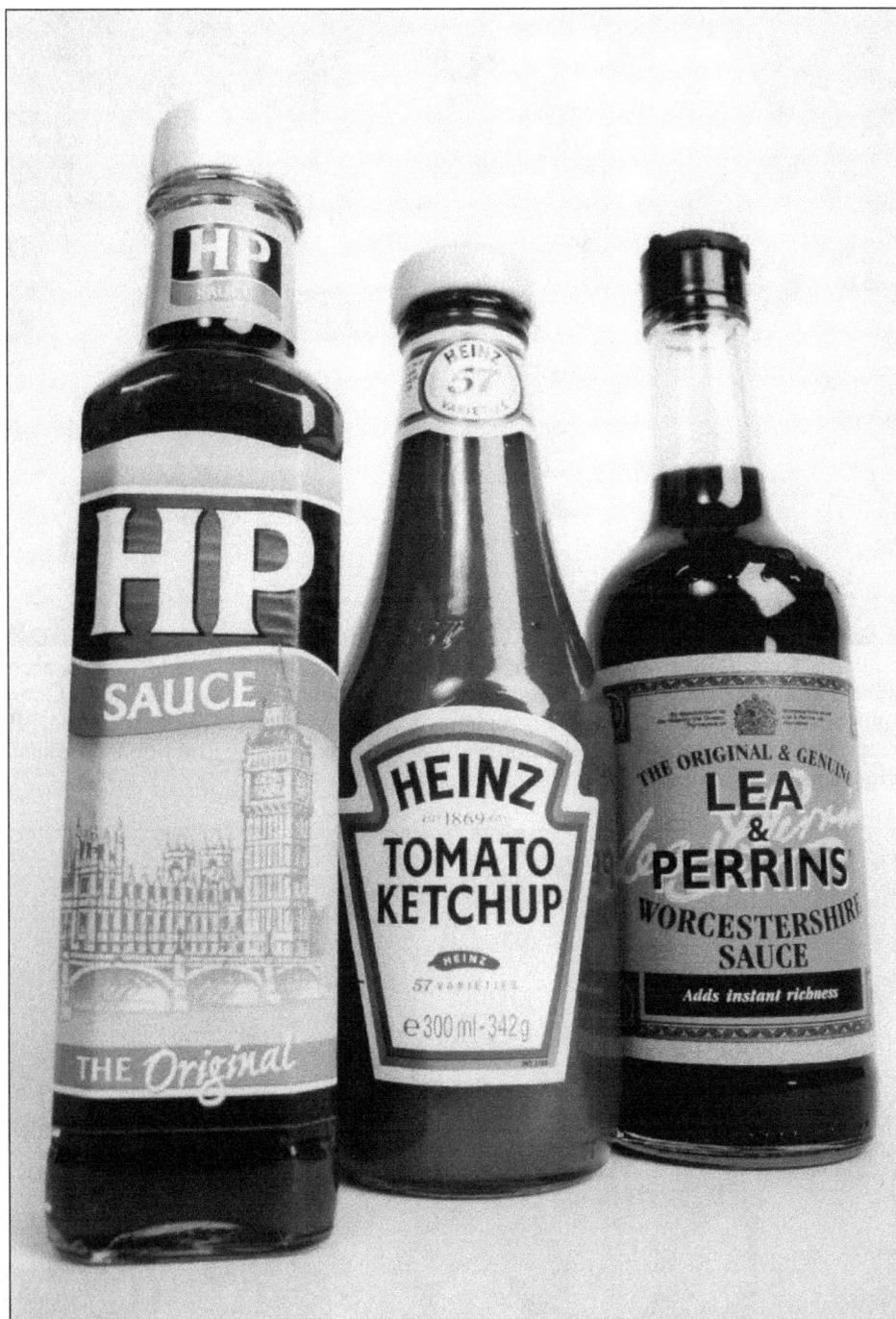

Lea & Perrins and HP joined the Heinz basket of brands in 2005. Both ranges are exported around the globe to more than 75 countries. Along with Heinz Ketchup, they sit proudly atop tables and counters in restaurants everywhere. Lea & Perrins is the world's largest-selling Worcestershire sauce. Truly a historic brand, it was first served in 1837 on the tables of ocean liners that traveled in and out of British waters. HP, which stands for Houses of Parliament, has long been Britain's favorite savory table sauce.

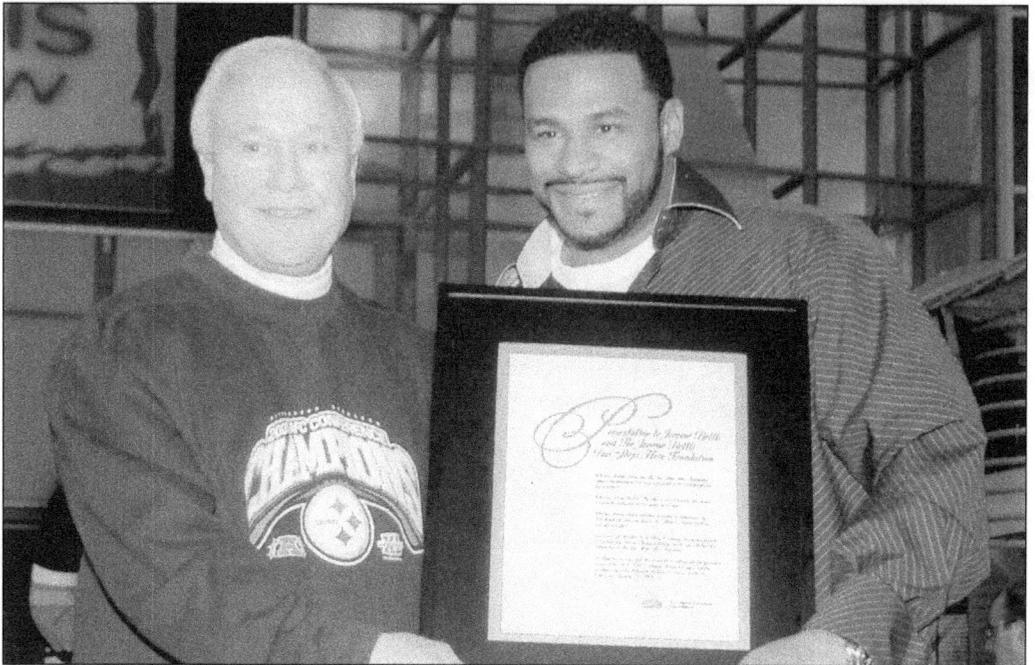

Jerome Bettis, former running back for the 2006 world champion Pittsburgh Steelers, accepted the 2006 Community Service Award from Jack Runkel, chairman of the H.J. Heinz Company Foundation. Bettis was recognized for his support of inner-city youth through the Jerome Bettis Bus Stops Here Foundation. Bettis was only the second recipient of the honor; the first was Roberto Clemente, the baseball star and humanitarian.

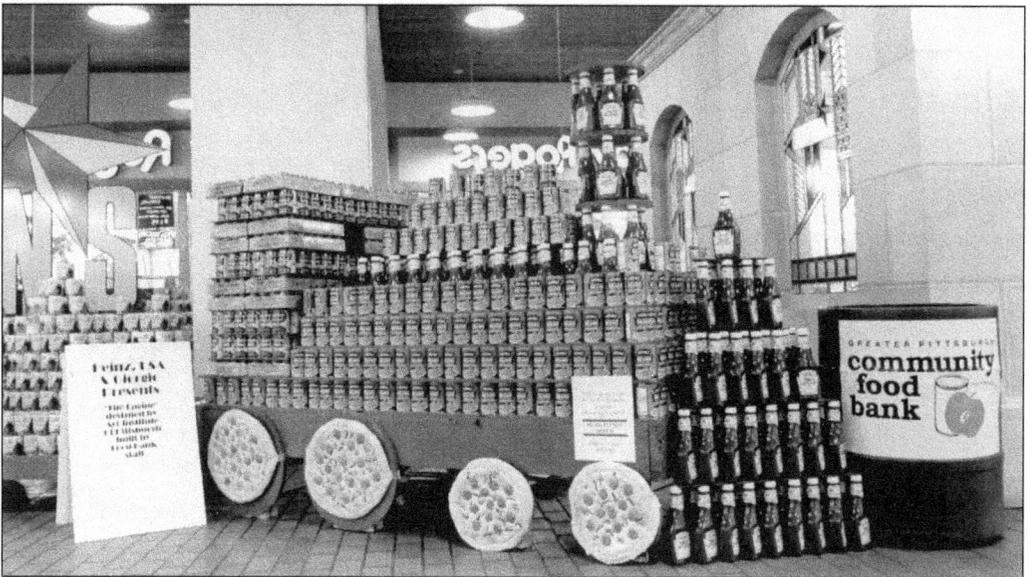

Alleviating hunger abroad and at home is a Heinz mission. Through strong support of food banks worldwide, Heinz has been a leading proponent in the fight against hunger. To draw attention to the need, many organizations—including the Greater Pittsburgh Food Bank—sponsor contests to construct massive sculptures using packages of food, which later are donated to local families.

When earthquakes hit the Umbria region of Italy in 1998, Plasmon pitched in with special gifts of toys and biscuits for children in the area. Similar kindnesses are regularly shown by the company and its employees anytime disaster strikes.

In 1923, Heinz was the first to use the "Circle U" symbol to designate a product as kosher. The insignia initially appeared on Heinz vegetarian beans after Heinz and the United Federation of Orthodox Rabbis collaborated on the design. Throughout the years, representatives of the Orthodox Union have been on hand at Heinz factories. One long-serving representative was Rabbi Morgenstern, who certified operations at the Pittsburgh plant. Heinz was presented with the Centennial Kashruth Founder's Award in 2003 for its trailblazing work.

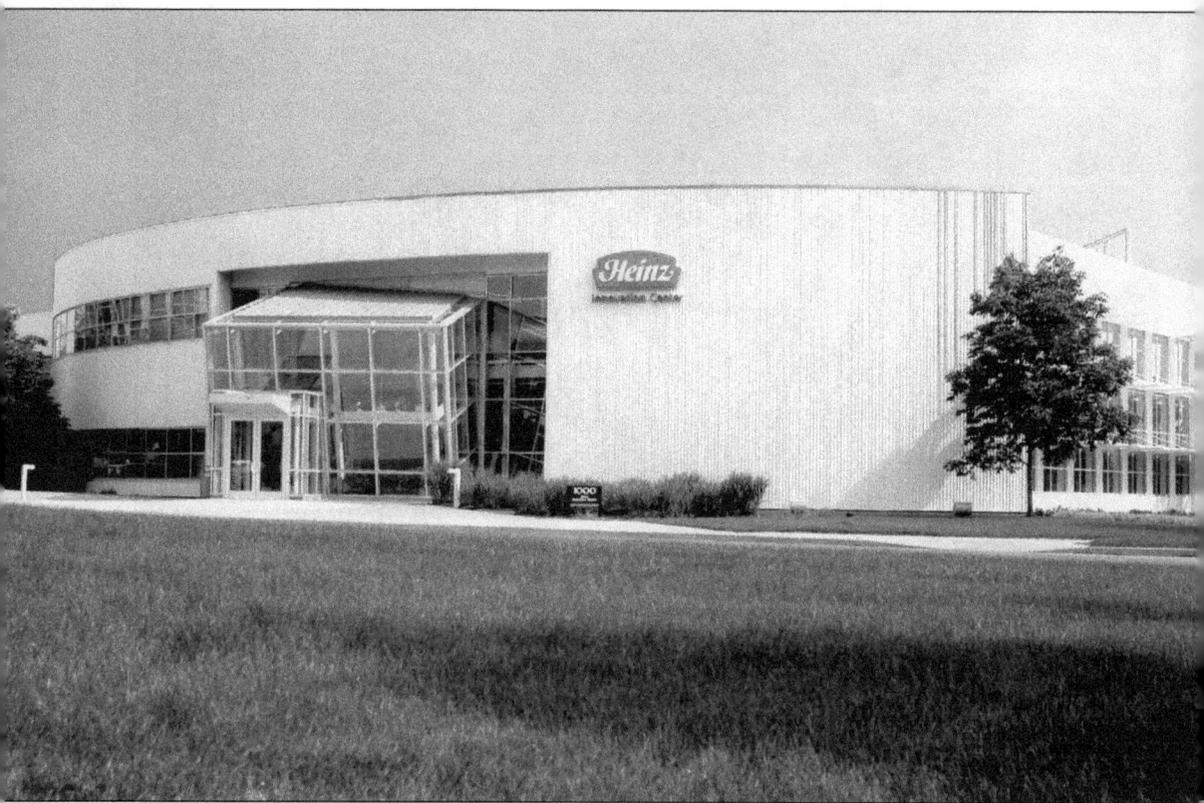

The Heinz Global Innovation and Quality Center opened in September 2005 north of Pittsburgh. The center is home to more than 100 chefs, food technologists, nutritionists, microbiologists, packaging engineers, and quality assurance specialists. The ultramodern structure centralized and updated the research and development and quality laboratories that had been located in the company's former complex on the city's North Side. The building also houses Heinz's International Center of Excellence for Ketchup and Sauces. Here resides Heinz's unparalleled tomato knowledge for the development of seeds that produce better-tasting tomatoes.

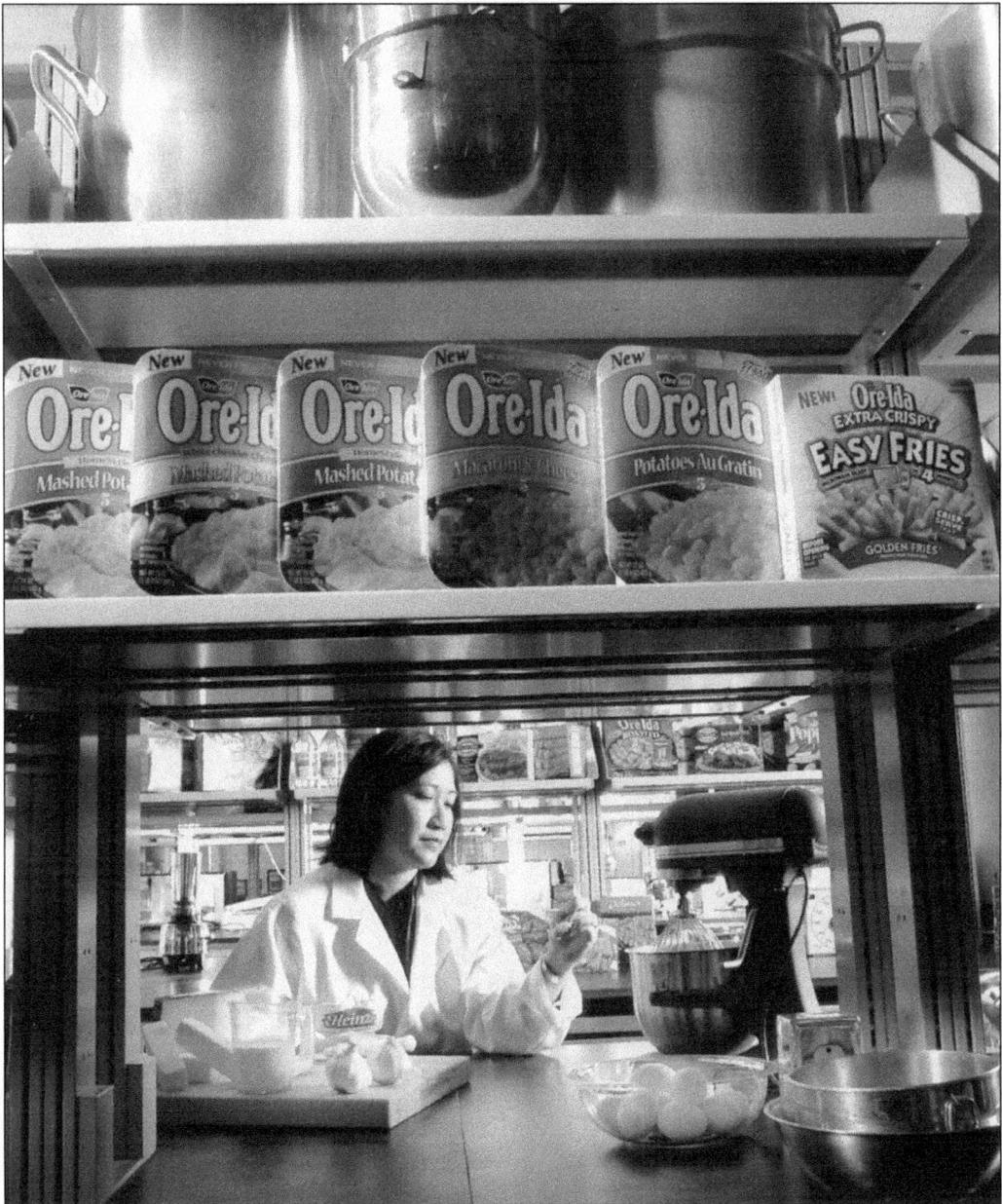

One of Heinz's biggest opportunities is in the fast-growing chilled section of the grocery store. Here Ore-Ida leads the way with tasty formulations for chilled mashed and au gratin potatoes, along with other varieties. Cora Towle, senior manager of research and development, prepared test batches at the Innovation Center.

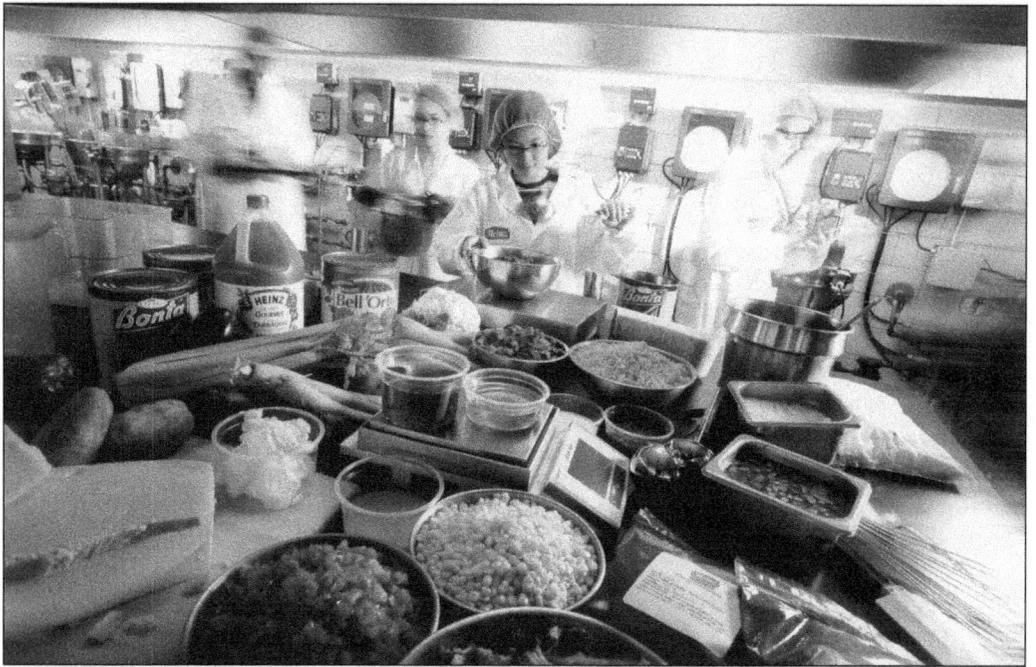

Soups have been among the most profitable food service products. Work on new varieties begins in the Innovation Center's "Kettle Row" under the watchful eye of food technologists, such as Marjory Renita.

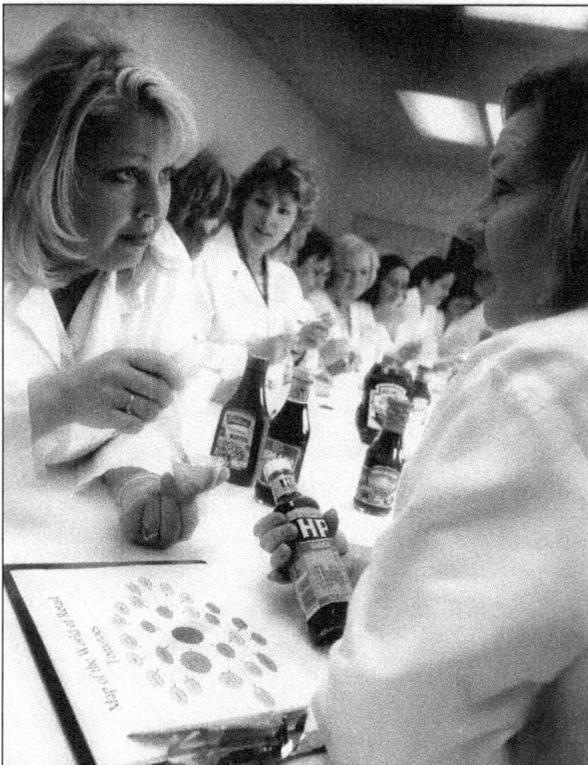

Few tongues in the world are more finely tuned than those of the Heinz Sensory Evaluation Panel, which meets at the Innovation Center. Their palates must discern minute differences in food attributes ranging from saltiness to sweetness to texture and mouth heat, and many more, on a 15-note flavor and texture scale.

H.J. Heinz Company is the world's largest maker of processed tomato products.

Visit us at
arcadiapublishing.com